1000
Faces of God

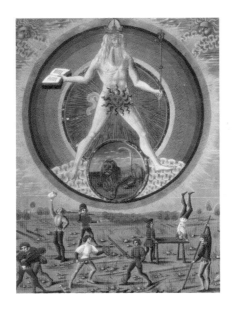

THIS IS A CARLTON BOOK

Text and design copyright © 2004
Carlton Books Limited

This edition published by
Carlton Books Limited 2004
20 Mortimer Street
London W1T 3JW

A CIP catalogue record for this book is available
from the British Library.

ISBN 1 84442 872 9

Printed and bound in China

Editorial Manager **Judith More**
Art Director **Penny Stock**
Executive Editor **Lisa Dyer**
Design **Zoë Dissell**
Copy Editors **Laura Maiklem** and **Sarah Sears**
Picture Manager **Adrian Bentley**
Production **Kate Pimm**

1000
Faces of God

REBECCA HIND

CARLTON
BOOKS

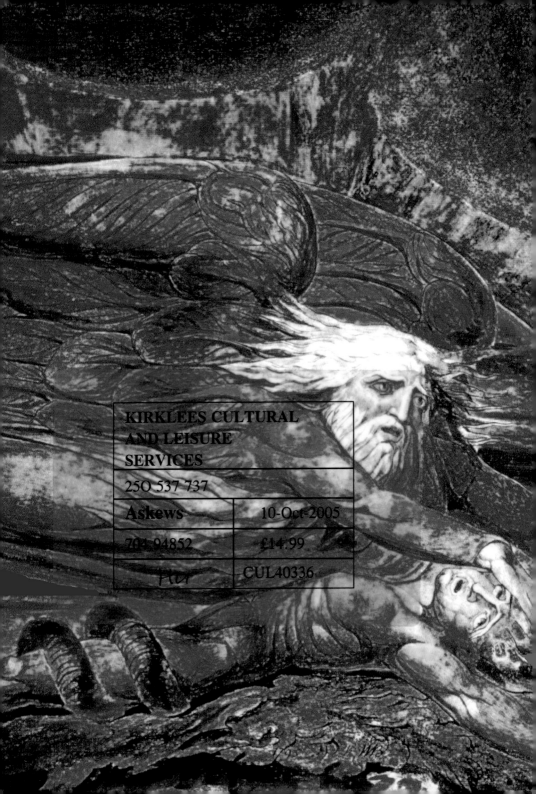

Contents

Introduction

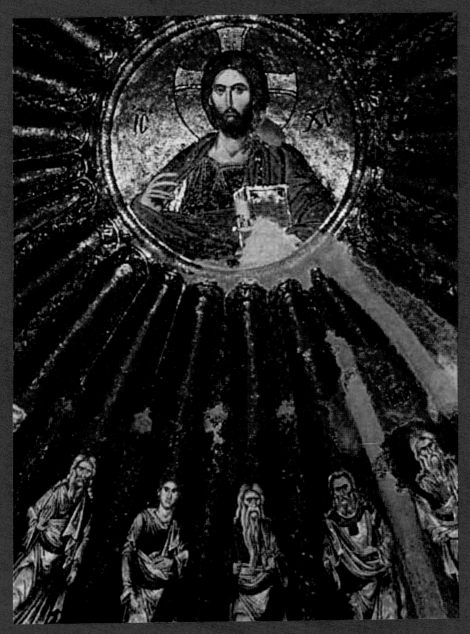

The world of religious art is broad and deep, and it is the intention here to give an overview of what we perceive to be the 'faces of God', approaching the wealth of material on the subject in a navigable and reasoned way.

In the light of the visual heritage handed down by cultures over the centuries, it seems that the living faiths of today bring with them a wealth of beliefs and traditions. Divided into three main sections, entitled 'God of Nature', 'The Cosmology of God' and 'Forms of the One', these are subdivided to help us look at how artists have expressed their understandings and needs. However, as God is bigger and greater than any mortal concept, we cannot expect Him to fit neatly into any human constraints; we cannot trap Him in a book. The best we can do is explore what we are given and keep looking.

BRINGING FAITH INTO FOCUS

This is why we are considering aspects of the divine in art from a variety of different angles, some issues being looked at more than once but by different artists. For example, in 'God Among Us', we can contemplate Christ's crucifixion through a variety of eyes. One may focus on the pain and humiliation of the event; another on Christ's internal struggle; and yet another on the forgiveness He offered to His torturers, and the compassion He showed the thief killed alongside Him. All are true, but none can contain the whole truth. These slight shifts in viewpoint broaden our outlook and feed our minds. Similarly art from one faith can be juxtaposed with that from another tradition; for example, we can see how guardian spirits vary in form from culture to culture, while essentially performing equivalent roles.

Since the first stick of charcoal was drawn from the fire and onto the cave wall, visual expression has aspired to communicate with, or of, the spirit. It is likely that the act of making cave art was part of ritual activity, perhaps in an effort to gain supernatural influence over the natural world. The link between art and religion goes far back in time, then, and touches every culture from cave to cathedral, from pyramid to palace.

A viewer 'reading' art has to be actively engaged, for to do so requires a commitment of time and application. Beautiful as they are, these images are never superficial; instead, they can unlock the door to deep faith and a closer understanding of our relationship with God. Any artist will tell you that in getting to know a subject it is important to look from every angle and in every light. In fact, even the name a faith attaches to God may be revealing. From Alpha to Omega, the names of God are many. They include, alphabetically: the Absolute, Adonai, Ahura Mazda, Allah, the Almighty Being Beyond Time, Brahma, Elohim, El Shaddai, the Holy Trinity, the Eternal, Jehovah, the Omnipotent, the Unknowable Essence, the Word and Yahweh – the Name which Must Never Be Spoken. In Islam there are ninety-nine beautiful names of God. Yet if there is a bewildering list of names, what of the faces?

No faith group would claim to know what God looks like. No artist would claim to have made a likeness. The only clue that we have to God's form comes from the Old Testament where God holds a mirror to us and we learn that we are made in His image (Genesis 1:27). In absolute contrast, in Judaism and Islam there must be no attempt to capture the face of God. So, given the lack of

information and other restrictions, why have artists persisted in making attempts to represent Him, and what is the role of art in religious life? The answer to the first question is simple. Someone gifted with the ability to make art has to do so, for to do so is irresistible, and secondly those who believe that their gift truly comes from God aspire to express thanks by turning it to His purpose.

Visual art can be thought of as an aid to meditation. It plays a narrative role in education, speaking of religious truths in a way that can never be put into words. Art can also play a part in ritual, lift the spirits and speak of God's love for us and what He intends us to become. This aspect makes the art sacred rather than merely functional.

ROLE, RITUAL AND REPRESENTATION

The earliest artists may well have been what we think of as pagans, those who believe the earth to be the mother goddess and so venerate the seasons, fruits of the earth and the effects of nature. Evidence unearthed at prehistoric sites across the world confirm this. It may well be that the act of collecting pigments was a sacred ritual in itself, as it still is in parts of Australia for Aboriginal artists. And there are representations of goddess figures, fertility signs and the alignment to sun and moon. Today there are still various pagan traditions that look upon natural things as sacred, and an urge to worship by water, mountains and woodland is a common theme. Gods may be seen in any natural form, something that finds connections with the gods of classical times – Pan, for example, made his pipes from the reeds which Syrinx's father turned her into, in an attempt to save her from him.

In ancient Egypt the artists' job was to aid continued existence after death; if someone's likeness was preserved, then so was life itself. In fact, one word for sculptor meant 'He who keeps alive'. So a form in solid stone or painted on a tomb wall need not be seen and admired. Its role was just to be and to preserve in clear, simple terms. Since those times the role of religious art has moved on and changed. Each religion has its own traditions, so there is no common visual language. It is worth looking now, then, at the role and form of visual art in some of the individual faiths.

CLASSICAL GODS

The ancient Greeks were polytheist, that is, they worshipped many gods. In fact, to worship one at the expense of others would be to neglect a part of your life. The twelve most important gods lived on Mount Olympus with Zeus, while the others were of the earth and underworld. By association, then, the gods were responsible for the crops and harvests and for death, although there were regional variations. Greek gods took human form, but did not have to endure the trials of human existence such as illness or ageing. Although idealized, these images were credible because of the artists' skill and understanding of the human form. Observing a cult was a way of life: the faithful would make sacrifice and prayer to the gods for fear of punishment through poverty, illness or bad luck. This was a pragmatic faith with little attention paid to inner, spiritual life.

Like the Egyptians, the Romans believed in the ability of a likeness to preserve the soul and so it was essential that the emperors, who were treated as gods, were depicted realistically. This lead to a truthful portrayal

that included imperfections. It was the duty of the individual to burn incense before these figures and, for the Christians who were keen to avoid the wrath of God which would have been incurred by worshipping idols, failure to do so had unhappy consequences. No art form develops in a vacuum and the Egyptians took to making their funeral portraits in this new, realistic way and so stepped sideways from painting what they knew, to what they actually saw.

JUDEO-CHRISTIAN BELIEFS

Judaism dates from about 2000 BC and is monotheistic – worshipping one God. Its early adherents were the Israelites, or Hebrews, whose law came directly from God through the prophets, notably Moses. Because the Jewish faith permits no attempt to make a likeness of God, Jewish art forms tend to focus on the synagogue and its rituals. The pattern for the design of the menorah, that is the seven-branch candlestick taken as the symbol of Jewish identity, was given by God to Moses on Mount Sinai. As well as having a ritual function, it is, therefore, a link with a significant event in the past. In early times, scenes from the Old Testament were painted on the walls of the synagogue, and much attention is still given to the decoration of the Torah and its ornaments and to the presentation of other books, especially the Passover Haggadah. Architecturally, the synagogue has taken many stylistic forms, but whatever the exterior form, protection of the Torah scrolls and the provision of a pulpit for scriptural readings are crucial.

Christians believe that God sent His son Jesus Christ to save mankind from sin and lead them to eternal life. On leaving His earthly life, Jesus sent the Holy Spirit to live among us. Early Christian art focused on simple signs, drawn to express allegiance. The most common was a fish, because the Greek word 'ichthus' is an acronym for Jesus Christ, God and Saviour.

When Christian artists first began to paint the figure of Christ and the disciples, these biblical scenes played a key part in educating the faithful. However, the power of the images proved controversial and there was talk of idolatry. But Pope Gregory the Great declared during the seventh century that 'Painting can do for the illiterate what writing does for those who can read' and while this gave a great boost to the acceptability and production of art, caution dictated that the tale must be told simply in order to avoid falling into idolatry and paganism. In 787AD the Seventh Ecumenical Council decided that as Christ had truly become man and taken a real body, it was, in fact, right and proper to depict Him, as to say otherwise would be to deny His incarnation. Furthermore, the Council acknowledged that images could enable a full relationship with Christ, a state acknowledged as more elevated than living by a mundane set of moral codes.

The early churches were decorated with frescos and stained-glass windows narrating stories from the Bible. Other art forms included illuminated manuscripts, Eucharistic vessels and, of course, sacred icons which radiate with God's spiritual truth and draw the viewer into a closer relationship with Him.

During the Renaissance, Christian artists produced some of the greatest and most powerfully moving images the world has ever seen. They occupy a level way beyond the narrative and speak directly to the soul.

ISLAM

The Qur'an is the Muslims' Holy Book; it contains the words of God as revealed to the prophet Mohammed during the seventh century. The *hadith* is the Islamic tradition handed to Muslims by the prophet Mohammed and is the guidance followed by artists. Mohammed chastised his wife A'isha for sewing human forms onto a piece of cloth, with words implying that only God can give life and a mortal must never try to make something lifelike. Thus, Islamic artists in the main confine their expression to patterns taken from natural form and from geometry. The word 'confine' implies a limitation, but Islamic art is rich and lush, colourful and exquisite. This discipline gives rise to gloriously decorated manuscripts and architecture with walls so beautifully carved with words from the Qur'an that the air seems thick with texture and pattern. Some Islamic sects even allowed the depiction of figures and these images usually appear on manuscripts, as the reader will see in 'Helpers and Friends'.

In common with Abrahamic faiths, the Baha'is see God as creator and sustainer of all, a power beyond our comprehension. He sends us the prophets to speak His word: Moses, Jesus, Buddha, Mohammed and, most recently, Baha'ullah. Worship takes place in homes or in temples, and we shall see some fine examples.

HINDUISM

Because Hindus believe that the source of all is present in everything, the function of the artist is simply to reveal the spiritual presence inherent in the materials. This manifestation enables the viewer to come into *rasananda*, blissful union with Brahma, the one supreme and all-pervading spirit. The Hindu faith is henotheistic, meaning that it acknowledges more than one god but worships only The One. Hindu temples are, therefore, richly ornamented with carvings of many gods and other figures, some of which may be manifestations of a god in a different form. It is the *sikara*, or temple tower, which draws the deity into the building, so this space is considered particularly sacred and potent.

BUDDHISM

While Buddhism acknowledges many gods, it is important to state here that the Buddha is not a god. The focus of Buddhism is on the spiritual and philosophical teaching of the Buddha, whose name at birth was Siddhartha, but Buddhist art began in symbolic form and depictions of the Buddha did not appear until around the first century BC, some 500 years after his death. So, because the teachings of the man were important, they were marked down in symbolic form on stupas (reliquaries), gateways and temple walls.

Lotus flowers stood for purity; wheels expressed Buddhist law; parasols were for spiritual power and protection, golden fishes for fertility and salvation; a vase represented spiritual abundance, a conch shell attention to teaching; an endless knot presented the connectedness of all things, while a banner symbolized the victory of knowledge and righteousness. Later the figures of the Buddha and of the bodhisattvas (those who reach enlightenment but delay nirvana, devoting themselves to helping others) express their message largely through posture and hand gestures, as will be seen in various places throughout the book.

JAINISM

To make their temples welcoming to the Jinas, the great spiritual teachers and ascetics who are also known as Tirthankaras, the Jains decorate their holy buildings.

The Jain faith forbids the taking of any life, even the microscopic forms in the earth, so the use of materials such as clay and ivory is forbidden. Originating in India in around the sixth century BC, the faith believes that all beings strive to be released from the cycles of birth and rebirth. The Tirthankaras assist in that process and are represented in art as being simultaneously calm and peaceful, strong and reliable. Sasanadevatas serve the Tirthankaras and respond to human prayer, so there is much devotional carving in Jain art, too.

SIKHISM

In this religion, believers put their faith in one God, and the word 'Sikh' means ' learner'. The place of worship is the *gurdwara*, and this may take the form of a simple room or an elaborate temple; housing the Guru, or teacher, is the important thing here.

Nevertheless, a purpose-built *gurdwara* will have parapets, a central dome and various cupolas, some of which may be stylized lotus flowers. Traditionally, there should be an entrance on all four sides of the building to welcome the faithful from all directions. The walls may either be white or richly decorated with coloured stones or gilding, and what decoration there is on the carpets and walls originates in natural forms and may be vibrantly colourful. The scriptures may be prominently displayed on cushions beneath a decorated canopy, but otherwise furnishings are minimal.

EASTERN MYSTICISM

Eastern arts in general take a mystical line of expression, and both Taoism and Shintoism are good examples of this. Shinto means 'the Way of the Gods' and believes that all things have a spiritual content. Thus, gardens hold a special potency and are made to bring you into contemplative contact with the elements. To the early Japanese there was no distinction between natural manifestations and those made by people, so the sound of the flute was as spiritually valid as the noise of a stream; being of the earth means being part of it. In Chinese, Tao means 'the Way' and is the source of all appearance, the unproduced Producer and that which regulates and stabilizes all that is. So Taoist art reflects these ideas by describing both mountains and the spirits that inhabit them. Gardens are important here, too, especially those around the temples.

I hope this brief introduction to beliefs of faiths will help with your reading and understanding of the images you encounter. Never underestimate the power of words, whatever the faith of their speaker, to paint images in your head: indeed, try to visualize now the pictures created by the words of Zoroaster when he asks,

> Who established the course of the sun and stars? Through whom does the moon wax and wane? Who has upheld the earth from below, and the heavens from falling? Who [sustains] the waters and the plants? Who harnessed swift steeds to wind and clouds? What craftsman created both sleep and activity? Through whom exist dawn, noon and eve?

In this chapter various aspects of nature are considered: 'Guardian Spirits' who look after the created world; 'God's Love and Blessings', the gifts we receive from God; then finally 'God's Helpers and Friends', the beings who respond to His goodness. However, we begin looking at 'Creation' and what that means to the different faith groups.

God
of Nature

CREATION AND DIVINE ORDER

Creation can, of course, be thought of as a process or as the product of that process – the cosmos and all that it contains. The Hebrew scriptures, known to Christians as the Old Testament, tell of the six days of God's creation, and that 'He renews the work of creation every day'. In Islam, God is the creator and disposer of all that is, while Zoroastrians refer to creation as Bundahism and Baha'is believe that everything reflects some attribute of God the creator. The Hindu faith acknowledges a fixed order called Rta, which must be maintained through ritual and sacrifice, while Hukam is the Sikh name for divine order. Jains and Buddhists do not believe in a creator, but because Jain gods are capable of rebirth they are part of the creation process, and Buddhists, too, believe in a series of levels that are open to reappearance. In the Shinto faith, Musubi is the mysterious source of all that is, while Tao is 'the Way' in Chinese and holds vital power – it cannot be defined, only discerned.

The artists responsible for the images on these pages are part of the creative process. Indeed, to Hindus the artist exposes the essence of the creator, which is present in all materials. So, what these pictures reveal is a wealth of ideas expressed according to tradition and teaching. They show us God the designer,

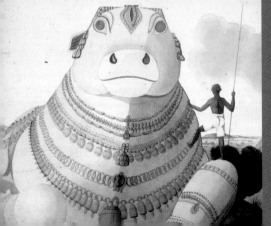

who has a plan for the cosmos and for us. We see the rolling spheres of earth, water, air, fire and planets and the Jain concept of unending cycles. We see the products of creation – the animals and birds are given their names, Adam and Eve inhabit their garden, the sun shines through a Shaman solstice marker.

Different societies use various signs to invoke the gods' continuing sustenance. Fertility symbols are widely used and appear in many forms, which link closely with nature. Sun, rain and harvests need to be prayed for and not until they have come can they be celebrated. By sharing their names with the planets, some of the classical gods brought the widest reaches of cosmology into every-day life for their followers. Those who lend their names to the months and days play a nominal part in the cyclical nature of creation.

PROTECTORS AND HELPERS

Guardian spirits may be invoked to help with an aspect of family or tribal concern. Spirits may guard by driving away evil, as carvings of mythical creatures in temples do, or by protecting a forthcoming harvest or hunt. As spirits, they can have no physical form, but artists have used the power of imagination to draw upon the traditions of their faith and describe a visual avatar. In this way the faithful have a tangible form on which to focus their prayers and aspirations, and a reminder of the spirits' continuing attention. The Four Heavenly Kings protect the Buddhist universe and Vaishravana is their chief (see pages 50–1). Similarly Fudo Myo-o is known as the Immovable One for his determination to destroy evil and stand firm (see page 55).

In 'God's Love and Blessings', it is interesting to see how hands are used.

In Christian art, blessings are indicated by the raised right hand with middle and index fingers together, the other two resting on the thumb. Charity and love are just two of the communications expressed by a figure of the Buddha, according to the *mudra*, or hand positions. However for love and blessings to mean anything there must be more than just gestures, symbols of intent. God's generosity is shown as gifts of talent, plenty and deliverance. So on these pages we see musicians and craftsman, mouths being fed and bodies healed.

Angels, God's messengers, feature in some of the world's greatest art and that is no coincidence; they offer supernatural comfort, deliver urgent news and are perceived as being a link between the divine and the earthly. In Buddhism the apsaras play a similar role, while Bodhisattvas, or 'enlightenment beings', delay their nirvana so as to help save others from suffering.

The omniscient Jain Tirthankaras help by building a ford across worldly struggles to safety and salvation. They are expressed in calm, gentle form, though their broad shoulders indicate strength and dependability. See them on page 95, where Moses leads the people of Israel across the Red Sea and St Christopher helps pilgrims. Saints, prophets, preachers and priests are all God's helpers, but ordinary people are, too. Places of worship are built and used; acts of worship consolidate our relationship with God; prayer, when directed towards others, fulfils His desire for us to love one another.

All faith groups have respect for the natural world and accept a caring role with responsibility for God's blessings. This makes us all guardians, helpers and friends.

Creation

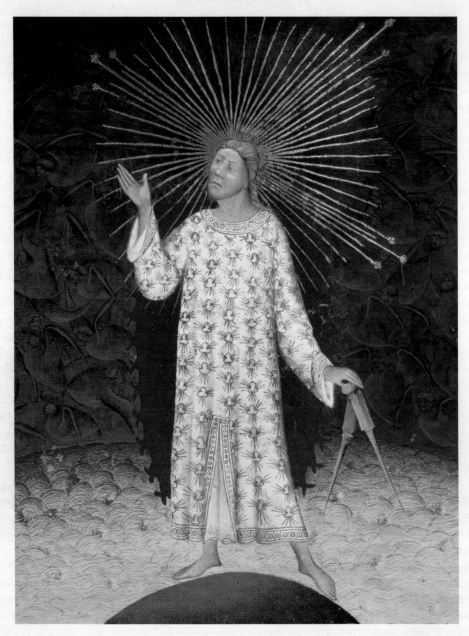

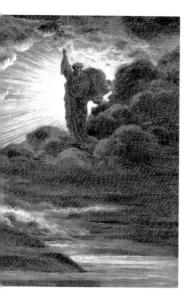

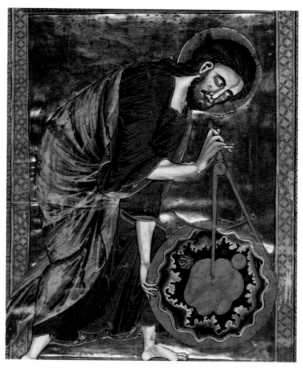

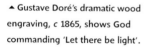
Gustave Doré's dramatic wood engraving, c 1865, shows God commanding 'Let there be light'.

▸ **Top to Bottom**
In this image, the great designer makes the earth and the waters. This is a miniature from a mid-13th-century version of the Old Testament.

In this 14th-century depiction of the third day of Creation, the universe is seen as a series of concentric rings, with plants brought into being in the centre.

◂ **Opposite**
Shown as the architect of the universe with a pair of dividers, this image of God is from the *Grande Bible Historale*, 1411.

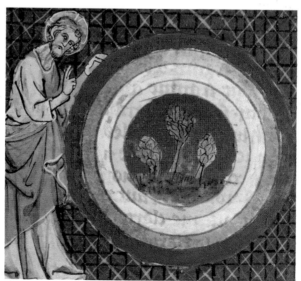

▼ This scene, from a 14th-century French Bible, shows the air being filled with birds, and the waters with fishes, on the fifth day of Creation.

▶ **Opposite Clockwise**
God names the unicorn while a variety of other beasts look on in this 14th-century manuscript.

Earth is depicted at the centre of concentric rings of water, air and fire, stars and sun, moon and planets. Heaven and the angels surround the whole, with God shown as a dove, upper right.

The *Holkham Bible Picture Book* shows the creation of the birds and beasts. The book was written and illustrated for an unidentified monk during the 14th century.

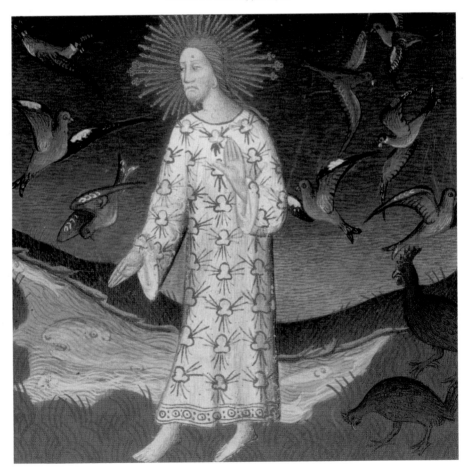

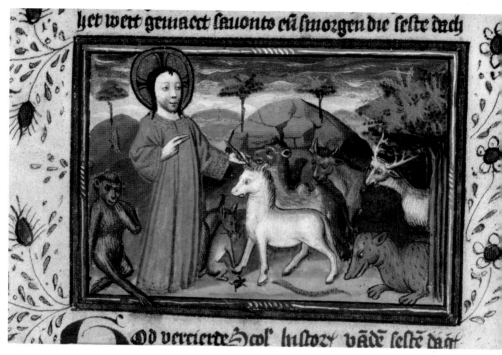

het wert gewaect sauonto en smorgen die seste dach

od vertierte Scol historia vade seste dach

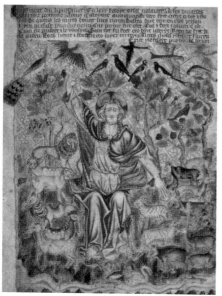

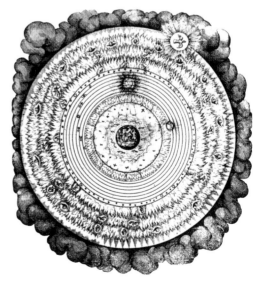

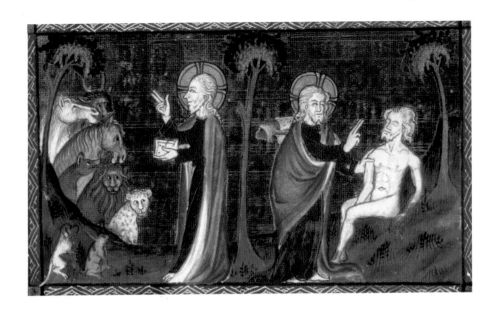

▲ On the sixth day, having made and named the beasts, God turns to the right and forms Adam from clay. A 14th-century French interpretation from *La Bible Hysteriaux*.

▼ **Left to Right**
The animals go about their business as God works on Adam. The circular format of the woodcut is a reference to the spheres of the universe, which God has already made. The image comes from the *Liber Chronicarum Mundi*, Nuremberg, 1493.

Deep in sleep Adam is unaware that God is forming Eve from his rib. From the *Liber Chronicarum Mundi*, 1493.

Greek elements are referred to in this 1508 woodcut, which shows the philosopher Thales' concept of the earth floating on water.

▶ **Opposite**
In this page from the Moutier-Grandval Bible, dated 840, we see the creation of Adam and Eve, their disobedience and their expulsion from the garden.

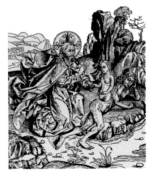

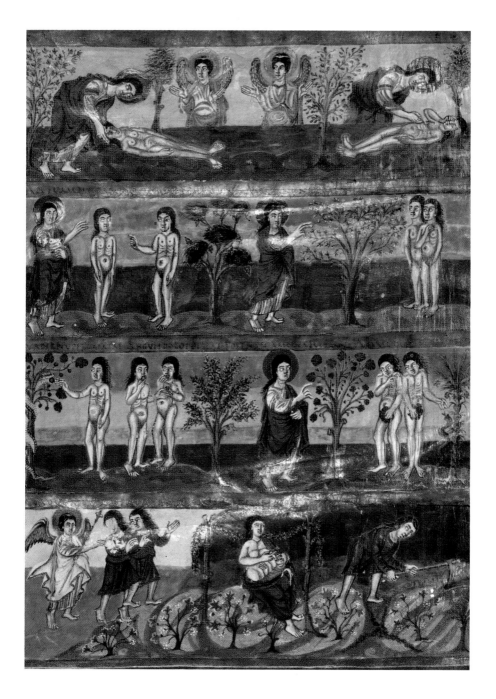

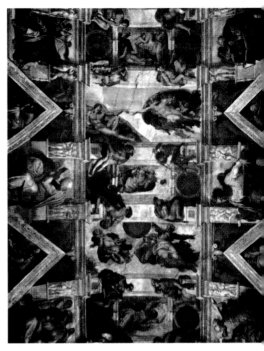

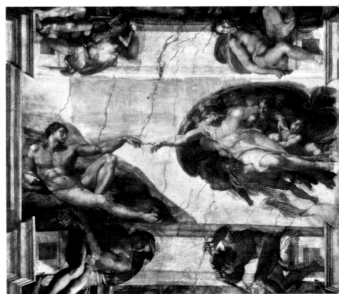

▲ A scene from the Bedford Book of Hours shows stages of the Creation and Fall, set within what would have been contemporary architecture.

▶ **Top to Bottom**
Scenes of the Creation in a section of Michelangelo's painting on the ceiling of the Sistine Chapel in the Vatican. The Creator is truly omnipotent here in a painting that was completed over four years, from 1508–1512.

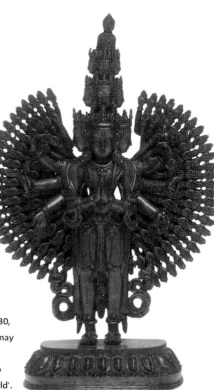

▲ In this scene from a family Bible, the shape of God's halo is a reference to the Holy Trinity. Notice its similarity to Michelangelo's depiction of God in the Sistine Chapel.

▶ The Buddhist figure, Avalokitesvara, c 1771–1830, takes different forms. He may be the 'lord who looks in every direction' or 'he who hears the sound of the world'.

▼ Christ oversees the world in a psalter map, c 1250, one of the earliest to show biblical events. It reflects medieval thinking that placed Jerusalem at the centre.

▼ A 14th-century depiction of Creation showing the 'light spheres' – elements circling around the earth, demons in limbo and the Holy One above.

▼ This 1830 diagram of the universe, Jambudvipa, expresses the Jain concept of unending cycles. It shows the mythical Mount Meru, the world's axis.

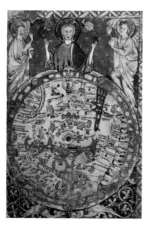

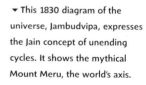

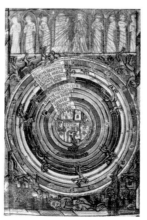

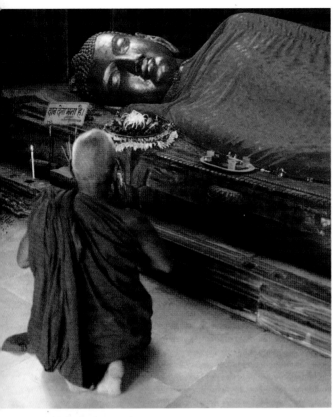

◀ At the shrine of Buddha's remains in Uttar Pradesh, India, a follower offers prayer in the knowledge that he is a part of the cycle of reincarnation.

▼ Left to Right

A carved wooden mask from West Africa. The spikes represent primordial seeds made by God to create the universe.

'Enduring Spirit' is a solstice marker at the White Shaman reserve near Alburquerque, New Mexico. It highlights an important aspect of the shamans' relationship to creation.

Pigments, as used in the art here, and their extraction from the earth are part of sacred ritual in the Aboriginal religion, while snakes represent a potent force for fertility.

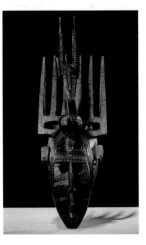

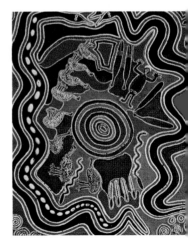

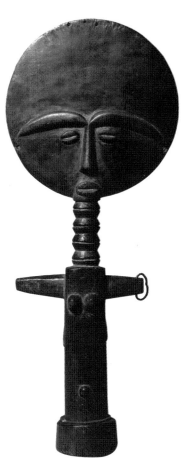

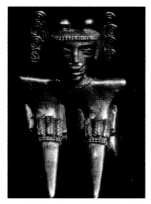

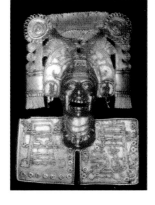

▲ A golden fertility pre-Columbian goddess. The enlarged breasts are a typical feature.

◀ An early 20th-century, carved-wood fertility doll from Ghana.

▲ This 15th-century gold pendant represents the Aztec god of the dead, Mictlantecuhtli, symbolizing creation's cycle of life and death.

▶ This Spanish cult goddess is shown bare-breasted and with necklaces. Found in St Sernin, she is now displayed in the Musée de Préhistoire de Carnac in north-west France.

▶▶ The head of a Venus figure, dating to 2200BC, was found in Landes, France, and is now displayed in the Musée des Antiquités nationales.

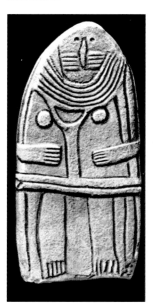

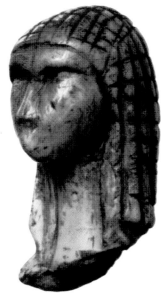

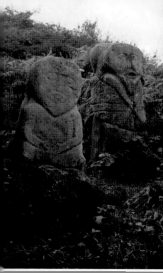

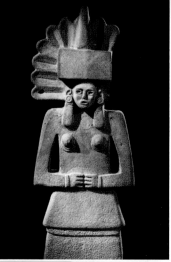

◀◀ Pagan figures in Fermanagh, Northern Ireland. The purpose of figures such as these is largely mysterious, but may have been an attempt to ensure fertility.

◀ A stone fertility sculpture of Tlazolteotl, goddess of the earth, sex and motherhood, who is also associated with the moon. From Mexico, *c* 900–1521 AD.

◀ Four Roman mother-goddesses. Such sculptures usually show three figures and it is not clear why a fourth is present here, although Celtic ideas were being fused with imported ones in Roman Britain.

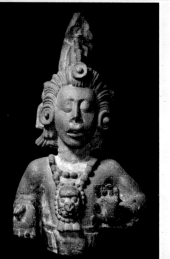

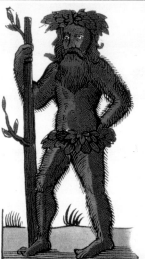

◀◀ A stone bust of the Mayan maize god, *c* 715 AD. His youthful poise represents the Mayan ideal of beauty.

◀ In this 19th-century interpretation, the pagan fertility symbol, the Green Man, is clad in leaves and clutching the wooden staff, symbolically the earth from which he came.

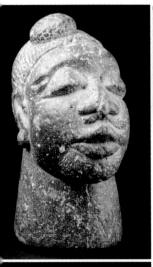

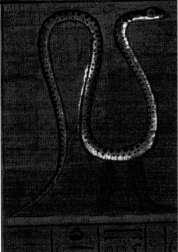

◀◀ Believed to have been made by the ancestors of the Kissi people, who inhabited the Sierra Leone before the Mende, these heads were found by local people during the preparation of farm lands. The Mende now make offerings to these Nomoli sculptures in return for increased harvests.

◀ Sito the serpent God on an Egyptian papyrus, c 1250BC. Many cultures have taken the snake as a sign of fertility.

◀◀ Masks such as this one from Torres Strait Islands, Australia, would be used in ceremonies to celebrate the ripening of the ubar fruit.

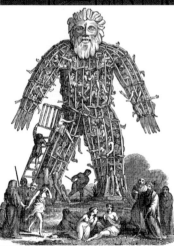

◀ A woodcut of the Wicker Man, from 1832. Julius Caesar reported that Celtic Druids would make human sacrifices to their gods by burning them alive inside giant wicker effigies.

◀ This group of Roman gods and goddesses was found in Wiltshire, England. Mars is shown with his usual helmet but the spear has been replaced by two ram-headed snakes, creatures from Celtic mythology – a sign of cultural fusion dating back to 300AD.

◀ Mars, the Roman god of war, and of spring, growth and nature, and the protector of cattle. He lends his name to March, the month of vernal equinox and the awakening earth.

◀ Saturn, Roman god of agriculture and time. Although time is an abstract quality, many cultures allocate a god to the aspect of life that regulates the rhythm of the seasons.

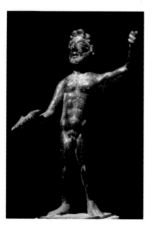
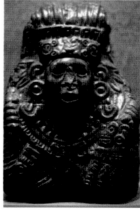

◀◀ Jupiter, ruler and king of gods. Because he shares his name with the largest planet, this Roman god makes us aware of the universe, the physical realm.

◀ A jade statue, c 1350, of Quetzalcoatl, an Aztec and Toltec god associated with the morning and evening stars, and the calendar. He is depicted as a feathered serpent, a reference to fertility.

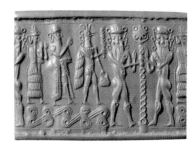

◄ A hematite seal from Mesopotamia, c 1350–1250BC, with the extended clay version far left. The seal depicts the worship of Lamma, the goddess of the night (and therefore of fallow periods), with gifts from the earth.

◄ Clockwise from Left

This wooden deity from French Polynesia may represent Rongo or Rogo, the god of rain, agriculture and turmeric.

The 'goggle' eyes identify this carved stone figure, c 1200–1521, as Tlaloc, the rain god from Mexico.

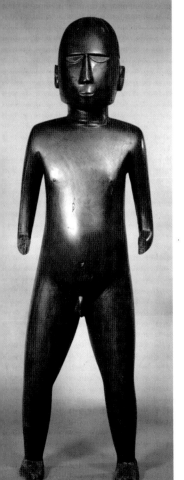

Three mother-goddesses are shown on this votive tin plaque. It originates from Roman London at a time when native Celtic religion was merging with imported belief systems.

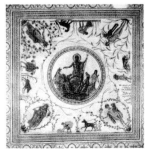

A fourth-century mosaic, displayed in the Bardo Museum, Tunis, depicts the 'Triumph of Neptune', the Roman god of the sea. He is surrounded by other creatures from the natural world, although they come from dry land.

27

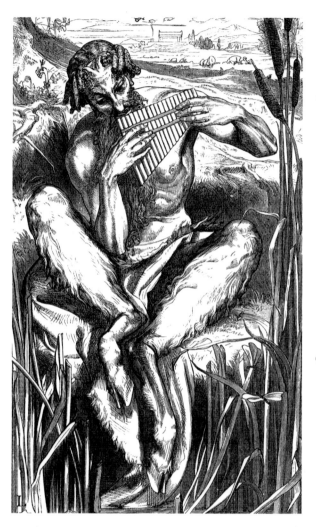

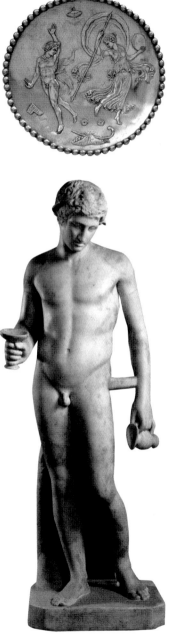

▲ Pan, the Greek god of the
fields, woods, shepherds and
flocks, as well as sexuality
and fertility, is depicted with
goat's legs, horns and ears.

▶ **Top to Bottom**
Maenads, followers of Bacchus,
dancing and playing music.

Pan at a young age, with his
horns just beginning to form.
The jug and wine cup make
evident his link with Bacchus.

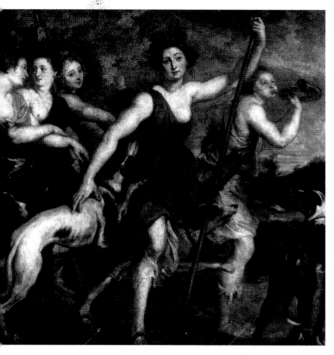

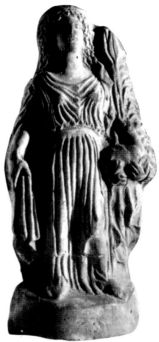

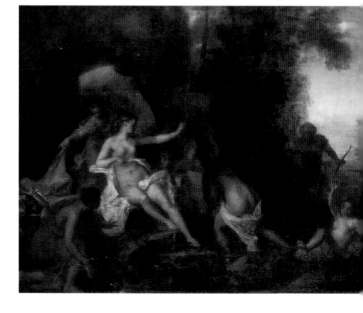

▲ This painting by Rubens shows Diana the Huntress, with hounds and attendants. It is hung in the Prado Museum, Madrid.

▶ **Top to Bottom**
This statuette, made of baked clay, c 300BC, is Diana the Roman goddess of hunting, woodlands and the moon.

'Diana and Actaeon', painted by Louis Galloche (1670–1761). Set in a woodland scene, this voluptuous painting shows Diana in her natural environment.

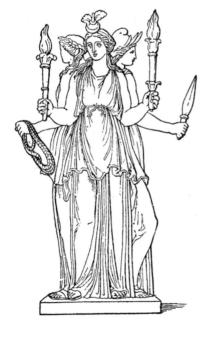

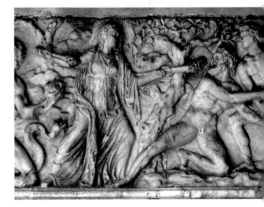

◀ Opposite

Clockwise from Left

A 1613 drawing by Matthaus Gundelach in ink and wash, shows Mercury with a caduceus, winged cap and heels. A caduceus is a winged staff entwined with two serpents.

Giovanni Tiepolo (1696 – 1770) painted 'Apollo Pursuing Daphne'. Dedicated to a life of virginity, Daphne fled to the gods for protection and was turned into a laurel tree.

This painting by Visentino shows Juno, queen of the Olympian gods, turning Calisto, the nymph of Jupiter who was hated by Juno, into a bear. After his transformation Calisto was put up in the heavens as the Bear constellation. The atmosphere is evocative of an impending storm.

Hecate, the three-bodied Greek goddess of the lower world who ruled over ghosts, magic and witchcraft, relied on the potency of nature for power.

A relief showing Hecate and the Giants. Offerings of honey, dogs and black lambs would be made to her.

▲ The marriage of Pluto to Persephone, Greek god and goddess of the underworld. This sinister-looking image comes from a 15th-century manuscript for Louis de Savoy.

◀ Taken from *The Magus*, 1801, by Francis Barrett, this shows Abaddon, angel of the bottomless pit, with Mammon, the false god of wealth and greed, and the demon Ashtaroth.

◀ An Egyptian papyrus from the Book of the Dead, *c* 1000BC, shows Padiamenet burning incense for Osiris.

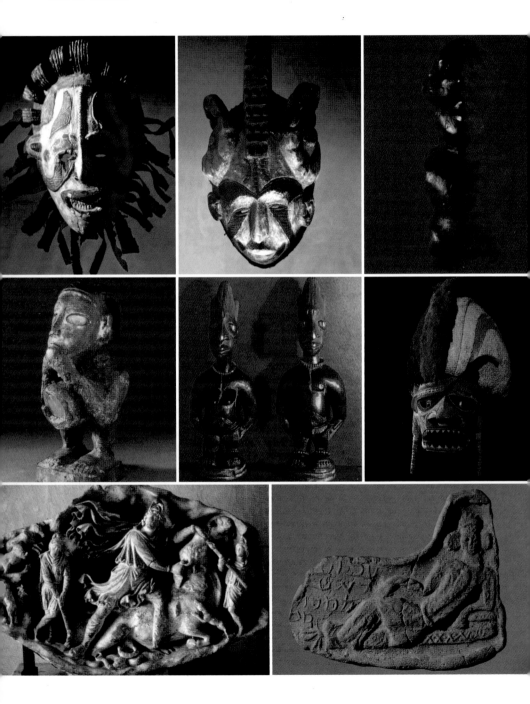

◄ Opposite Clockwise from Left to Centre
An Igbo Maiden Spirit mask from south-east Nigeria. It would have been worn by a man miming female activities during funeral ceremonies.

Another Igbo Maiden Spirit mask, used to evoke the power of nature.

Made towards the end of the 19th century, this West African witch doll or poppet would have been used in black magic.

A helmet mask, or *tatanua*, from Papua New Guinea. Such masks are used in ceremonies to honour the dead.

This plaque is probably from Uruk in southern Iraq and dates from 100–200AD. The inscriptions are a dedication to Mitra, also known as Mithras.

In Persian mythology, Mithras was the god of light. Here, in a marble sculpture c 100AD, we see him slaying the bull.

An African fetish figure. Fetishes may be regarded as idols or be used to exercise power and protection.

These two Ibege magical figures are from Yoruba in West Africa.

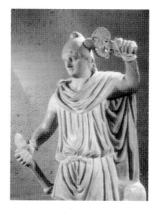

▲ Mithras was adopted into the Roman pantheon via Asia Minor. Associated with the Zoroastrian faith, where fire and the sun are symbols of god, here he is shown armed and wearing a Phrygian cap.

▶ Top to Bottom
Mithraism insisted on a high moral code of honesty, purity and courage. For these reasons his image was favoured by soldiers, officials and merchants.

According to legend, Mithras slew a primordial bull and fertilized the world with its blood. This depiction of the sacrificial scene was found in London in 1889.

This mosaic from Sicily, dating from 200–400AD, shows three young men making a sacrifice to the goddess Diana.

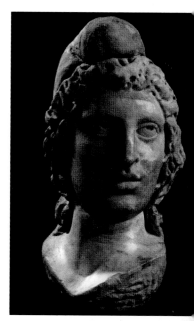

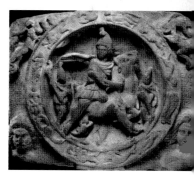

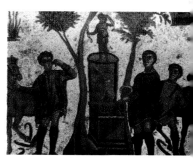

▾ Clockwise from Left

Venus, in a third-century mosaic. The design on her belly gives it a rounded form and haloes are suggested around the heads of the smaller figures.

In Sandro Botticelli's 'Birth of Venus', *c* 1485, the breath of life is blown into the goddess of love by the angels on the right.

'Venus and Mars' – love and war together – by Botticelli, *c* 1485. The cherub blowing into a shell may be a reference to Venus' birth from the sea.

▸ Mars' role of protector and his fertility is implied in a Veronese painting, 'Mars and Venus United by Love', *c* 1570.

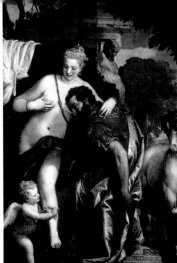

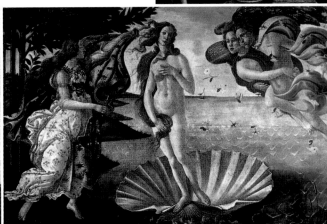

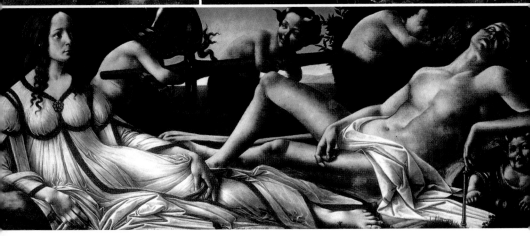

▸ This well-preserved painting of Mars was discovered on a wall in the House of Venus in Pompeii. Because of his lineage in myth, the Romans regarded themselves as children of Mars, so he was their protector.

▾ Left to Right

The sun and moon are brought together in this head of a bearded man with a Christ-like countenance, from Roman Britain, 200–300AD.

Mercredi, Jeudi, Vendredi – Mercury, Jupiter and Venus: these planets and gods lend their names to the days of the week and the cycle of time.

An image of the Celtic sun god, Sul, found in Bath, England.

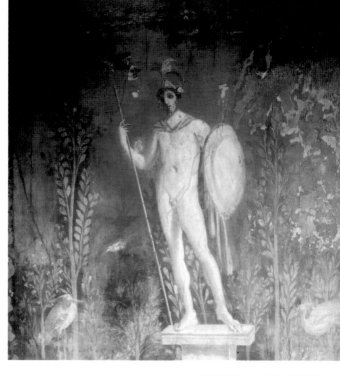

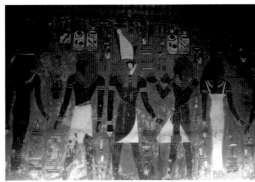

▲ Oceanus was a Titan and the divinity of the stream that flowed beneath the earth. This silver dish is from Roman Britain.

▼ Left and Centre
This 1834 woodcut shows the Saxon god Crodon holding a symbol of the sun.

In another woodcut, figures prostrate themselves before the sun god, who will ensure their harvests, warmth and light.

▼ Horus, the Egyptian sun god, formed in bronze. Material and meaning are closely woven in the sculpture.

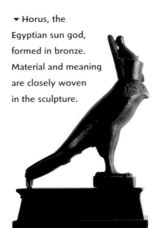

▲ King Horemheb is depicted on a wall painting in the Valley of the Kings, Egypt. He is flanked by Isis, goddess of fertility, and Horus, the sun god.

▼ In this 1834 woodcut, a Saxon idol stands in moonlight, holding a disc that shows a phase of the moon. Along with eclipses and other celestial phenomena, the phases of the moon mark time and ritual, and give a sense of mystery.

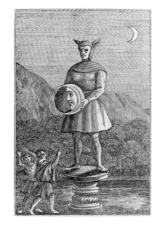

▶ Tyr, the Norse god of the sky, sacrifices his hand to blind the Fenris Wolf, a force of terror and destruction.

▶▶ 'The Wolf-Charmer' by John La Farge (1835–1910). Belief in wolf-charmers was widespread in France during the first part of the 19th century.

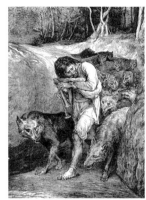

▶ The Norse god Tyr and the Fenris Wolf, Fenrisulven, who was fathered by Loki, god of mischief and destruction.

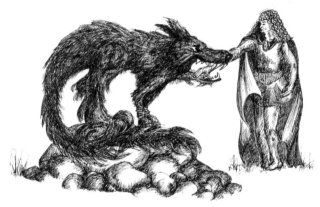

▶ The Fenris Wolf and the Midgard Serpent feature in this frantic scene of destruction. As well as being signs of fertility, snakes can also represent an evil threat. Notice the sun breaking through the clouds, which indicates a sign of help from the natural world.

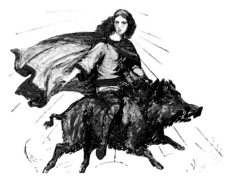

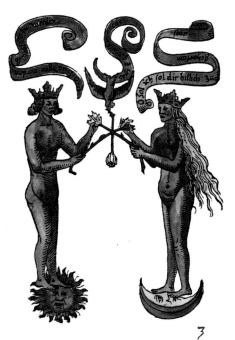

3

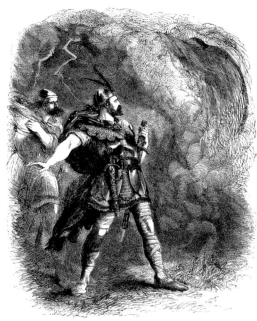

⤊ Freyr, the Norse god of fertility, rides a boar which is said to have moved more swiftly than any horse. A drawing, after A S Murray.

▲ An alchemical depiction of *hieros gamos*, or sacred marriage, from the Rosarium Philosophorum, a series of 20 woodcuts from Frankfurt, 1550. The sun and moon reflect the cycle of time.

⤊ Lycanthropy is the supposed transformation from human to wolf. According to the *Historiae Animalium* by the naturalist Conrad Gesner, this forest demon was captured in Germany in 1531.

▲ Thor, the Norse god of thunder. As thunder cannot be painted, the storm is expressed in lightning, cloud and contrast.

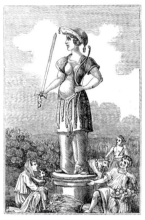

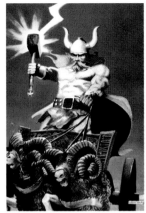

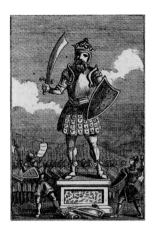

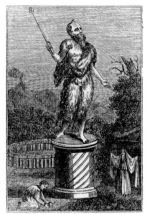

⚑ Thor is the son of Odin and Thursday is named for him. In this 1834 woodcut, he is crowned with a halo of stars and enthroned with clouds billowing around him.

▲ In a section of the woodcut, Freya, or Frigg, the Norse goddess of love and the wife of Odin, stands on a pedestal. The day Friday is named for her.

⚑ A painting of Thor by Gordon Wain, 1983. It shows the god thundering along in a chariot powered by a bolt of lightning.

▲ The Saxon god Tuisco, or Tuisto, is depicted in this woodcut. Known as an earth-bound god, here he is elevated above figures and forest. His satyr-like appearance marks him as a woodland, or sylvan, deity.

⚑ Odin, supreme creator and Norse god of culture, war and the dead, dined in Valhalla, the Hall of the Heroes, with those killed in battle. Woden is his Saxon name and the source of the English name of the day, Wednesday.

▲ 'Freya's First Task', by the artist John Scott.

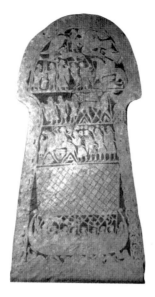

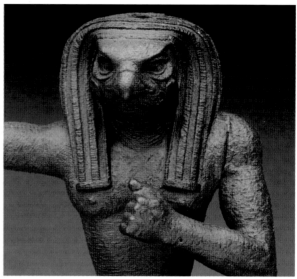

▲ This picture stone, from Sweden's Baltic island of Gotland, offers a narrative of Norse mythology, c 750AD.

▲ A bronze figure of Horus of Pe, the Egyptian falcon-headed solar deity. His counterpart is the jackal-headed Horus of Nekhen. The figure was made some time after 600BC.

▼ These four wooden jars represent the sons of Horus and date to c 700BC. They also relate to body parts: the intestines, stomach, lungs and liver.

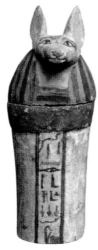

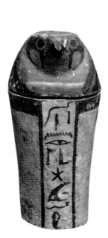

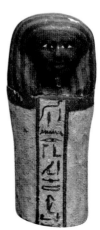

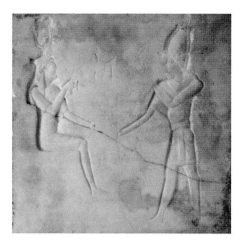

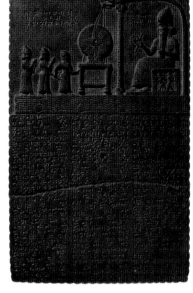

▲ Isis and Osiris, Egyptian gods and parents of the falcon-headed god Horus, are depicted here economically in a bas-relief dated from after 600BC.

▶ **Top to Bottom**
From the early 19th century in southern Iraq, this piece shows Shamash, the sun god, holding the symbols of divine authority, a rod and ring. The sun, moon and Venus are also depicted.

A Shoshone Sun Dance is expressed on moose skin in this 20th-century Sioux Indian painting.

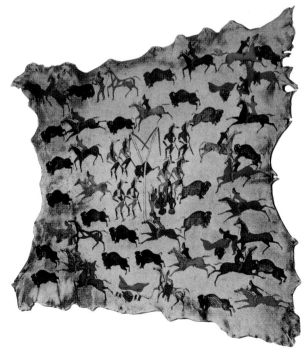

Guardian Spirits

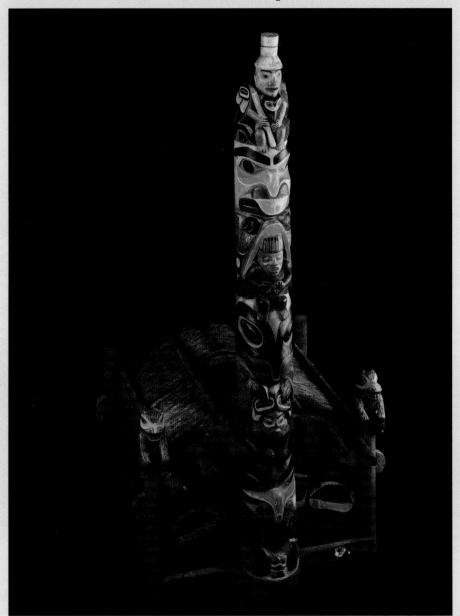

◀ Opposite

This painted wooden model of the *haida*, or chieftain's house, originates from 1890s British Columbia. The chieftain would be responsible for spiritual leadership and protection. The 'totem' pole illustrates a tribal legend; true totems are guardian spirits from the natural world and often adopted by Native Americans as a symbol of individual or family identity.

▶ The 'Death of Joseph', c 1840–1904, depicts the chief of the Nez-Perce tribe, who led Native Americans to protect their lands. This image comes from *Le Petit Journal*, Paris, 1904.

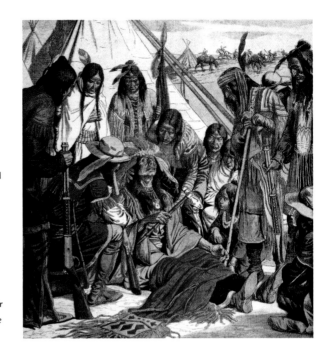

▼ An American god, or *kewas*, guarding the dead. The engraving is by Theodor de Bry, 1590, after a watercolour by John White.

▼ From China, 947AD. Vaishravana, the ferocious-looking Guardian King of the North, stands on the hands of the earth goddess with his attendants. The banners and ribbons add to his formidable presence and power.

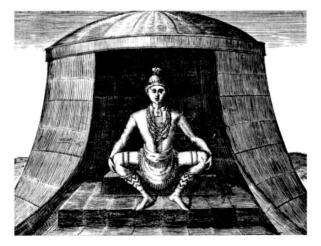

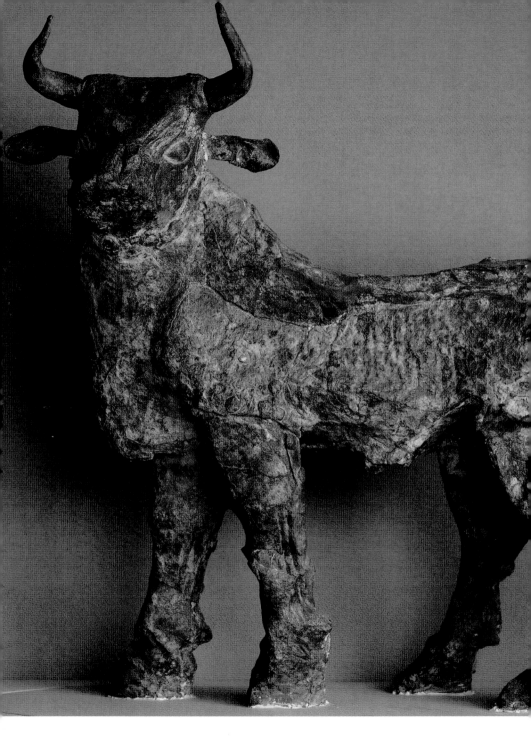

◄ **Opposite**
From southern Iraq, c 2600BC.
The bull is from the temple
of Ninhursag, Mesopotamia,
where it would have played
a role in repelling evil forces.

▶ This ivory griffin-headed
demon originates from eastern
Anatolia (Turkey) c 700–800BC.
Such figures were protective
deities – their frightening image
intended to ward off evil.

▼ A winged bull from the site
of a temple devoted to the god
Haldi, Anatolia c 700BC. It would
have decorated a throne.

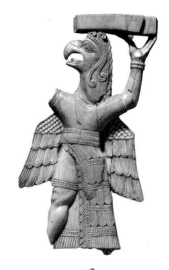

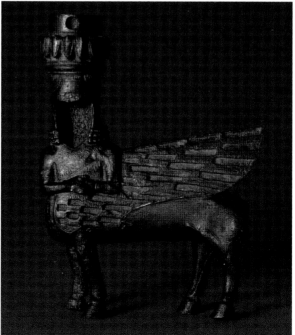

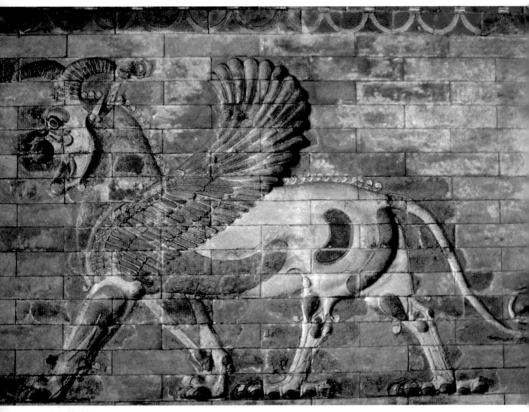

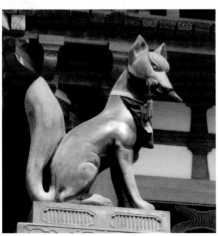

▲ A Persian griffin lion relief in glazed brickwork, *c* 530–330BC, now in the Louvre, Paris. With a lion's body, powerful wings, claws and horns, this image could only be protective.

◀ A stone fox (*kitsune* in Japanese) guards an Inari Shinto shrine – the Fushimi Taisha. In Japan foxes were seen as divine messengers of Uka no Mitama, the Shinto rice goddess.

▶ Saut d'Eau, Haiti, a place of pilgrimage for Voodooists. In the early 20th century, the Iwa spirit of love appeared here in the form of the Virgin Mary.

▼ **Left to Right**
A feng shui mirror from Hong Kong depicts eight trigrams and a central protective deity.

Two drawings of a spirit guide produced during a seance in 1884, from *Twixt Two Worlds*, a narrative of the life of the British medium William Eglington. Such guides are meant to keep one away from trouble, and in so doing act as a guardian.

◀ 'Fukkensaku Kannon with two Guardian Deities', a hanging scroll from the 12th or 13th century. In Japanese Buddhism Fukkensaku captures the hearts and minds of the faithful with a rope. In this way he can lead his followers along the correct path.

▼ Left to Right

This Maori amulet, or *hei tiki*, is a palisade guardian from Rotorua, New Zealand.

A Japanese Shinto gateway guardian from the Kamakura period (1185–1333AD).

A 19th-century ancestor figure from Luba, the Congo. Female forms were often thought to be efficient guardians as 'only the body of a woman is strong enough to hold a spirit as powerful as that of a king'.

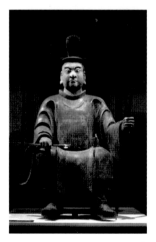

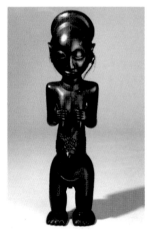

▶ From the Valley of the Kings in Egypt, *c* 1325BC, this figure would have held knives with which to protect the dead from creatures of the underworld.

▶▶A 14th–15th-century figure of Aizen Myo-o, one of the five 'Kings of Light' who protect the worshippers of the Shingon sect of Japanese Buddhism.

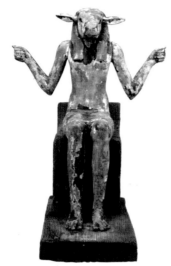

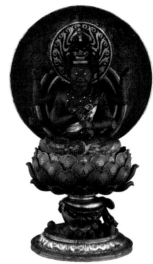

▼ A Haitian Voodoo flag representing the Gede spirits, which oversee the cemetery.

▼ This carved wooden figure with antlers and a long, flat tongue is a tomb guard, dating to the Eastern Zhou period, China, in the fourth century BC. The antlers are indicative of a shamanic connection.

▼ This 18th-century embroidery shows the Dharmapala, who guards the dharma, or essential nature of the universe. Dharmapala figures, of which there are eight, are protectors of the Buddhist faith.

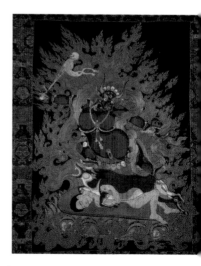

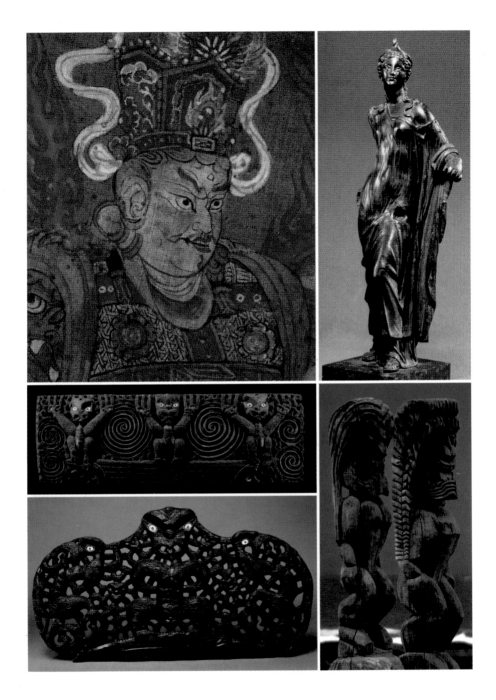

◄ **Opposite**
Clockwise from Left
A mid-10th-century Chinese painting on silk, depicts Vaishravana, Guardian King of the North and one of the Buddhist celestial kings. He protects believers against evil and upholds the law. Here he is shown patrolling his domain.

A second-century bronze of Venus, or her mother, Dione, found in Greece. The statuette was probably a household deity.

The ugly countenances of these carved Hawaiian figures from the Hale-o-Keawe temple are intended to repulse evil.

An early 19th-century Maori door lintel from Poverty Bay, New Zealand. This may represent either Hinenuitepo, the goddess of death, or Papatuanuku, the earth mother.

A late 19th-century lintel from a Polynesian Maori meeting house. The entrance to the house is especially sacred as it marks the passage from the domain of one god to another.

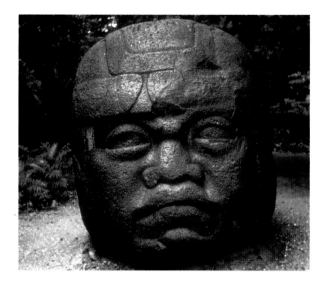

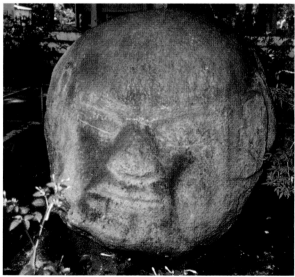

⤴ A Meso-American carved head from La Venta, the Gulf of Mexico, 1150–800BC.

▲ This protective carved head from Guatemala is dated to 1500–100BC.

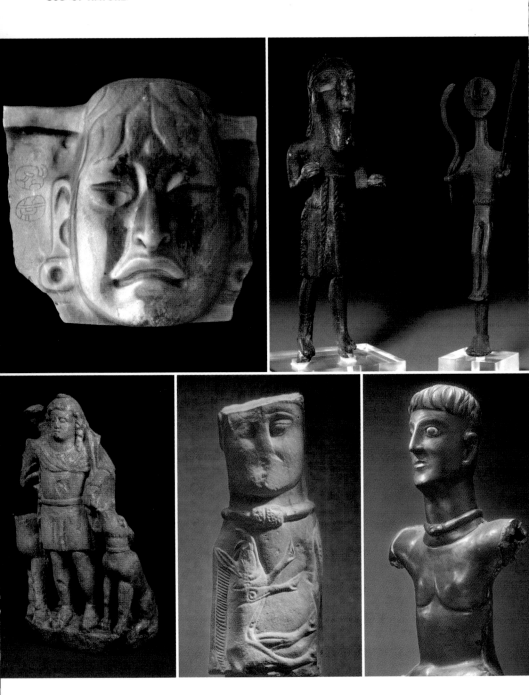

◄ Opposite
Clockwise from Left
This jade chest ornament was
made by the Olmec people of
Mexico in the Middle Prelatic
period (1000–600BC). A
guardian figure was thought to
bring safety and offer moral
support to the wearer.

These copper figures come from
Lebanon, c 2000BC. The figure
on the left has lost his weapons
but is in a protective stance.

From first-century France, this
Celtic divinity is made from sheet
bronze over deer hoof. He has
the strong, alert look of a warrior.

A Celtic deity in stone wearing
a torque and with a wild boar.
Figures like this were often
domestic gods, protecting the
home and its occupants.

Found in London, this is an
amalgam of a Celtic hunter god,
the Roman god Apollo and an
Eastern saviour god – an
eclectic combination designed
for maximum potency.

▶ This 10th-century Anglo-
Saxon manuscript shows a Norse
ship with a dragon's head mast.
Norwegian law required the
removal of such features before
entering the port, 'so as not to
frighten the spirits of the land'.

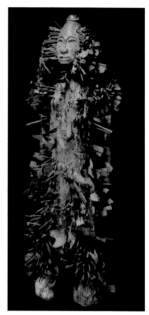

▲ Offerings of food and flowers
were made to this Polynesian
fisherman's god before an
expedition. It dates from the
late 18th to early 19th century.

▲ In late 19th-century Congo,
wooden figures embedded with
nails were thought to catch
thieves or witches and preserve
health, wealth and good fortune.

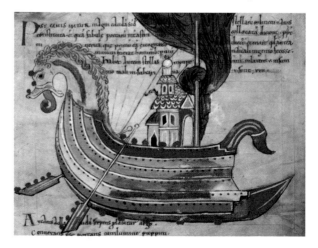

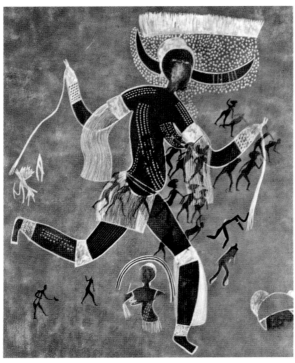

◀ This prehistoric rock painting of a horned goddess was found at Tassili, Algeria. The athletic movement implies strength and health, and the horns, protection.

▼ **Left to Right**
This 1225BC Egyptian deity resembles the god Bes, whose role was to repel demons.

Unusually, this 18th- or 19th-century wooden Polynesian figure has three figures on its chest and two on its arms. The face implies a protective nature.

Fertility figures such as this many-breasted one, of Artemis of Ephesus, c 300BC, are thought to help safeguard the future through abundance.

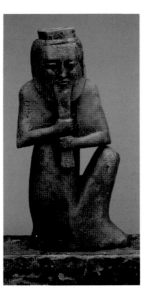

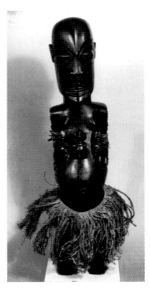

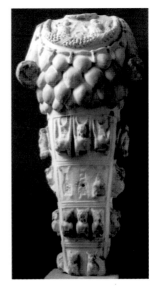

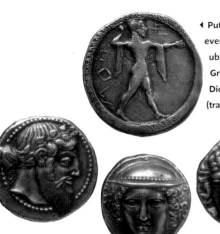

◀ Putting gods into portable, everyday use makes them ubiquitous. Here are the Greek gods Poseidon (sea), Dionysus (wine), Hermes (travel) and Apollo (healing).

▼ In Japanese Buddhism the Myo-o deities usually take frightening forms. Made by a monk in 1282, this drawing shows Fudo Myo-o amid the flames, protecting souls.

▼ In southern Thailand this feng shui dragon acts as a protector for a cemetery. Again, the scary appearance is aimed at the enemy, not the ones who brought it into being.

▲ An 11th-century carved feminine deity derived from Laksmi, the wife of Vishnu – the goddess of fortune, harvest and fertility in the Hindu tradition.

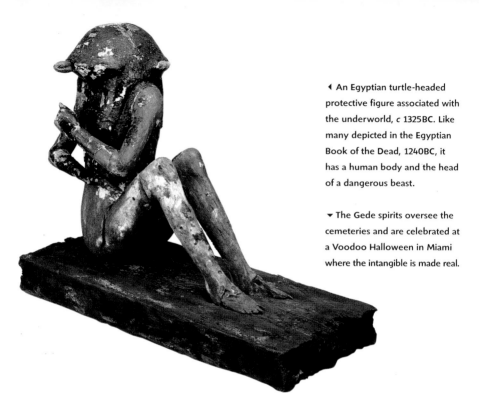

◀ An Egyptian turtle-headed protective figure associated with the underworld, *c* 1325BC. Like many depicted in the Egyptian Book of the Dead, 1240BC, it has a human body and the head of a dangerous beast.

▼ The Gede spirits oversee the cemeteries and are celebrated at a Voodoo Halloween in Miami where the intangible is made real.

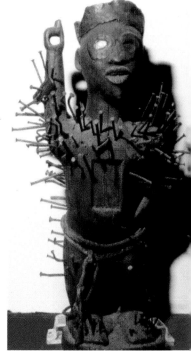

▲ By appealing to Voodoo spirits, curses can be directed to an enemy, symbolized in effigy.

▼ Left to Right

These two magical figures are of the type used in ritual for defence against evil.

▶ This Voodoo figure is from Zaire, West Africa. Nails driven into a figure or effigy represent a spell, or curse, against the perceived enemy and thus ensure the protection of those who commission the act.

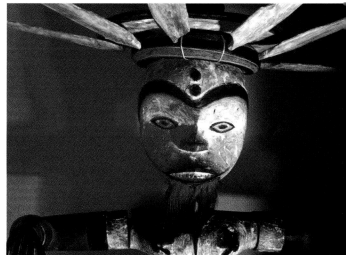

God's Love and Blessings

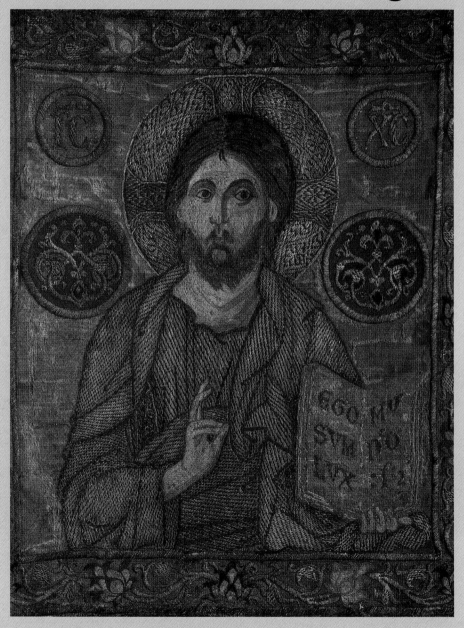

▸ A concert of the Five Orders, 1522. Within the framework of an illuminated Latin psalter, God blesses a group of priestly musicians, who use their gifts in worship.

▸ Here, in a page of illuminated Ethiopic text, God is shown giving benediction to the men building the Tower of Babel. The image is workmanlike, busy and practical.

◂ Opposite
This 13th-century embroidery in the Victoria and Albert Museum, London, shows Christ with His hand raised in blessing.

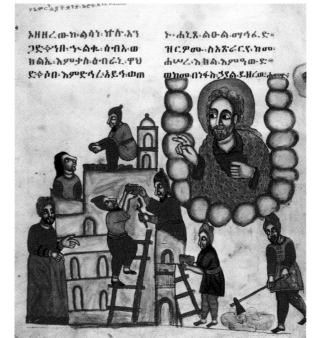

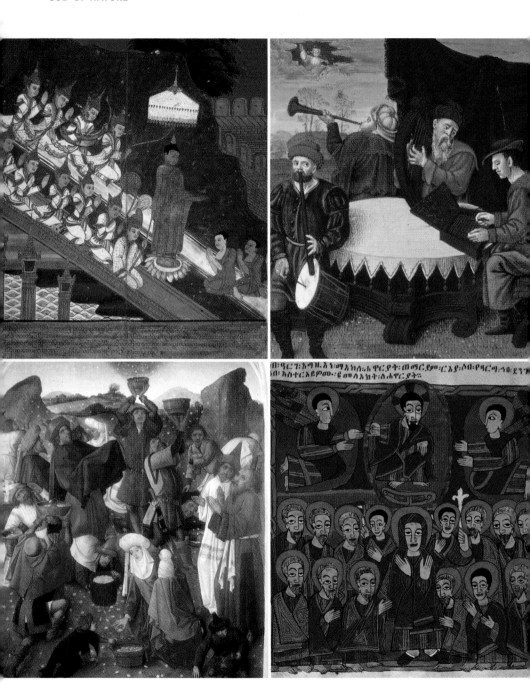

Clockwise from Left
Buddha and the Apsaras,
looking down from Nirvana.
The priests kneel to receive
the blessing. Buddha is sitting
beneath a parasol, which
symbolizes power and
protection, and on a lotus
flower, which signifies purity.

In a Psalter produced for
Henry VIII (c 1520–47), Johannes
Mallardus depicts four musicians
engrossed in their art, as God
gives His blessing.

In *The Life of Christ*, an Ethiopic
text dating from 1744, the
apostles listen to Christ and
angels attend God as He blesses
the gathering from above.

In this 15th-century Dutch
painting, the Israelites receive
manna – food from heaven – in
the wilderness.

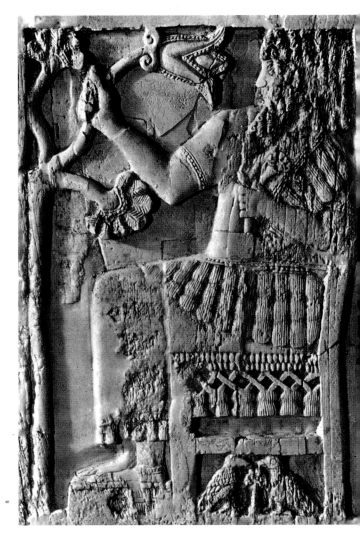

▲ A carved ivory plaque, from
800–900BC, shows an Assyrian
god plucking one of the gifts of
the natural world while sitting
enthroned with dogs at his feet.
The carving is displayed in the
Ashmolean Museum, England.

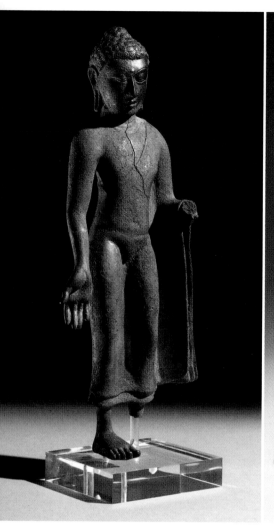

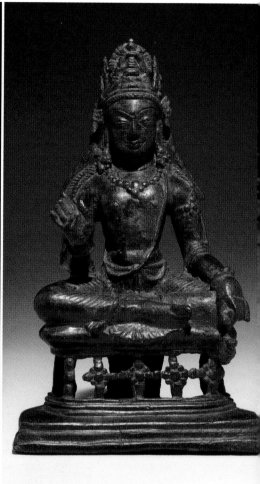

▲ The right hand of this bronze Buddha forms the gesture of charity, or *varada mudra*. The sculpture comes from eighth-century India in a time when Buddhist stupas (domed edifices housing relics) were flourishing.

▲ A bronze seated figure of Maitreya, the embodiment of all-embracing love, from 10th-century Afghanistan. Maitreya is usually depicted with his feet placed firmly on the ground.

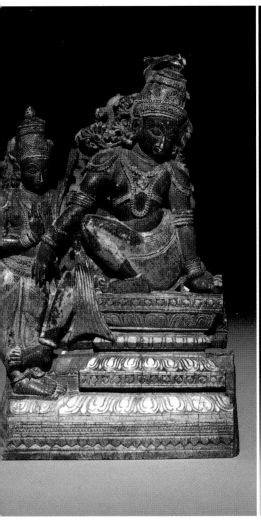

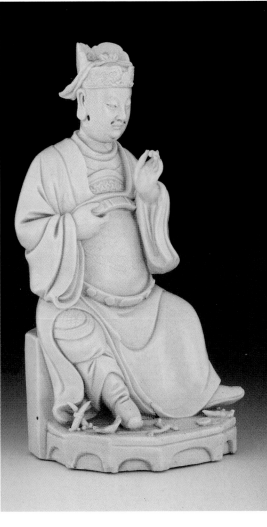

▲ In the Hindu epic, the
Ramayama, Rama and his wife
Sita are separated by the demon
Ravana. Here, in a depiction of
filial love, Rama is comforted by
his brother. Eventually Rama
and Sita are reunited.

▲ This statuette of a Buddhist
god, dated to 1616, is thought
to be Cai Shen, the god of
wealth – not surprisingly a
popular figure.

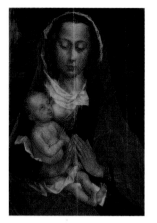
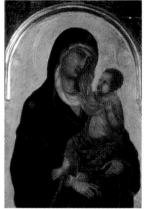
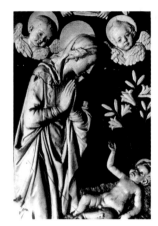

▲ Left to Right

In Rogier van der Weyden's
Madonna painting, c 1460,
Christ, God's gift to the world,
is entrusted to one whose
motherly love was equalled by
the strength she would need
during the course of His life.

Duccio di Buoninsegna's
(1255–1319) 'Madonna and
Child', painted in the 13th
century, reveals the trust
between loved ones.

From the school of Della Robbia
(1435–1525), this relief of the
Adoration also speaks of God's
love for Mary and her love for
the Child.

◀ Sandro Botticelli, in his 1501
painting, the 'Mystic Nativity',
combines the scene of His
birth with a foretaste of the
second coming.

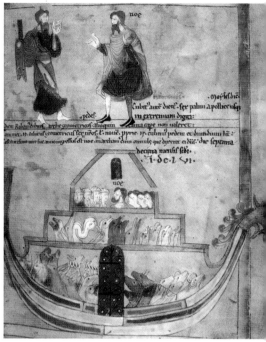

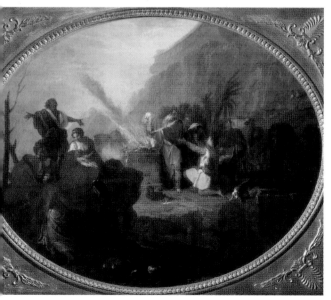

▲ Left to Right

In this 11th-century view of the Flood, God provides protection for Noah, his family and the animals by instructing Noah in the way to build the Ark.

Here we see the animals and Noah's family safely inside the Ark, protected by God's love.

◄ In this painting by Nicolas Bertin (1668–1736), Noah gives sacrifice in thanks for the blessing of deliverance. The waters from the Flood have gone and blue skies are overhead.

 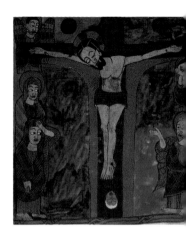

▲ **Left to Right**

This 1232 Armenian Gospel illustration shows Christ's love releasing the souls of the Prophets from limbo.

A page from a 15th-century *Biblia Pauperum*, where David is given the strength to tackle Goliath and Christ releases souls from limbo.

Jesus shows His love by making the ultimate sacrifice. This scene, from 'Council of the Apostles', was painted in 1744.

▼ 'The Presentation at the Temple', painted 1460–64 by Giovanni Bellini (1430–1516). Mary hands her child to Simeon for the ceremony of purification; he blesses them and acknowledges Jesus as the Messiah.

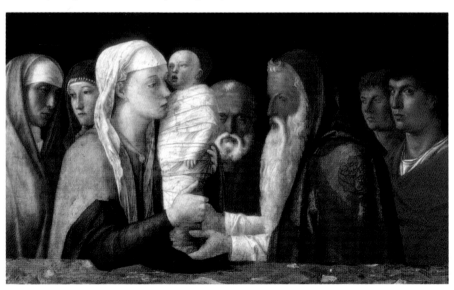

▼ Venus, goddess of love, is lovingly depicted in marble, c 100–150AD. This piece may well have been inspired by one made around 360BC by the celebrated sculptor Praxiteles.

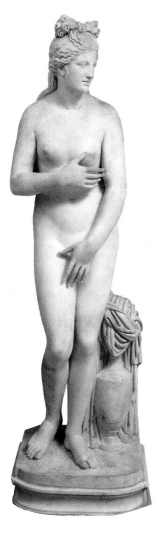

▲ The arts are gifts and blessings. To use them to the best of one's ability is an act of sharing, worship and returning thanks. In this wall painting at the Spituk Gompa monastery in India, a Buddha is shown playing music.

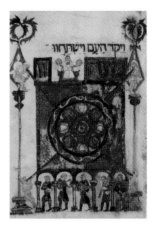

▲ In this act of worship, set in a scene of plenty, *c* 1500, music is provided by the harp at the man's feet and trumpets above.

▲ A fourth-century gold pendant shows Orpheus, the mythical poet and lyre player, along with other characters.

▲ This 1350 Spanish prayer book, *The Barcelona Haggadah*, would have been used to celebrate Passover.

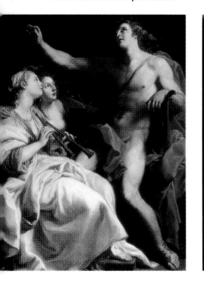

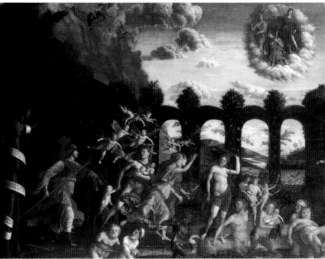

▲ Pompeo Batoni (1708–1787) shows us the god of music, whose gifts are plentiful, in 'Apollo and Two Muses'.

▲ In this painting by Andrea Mantegna (1431–1506) Minerva, the goddess of wisdom and patroness of the arts and trades, chases vices out from the garden of virtue.

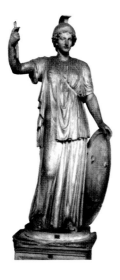

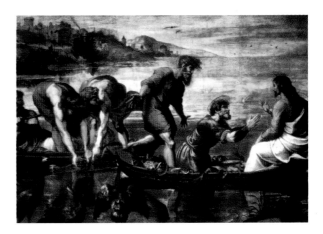

▲ Here Minerva holds a shield and wears a helmet, but as patroness of the arts, she supports those in creative fields.

▲ Early art proves that we have always appealed to the gods for our daily needs. In Raphael's (1483–1520) interpretation of the miracle, 'The Miraculous Draught of Fishes', Jesus calmly looks on as the nets are drawn in, while sea birds hope for a share of the catch.

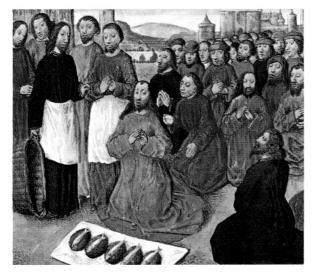

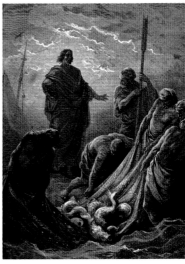

▲ In this 15th-century Bible illustration, Christ prepares to feed the crowd of five thousand with the lunch provided by just one child. His disciples pray with Him and the crowd looks on.

▲ God's blessings are given in the 'Miraculous Draught of Fishes', as published in Gustave Doré's 1865 *Bible Illustrations*.

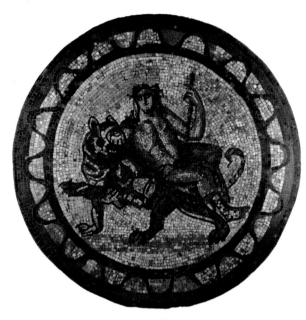

◀ From the first or second century, this mosaic, which was excavated in Leadenhall Street, London, shows Bacchus riding on a tiger, a reference to his mythical visit to India.

▾ Left to Right
Indra, God of the Indo-Aryans, is the source of fruitfulness and rain. Here he is shown in a 19th-century engraving.

God of wine and giver of ecstasy, this statuette of Bacchus from Roman Britain carries an empty cup, yet leans against a fruitful vine.

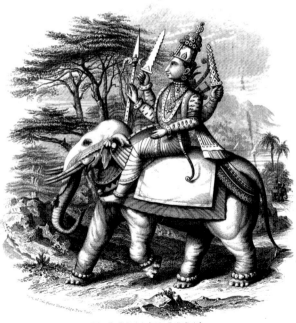

Indra. The Hindu God of Light, Vedic Period.

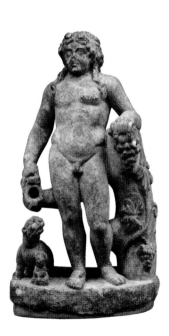

▶ **Clockwise from Left**
Bacchus' aesthetic is still an extremely popular one. Here he is set into the wall of a modern house in Sicily.

The Italian painter Michelangelo Caravaggio painted Bacchus (c 1597) resplendent on a couch with wine, vines and other fruits. The painting now hangs in the Uffizi Gallery, Florence.

This god of sickness, made by the Isleta people of Mexico, indicates that the deity did indeed sympathize with sick.

The Buddha of this first-century statue offers the reassuring gesture of *abhaya mudra* – that of being without fear.

In this 19th-century depiction from India, a woman seeks protection from the demon Mara beneath the statue of a Buddha as a band of heavily armed men and an armed elephant approach the scene. The Buddha remains unmoved.

This sculpture of Bacchus was found on the floor of a disused temple to Mithras in London, and shows a change of allegiance by the worshippers.

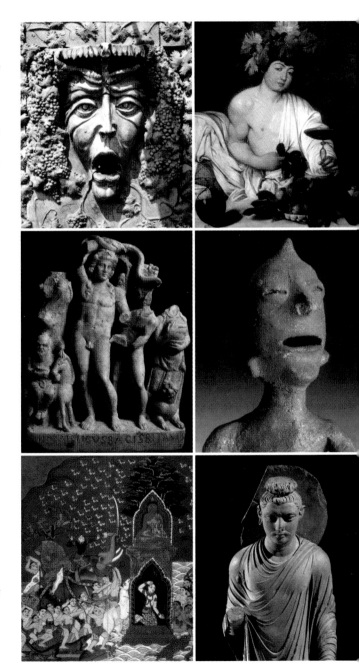

▾ Clockwise from Left

Christ performs the miracle of restoring hearing to the deaf in a chromolithograph from a 19th-century illustrated Bible.

Gustav Doré's illustration of Jesus curing a man sick of the palsy, from his 1865 Bible. Light radiates in a halo from Christ's head and falls onto the patient as he receives healing.

In this mid-19th-century Bible illustration, the daughter of Jairus, leader of the synagogue, is raised from the dead by the words *taltha koum* and a touch from Jesus' hand.

Jesus drives out a devil and raises His friend Lazarus from the dead in this painting and calligraphy by Rotakes, after an Armenian Evangelistery *c* 1394.

▸ Opposite
Clockwise from Left

Martha and Mary kneel at Jesus' feet as he raises their brother Lazarus. From a 13th-century Evangelistery.

This scene shows Lazarus revived from his tomb and being led, to the astonishment of all but Jesus. Martha and Mary convey a mixture of fear and gratitude. After an Armenian Evangelistery, *c* 1269, by Toros Roslin.

Albert van Ouwater brings realism and humour to his 'The Raising of Lazarus', *c* 1455 – one of those present holds a cloth to his nose.

'The Healing of the Blind Man' by Duccio di Buoninsegna (1255–1319) gives us a 'before and after' view, as the cripple throws away his stick and walks.

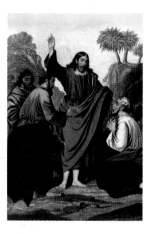

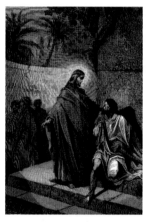

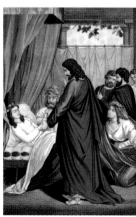

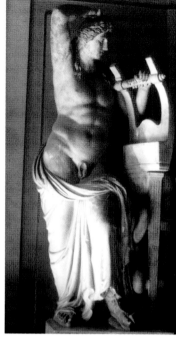

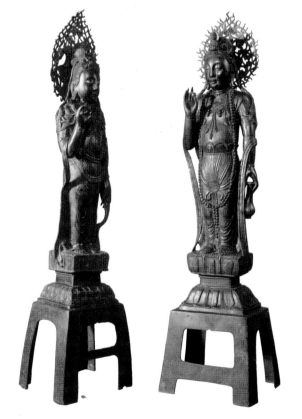

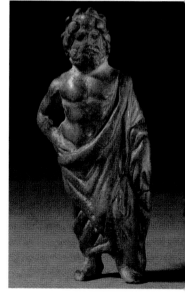

▶ Cult statues, such as this marble one of Apollo from Cyrene, dated to the second century, acted as avatars in shrines and temples, where they became the focus for ritual activity and appeals for help.

◀ **Opposite**
Clockwise from Left
The Corbridge Lanx, from fourth-century Roman Britain, shows a shrine to Apollo. He stands at the entrance with Artemis, Athena and two other women.

A second-century Apollo with his lyre. In addition to being god of light, poetry and prophecy, he was god of music.

Here we see a bronze figurine of Aesculapius, the Roman god of healing, dated from between the first and fourth centuries. He leans on a snake-entwined staff, the caduceus, which is now recognized as the symbol of medicine. The snake and staff represent the support he gave to the sick.

Two bronze statues of Guan Yin, the Chinese Bodhisattva of mercy who protects women and children, and to whom childless women can turn. The figure on the right holds a jar containing the nectar of immortality.

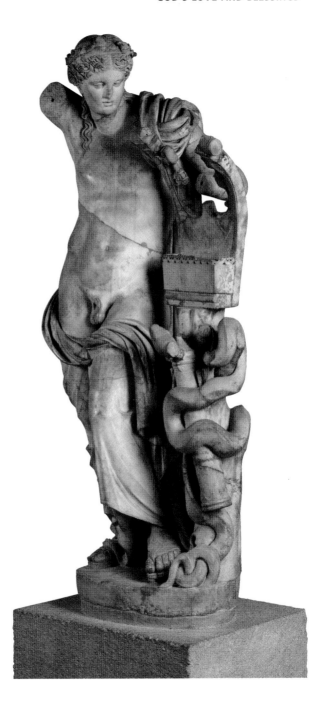

God's Helpers and Friends

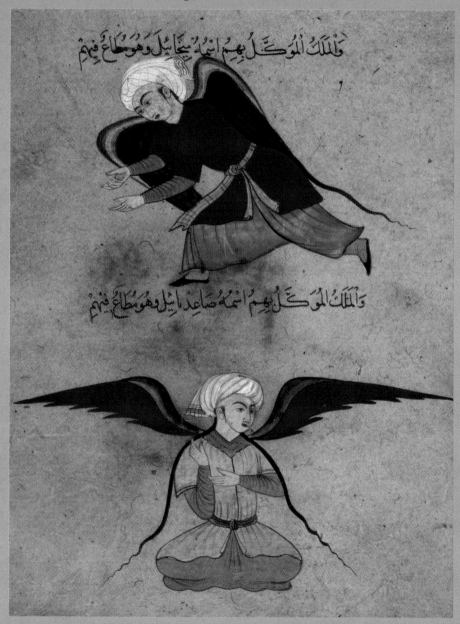

◀ **Opposite**
Two angels, from the
illuminated manuscript *Aja'ib
al-Markhtukat* (*The Wonders
of Nature*), by al-Kazrvin.

▼ Also from the *Aja'ib al-
Markhtukat*. Notice how the
pattern of dress and stylized
wings of the angel are in the
Arabic tradition, combining
nature and geometry in design.

▼ Archangel Jibril (Gabriel) – a
messenger from God in both
Islam and Christianity – strides
over a cloud in the Islamic
text, *The Wonders of Creation
and the Oddities of Existence*,
1375–1425.

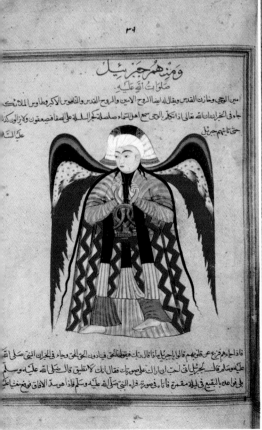

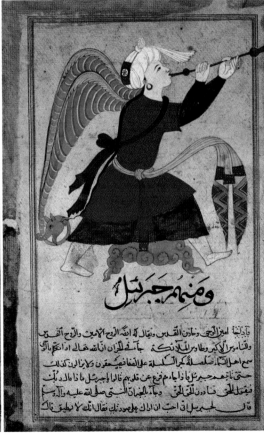

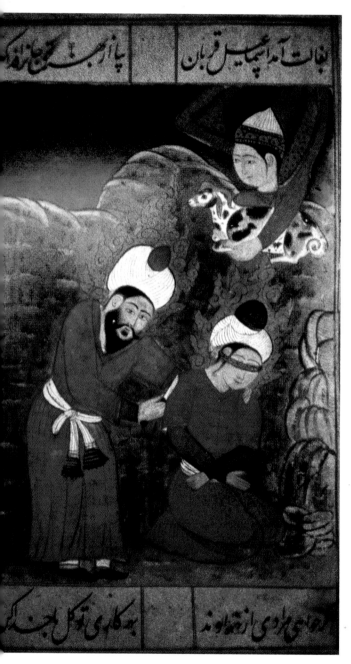

▲ A woodcut from 1557 illustrates a passage from the Bible in Genesis 22:9–10, in which the angel prevents Abraham from harming his son, and the ram caught in the thicket is to take the boy's place.

◄ An Islamic manuscript from the 18th century shows Abraham preparing to sacrifice his son. God sent an angel to intervene and the boy was saved.

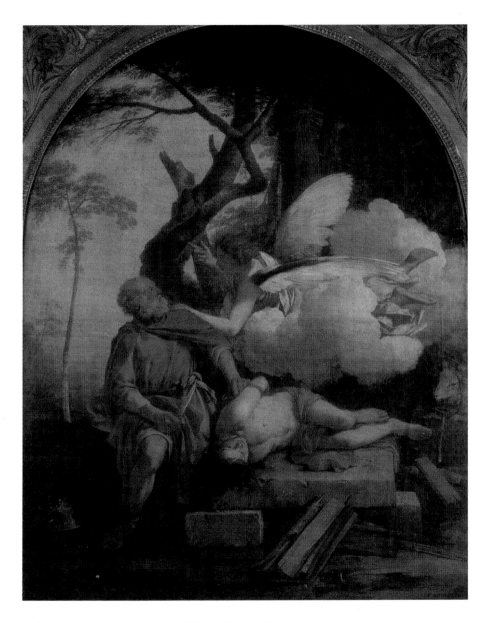

▲ The French Baroque painter Laurent de la Hire (1606–56)
interpreted the story of Abraham and his son, with the angel
arriving in a flurry of cloud, in oil on canvas.

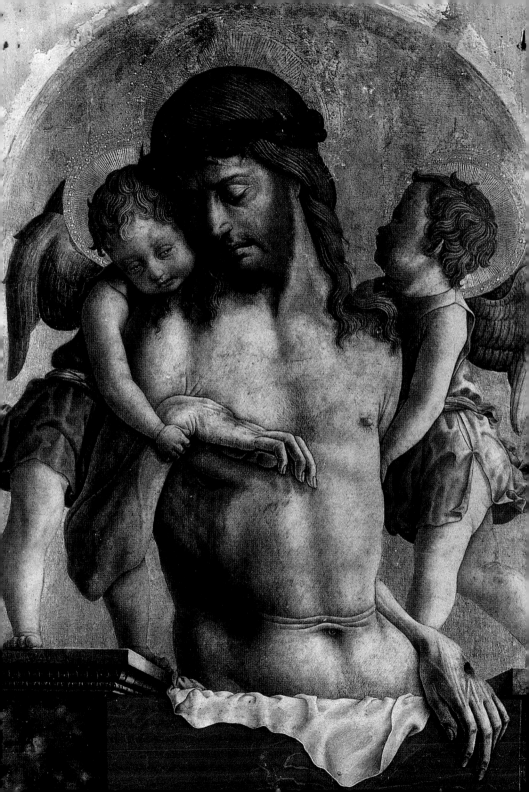

◀ **Opposite**

'The Dead Christ Supported by Two Angels'. Carlo Crivelli painted this image of Christ, a popular subject among 15th-century artists, in egg tempera on poplar, c 1470, as part of an altarpiece.

▾ Gentile Bellini's egg tempera painting of Christ supported by two angels, c 1465–1469, was made to encourage meditation on Christ's passion and sacrifice. It can now be seen in the National Gallery, London.

▶ **Top to Bottom**

Here two angels spread their wings to protect the Ark of the Covenant. It is taken from the North French Hebrew Miscellany, c 1280, written by Benjamin the Scribe.

Francesco Trevisani (1656–1746) painted 'Christ Between Two Angels' in oil on canvas. It catches the moment between death and resurrection. The light sweep of the angel's wing above Christ brings His head into focus and reads as a halo.

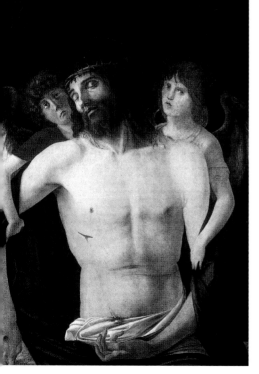

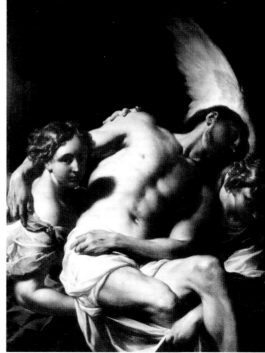

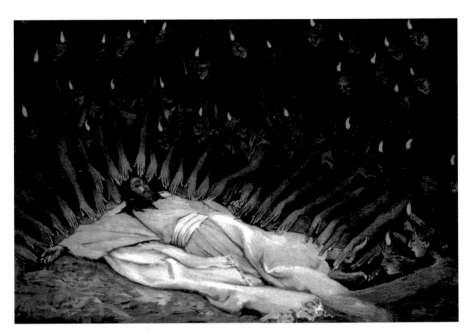

▲ Clockwise

James Tissot's 'Life of Our Saviour Jesus Christ', 1897, depicts angels ministering to Christ. The composition puts the viewer in the same space as Christ, suggesting that we are part of that circle of helpers.

On an illuminated manuscript, the Angel Uriel appears to Ezra and reveals visions of the future. Thought to be a contemporary of Moses, Ezra was a scribe and a priest, and had a major role in upholding Hebrew laws.

Taken from the 12th-century Spanish manuscript, the Silos Apocalypse, by San Sebastián de Silos. A seven-headed beast is attacked by angels with spears. Bodies lie on the ground; one seems to be in a cage.

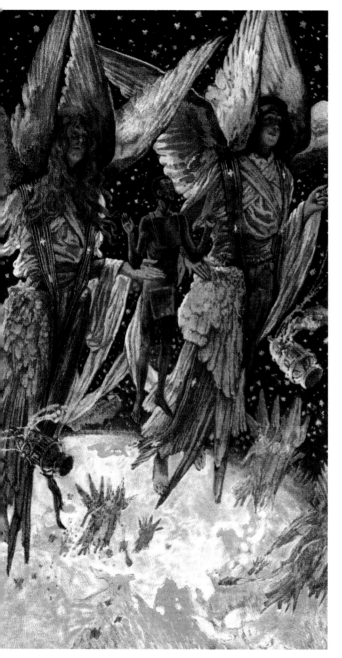

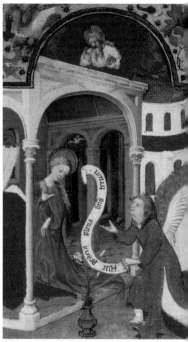

▲ A scene from a 15th-century Book of Hours dedicated to the Virgin. The Angel Gabriel brings news to the Virgin Mary that she is to bear the Christ child.

◄ This illustration by James Tissot for 'The Life of Our Saviour Jesus Christ' illustrates a passage from Luke 23:43. The soul of the penitent thief is carried by angels to heaven – a sign of the power of repentance and forgiveness.

◀ This Tuscan manuscript, c 1375, illuminates the letter 'R' with a scene from the Annunciation, where Gabriel holds a scroll containing the words of God while other angels look on.

▼ Left to Right

An early 14th-century Byzantine mosaic shows the Annunciation. It may be viewed in the Victoria and Albert Museum, London.

In this Annunciation scene, by Lorenzo Lotto (1480–1556), the Archangel Gabriel holds a Madonna lily, a flower often associated with the Virgin Mary.

A coloured lithograph, c 1850, from a version of John Bunyan's *Pilgrim's Progress*, depicts the angel Secret bringing a message from the Merciful One to Christiana.

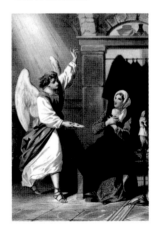

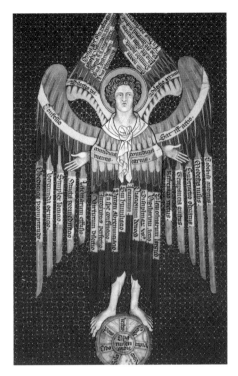

⌃ Left to Right

An angel from the 14th-century De Lisle Psalter, shown as a messenger with words on his wings and the world at his feet.

A page from a Latin text shows Christ surrounded by angels with the faithful below.

▸ Angels pay homage to Adam on an Islamic manuscript, the *Majalis al-ushshak*, c 1560.

⏩ The Virgin Mary as protector of sailors and travellers in a 19th-century woodcut.

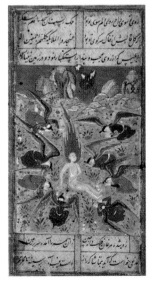

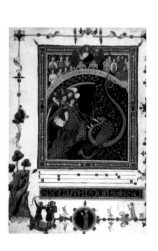

▲ **Left to Right**

El Greco (c 1545–1614) depicts St Peter in prayer with the keys to heaven on his lap.

An angel in a blaze of light releases St Paul from prison in this painting by Raphael.

▼ **Left to Right**

Angels calling shepherds to worship the Christ Child, from a 16th-century Book of Hours.

A Syrian pilgrim bottle, c 1330, probably contained earth or water from a sacred site.

A Tuscan choral manuscript shows St Michael and angels in battle with a dragon, along with a smaller scene where the saint helps defenders of the besieged town of Manfredonia in 492 AD.

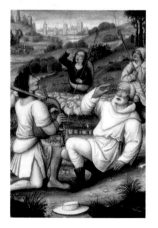

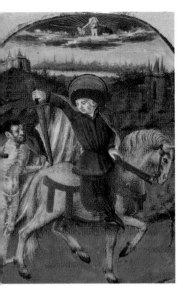

◄ **Top to Bottom**

St Martin cuts his cloak in two to share with a beggar. From a 15th-century Book of Hours.

Illustration by Tissot, *c* 1890. Here we see Christ calling for Matthew to cease collecting taxes and follow Him.

▼ The cupola of the 14th-century Church of Christ in Constantinople (Istanbul), Turkey, is richly decorated with images of Christ and the saints.

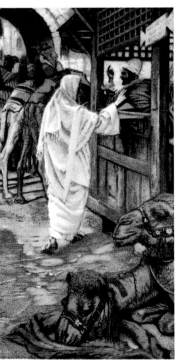

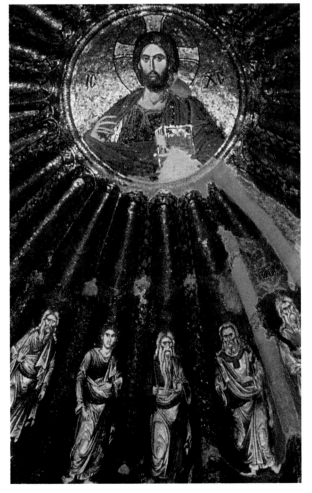

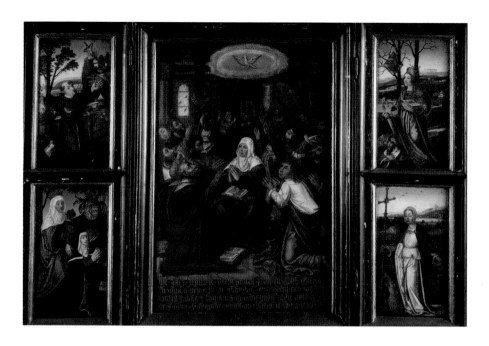

▾ With Christ's blessing from above, Augustine of Hippo, the Italian theologian and philosopher, is listened to by earthly followers.

▴ A 16th-century Flemish School triptych shows the Virgin Mary surrounded by various saints and the Holy Spirit as a dove.

▾ A painting on wood by the Italian Lorenzo Monaco (the Monk), (1370–1422). It depicts the coronation of the Virgin surrounded by adoring saints.

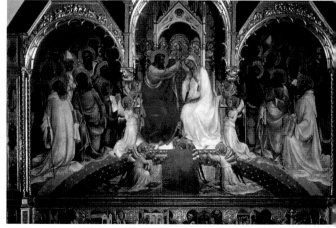

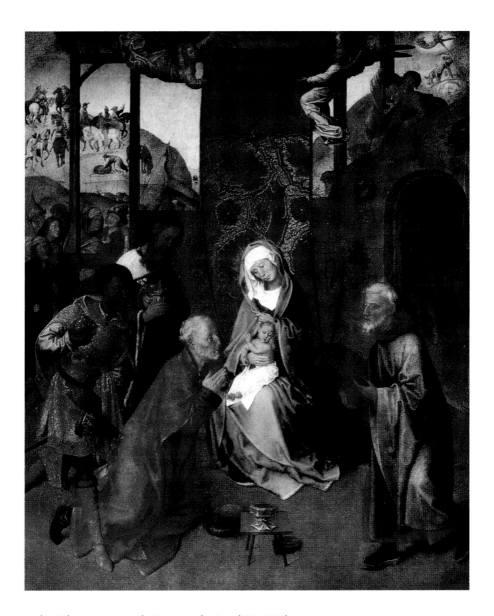

▲ This 15th-century picture by Hugo van der Goes (1435–1482)
illustrates the human and heavenly response to the birth of the Christ
Child. The red backdrop links with the reds to the left of the picture,
taking the holy scene to the outside world.

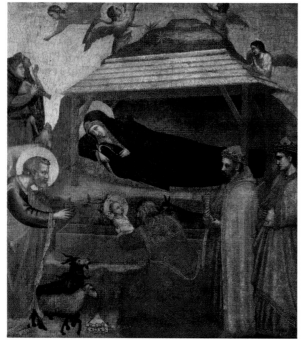

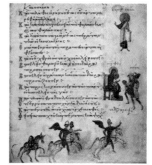

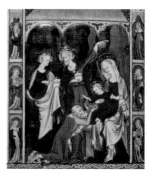

⬆ 'Adoration of the Magi', c 1470, by Botticelli (1445–1510). The tiny baby is dwarfed by the crowd of worshippers, who come in rich robes and in workmen's clothes.

▲ Giotto's (1266–1337) interpretation of 'The Epiphany', c 1320, uses rich pigments and gold. Describing the Magi's devotion becomes an act of devotion in itself.

⬆ An illustrated Greek text by Theodorus Caesarea, 1066.

▲ The Infant engages with the Magi in this 14th-century Latin psalter.

▾ Worshipful music is used in the singing of psalms and here in the illumination of a page from a 15th-century psalter.

⍖ Al Buraq, the Prophet's winged steed, is shown here on an Islamic tapestry. According to tradition, he flew Mohammed to Jerusalem to pray with Jesus and Moses.

▾ The choirs of the saints surround Jesus Christ – raising His hand in blessing – and are in turn surrounded by angels. A page from the Psalter of King Aethelstan, c 900–939AD.

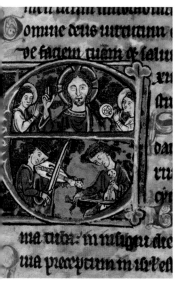

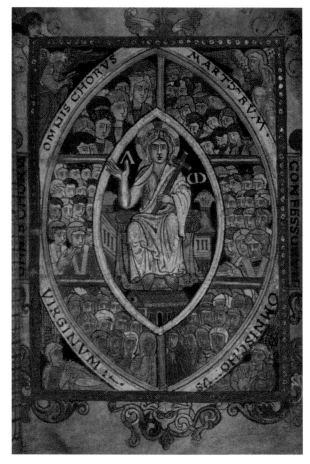

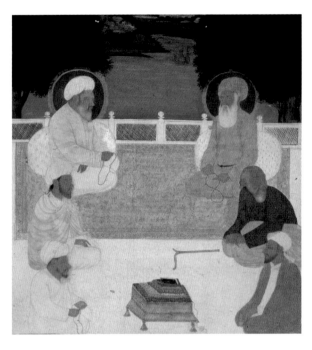

◀ Sufi saints with prayer beads. Sufi Muslims seek close experiences of God and are often described as being mystics.

▾ **Left to Right**

A stone relief of a sphinx from 5th century BC. This is one of a pair that would have adorned a Zoroastrian temple.

The building of the Tower of Babel and Zoroaster from *Secreta Secretorum, c* 1425. Zoroaster (or Zarathustra), the Persian prophet, is shown in the lower image, dealing with two devils.

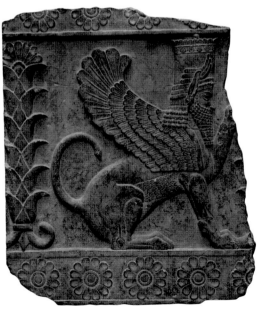

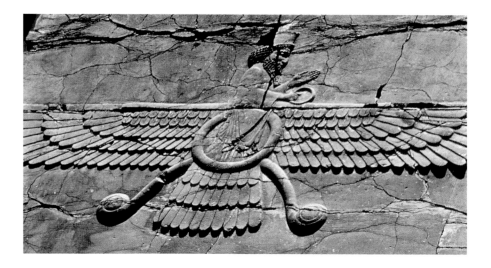

▲ The Farohar, or Frashavi, is the symbol of the Zoroastrian faith and the guardian angel of mankind. Frashavis keep the planets in motion and maintain life on earth.

▼ A 15th-century Flemish miniature of Zoroaster in his study, with followers outside in a courtyard. Zoroaster saw himself as a prophet bringing a new message from the Wise Lord, Ahura Mazda.

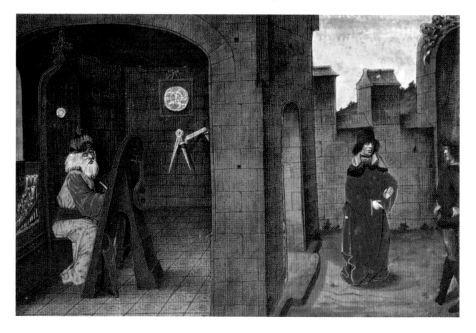

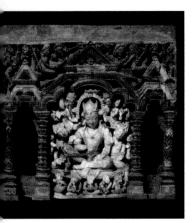

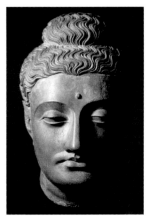

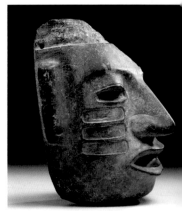

▲ An ivory Bodhisattva with attendants, from 18th-century Kashmir. Originally it would have been brightly painted; traces of pigment remain on the surrounding wooden shrine.

▼ The Buddhist faithful can find *abhay mudra*, or reassurance, in this hand gesture. In the 13th century the walking figure was a feature of Thai art.

▲ The calm, serene and symmetrical head of a Buddha from second-century India shows the influence of classical Greek and Roman sculpture.

▼ In Vajrayana, or Tantric, Buddhism, the Adi (Supreme) Buddha is Vajrasattva. Here the figure is carved in stone in an image that dates from the 10th century.

▲ A black limestone mask from Mexico, 150BC–700AD. Teotihuacan style is evident in the character of the features. The marks on the cheeks may represent facial painting.

▼ Broad-shouldered, unrobed, with a cap of curls and long earlobes, this piece has the usual iconographic detail of a third-century Indian Jain Tirthankara.

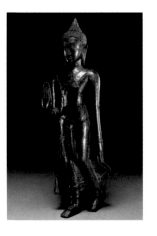

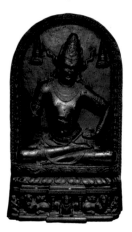

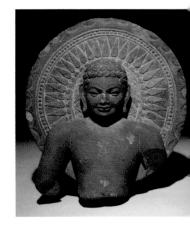

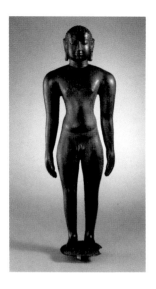

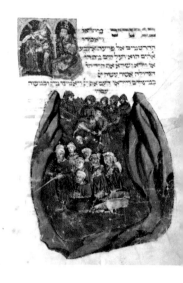

▲ A bronze Tirthankara from India in the 11th–12th century. The 24 Tirthankaras allow Jain followers to cross from suffering to joy and knowledge.

▲ Two of the 24 Tirthankaras are shown being attended to by devotees. Painted on paper, this religious work originates from India, c 1720.

▲ In a vividly executed illustration from a 15th-century Bible, Moses leads the Children of Israel to safety through the Red Sea.

▶ In this painting by Hans Memling (c 1440–1494), St Christopher carries the Christ Child on his shoulders, through the water. The saint had been urged by a hermit to live next to a particular river and help pilgrims cross its tricky waters. One night he carried a child whose weight seemed to increase so much that the two only just reached safety. The child was Christ, who told him he carried the burden of the whole world and his maker.

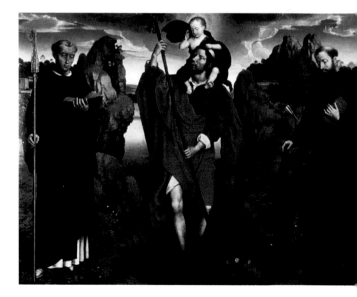

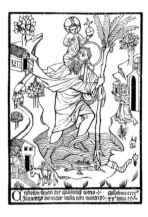

▲ This 15th-century woodcut shows Christ on St Christopher's shoulders crossing a stylized stream and dwarfing the peripheral, less important figures in the picture.

▲ Garuda is a half-bird, half-man creature of Hindu mythology. He is the vehicle, or *vahana*, on which Vishnu rides, and a messenger. This depiction is from 13th-century India.

▲ Here we can see the Buddha surrounded by deities, or apsaras, one of whom carries a parasol, a symbol of spiritual protection and power, over the Buddha's head.

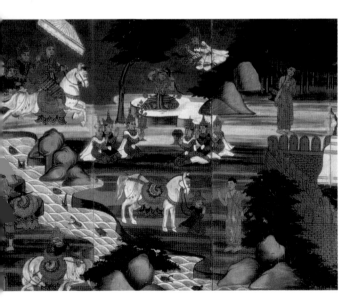

◀ A 19th-century picture of apsaras on white horses outside a Buddhist shrine. The one leaping is protected by a parasol. Apsaras are flying spirits and frequently appear as helpers and messengers in Buddhist art.

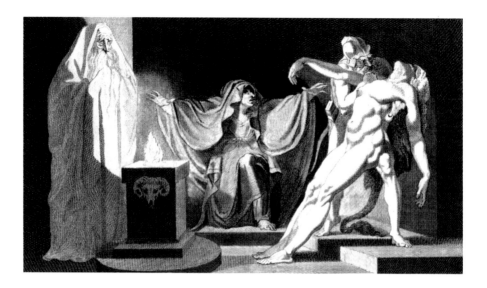

▼ Hermes, the messenger god, superbly formed in bronze, Italy, c 200–100BC. He would have originally carried a *kerykeion* (snake-entwined staff).

▲ Having been promised no reprisals, the witch of Endor brings Samuel out of the earth to help Saul. A dramatic engraving after Fuseli, c 1792.

▼ 'Saul and the Witch of Endor', an engraving from 1804, in which Saul tries to communicate with the dead Samuel via the witch.

▼ 'Juno Borrowing the Cestus from Venus', c 1782. This is a romantic depiction of the two goddesses.

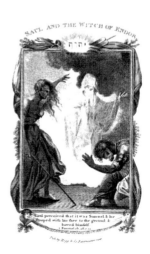

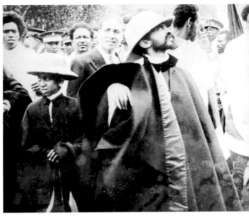

▲ Left to Right
Emperor Haile Selassie was
originally Crown Prince (Ras)
Tafari, but was crowned
Ethiopian Emperor in 1930.
He is regarded as a Messiah,
or even God, by Rastafarians.
The Rastafarian movement
began in Jamaica in the 1930s.

◀ This is Abdu'l-Baha, head of
the Baha'í Faith from 1892–1921.
Baha'í was founded in 1863 by
Mirza Hoseyn ali-Nuri, who
declared that he had a new
revelation from God.

▶ Opposite
This richly illuminated
manuscript of 1423 shows
a busy scene with people
going about their business
and one appealing to God.
The angel, above, acts as
a visual link and a helper,
guiding people to God.

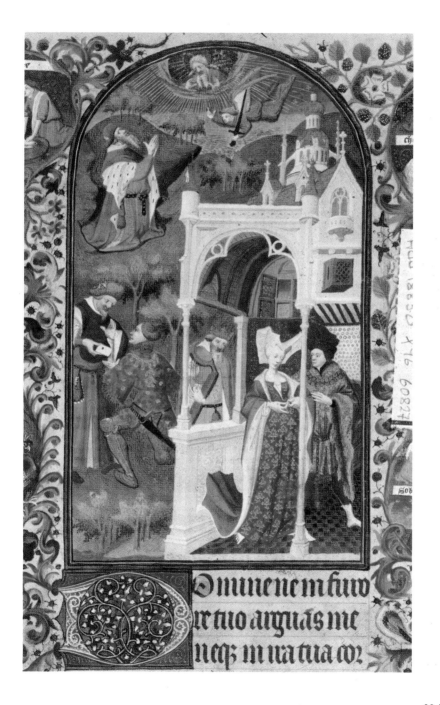

▲ The Hindu Lord Shiva
Temple in Kathmandu, Nepal.
Colour, shape and movement
make an inviting scene at this
place of worship.

▲ The ruins of a Fire Temple
stand at Naqsh-i-Rustani near
Persepolis. A sacred fire fed
with sandalwood is a feature
of Zoroastrian worship.

▲ This is the Vat Sisaket Temple
in Laos. It is an image of calm,
order and peace.

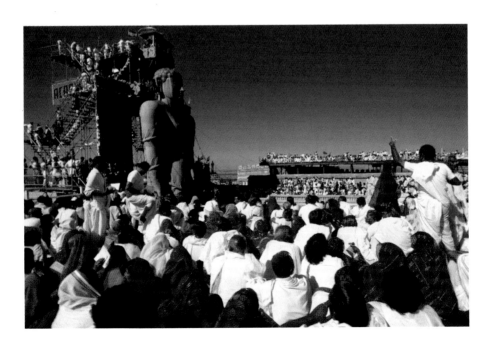

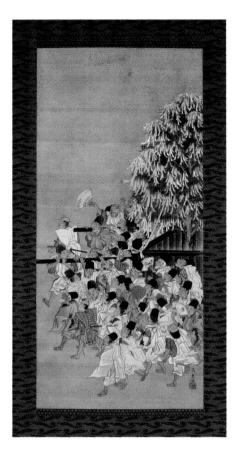

▲ A 19th-century depiction of a Shinto shrine festival. The tree carried by excited crowds is decorated with *gohei*, strips of white paper symbolizing the sacred.

◀ **Opposite**
Crowds at a Jain festival in India surround a statue of Lord Bahubali, the first person to achieve liberation in this world cycle.

▲ The frieze on this first-century Bimaran Reliquary from Gandhara, Afghanistan, shows an early depiction of Buddha with some of his attendants.

▲ A 10th-century painted silk banner illustrates a double image of the Buddha. The banner is a sign for victory of the spirit, and it is one of the *astamangala* (the eight gifts showing veneration).

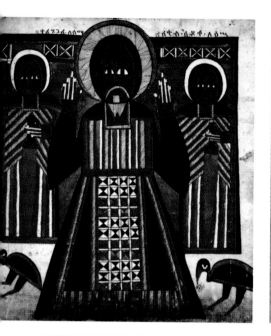

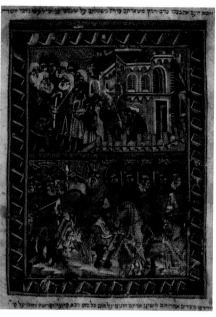

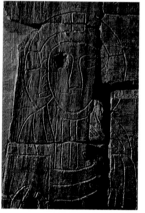

▲ **Left to Right**

Three saints on a manuscript. Two of these highly stylized figures stand with swords on an Ethiopic text.

This illustration from a Hebrew service book, from Spain, shows the Exodus – the Israelites leave Egypt with the Egyptians in pursuit.

▲ This image of Christ is from the coffin of St Cuthbert, c 687 AD. Cuthbert was visited by an angel, who left him loaves of bread; miraculously his body did not corrupt after death.

▲ The Egyptians are caught in the waters of the Red Sea; the Israelites are safely on dry land. From the Leipnik Haggadah, 1740, a Hebrew service book read on Passover Eve.

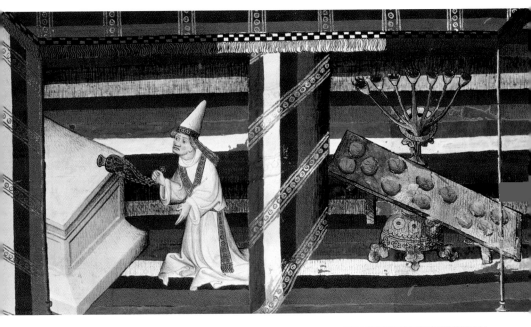

▲ Aaron, in the tabernacle, swings incense in a censer. To the right is a Menorah, the seven-branch candlestick and symbol of Jewish identity.

▶ These portraits, dating from 1840–1865, are of Sikh heroes. The one on the bottom left appears to have a halo.

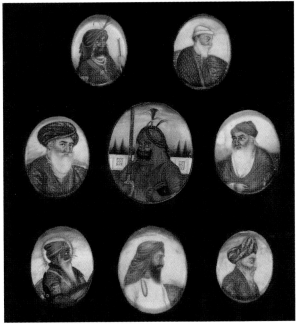

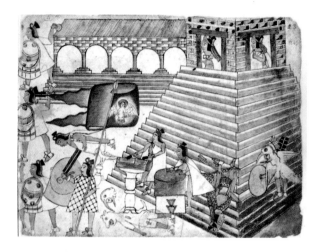

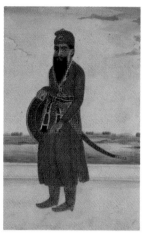

▲ Aztec warriors defend the temple of Tenochtitlan, in Mexico. The temple was built in 1325 on an island linked to the mainland by three causeways, as a place to meet with the gods.

▼ In the Hindu epic *Ramayama,* by Valmiki, the monkey Hanuman helped Rama in the rescue of Sita from the kingdom of Lanka. He appears twice in this picture, dating from 1653.

▲ Maharaja Ranjit Singh, c 1780–1839, was founder and ruler of the Sikh kingdom in the Punjab.

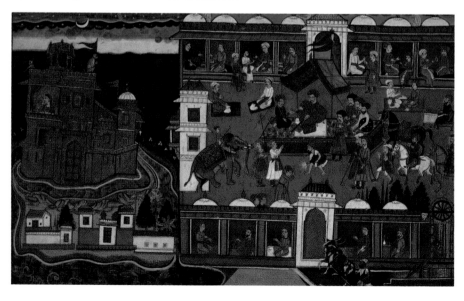

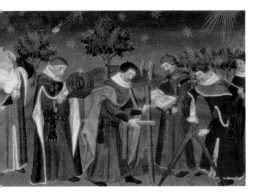

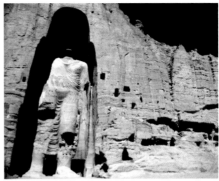

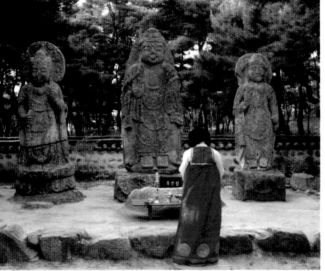

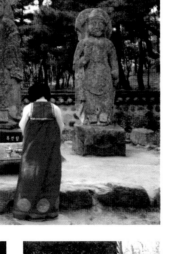

▲ Above Left to Right

A 15th-century depiction of medieval astrologers at work, probably Egyptian in origin. Astrology is accepted in some faiths but not in others.

A standing Buddha at Bamiyan, a holy place with carved and decorated caves, in Afghanistan. The figure stands well over 30 metres (100 feet) tall.

◀ A Buddha and two attendants are prayed to by a young girl in South Korea. Before the figures stands a small altar.

◀◀ A third-century carving on a limestone stupa shows Buddha being worshipped and guarded by lions.

◀ In a 15th-century manuscript tonsured monks sing praises to the Lord. The monastic life involves frequent periods of praise as well as work.

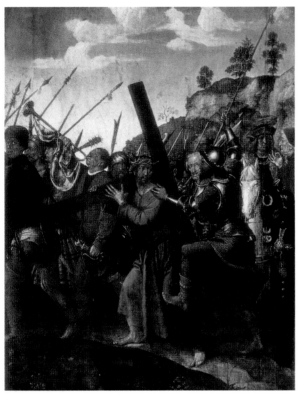

◀ 'Jesus on the Road to Calvary', by Michel Sittow (1469–1525). A Roman soldier pushes and kicks the Christ figure with the crown of thorns; His friends are lost in the crowd.

▼ 'Christ on the Cross between Two Thieves', by Francken the Younger (1581–1642). One of the thieves was saved by his belief in Christ – notice the symbolic light hitting the figure on the right.

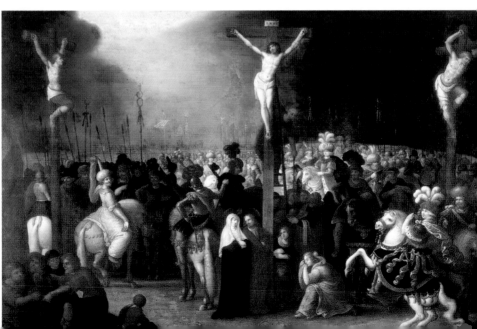

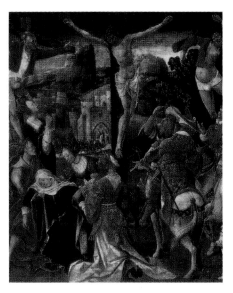 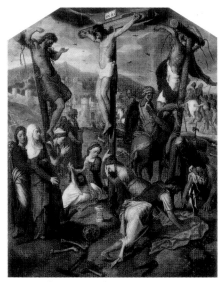

▲ Left to Right

The Flemish painter Cornelis Engelbrechtsen (1468–1533) depicts the response to Christ's death on the cross from His friends and His fainting mother.

'Calvary' by Pietersz. Dread and disbelief for Jesus' followers amid the tools of the Crucifixion and symbols of mortality.

◀ 'Ecce Homo' – 'Behold the Man' – by Quentin Metsys (1465–1530). Pontius Pilate brings Christ before a jeering crowd. Only days before this event the same people welcomed Him as a friend.

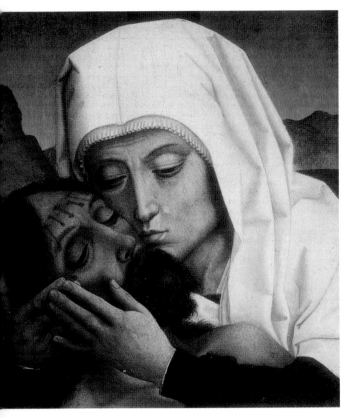

◀ Gerard David (1460–1523) shows us the 'Lamentation of Christ'. This bold composition cuts the picture plane in two – one for sacrifice, the other for sorrow.

▼ In this 'Pietà', painted c 1500 by the Master of Saint Germain des Près, Jesus' followers pause in prayer; the crowd has left and the thieves still hang on their crosses. From the Louvre Museum, Paris.

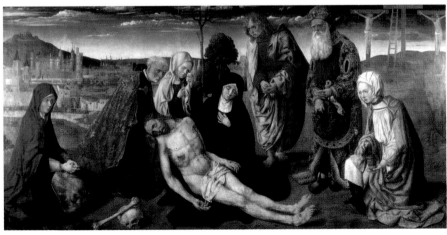

▶ Christ's sores and scars make this image a difficult one to study. The cockerel, upper left, is a reminder of Peter's denial.

▶▶ This scene shows the Deposition, Entombment and Lamentation of Christ. After an Armenian Evangelistery, *c* 1268.

▼ Left to Right

Albrecht Dürer sums up the black atmosphere of the Entombment in his use of strong line and shape. From the series 'The Great Passion', 1497–1500.

'The Entombment', 1450, by the Flemish artist Dieric Bouts (*c* 1415–1475). Christ is lowered with care into the tomb.

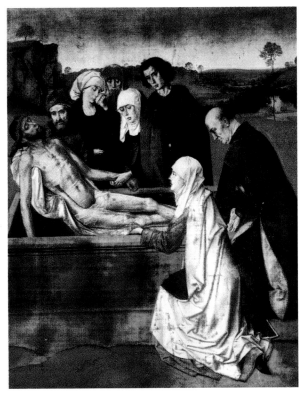

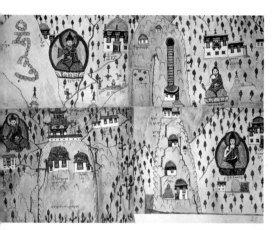

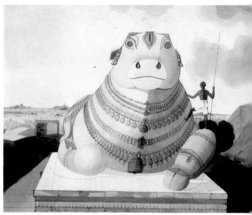

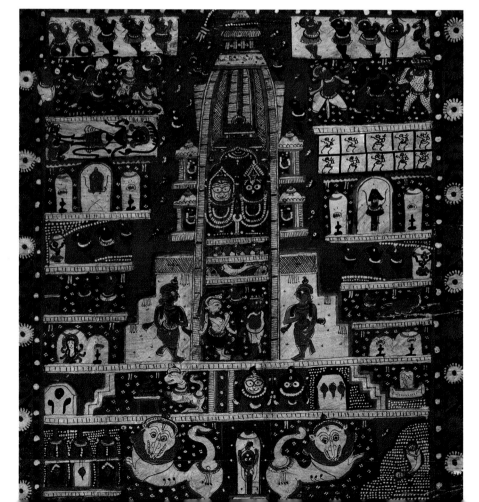

◄ **Opposite**
Clockwise from Left
Buddhist stupas, buildings and people on a map of mountains and trees; faith is a part of the landscape here.

The great bull Nandi, 'the Happy One', is the vehicle of Lord Shiva and often guards Shiva's shrines. The painting dates to 1806.

The Hindu Jagannatha Temple is represented here in stylized form, *c* 1920. The faithful dance in worship.

▼ A colourful 17th-century scene showing a Rajput king worshipping Krishna, an avatar or incarnation of Vishnu. Krishna is wearing prayer beads and holding a lotus.

▼ On an illustrated page of a copy of the Qur'an, the faithful are shown making a pilgrimage to Mecca.

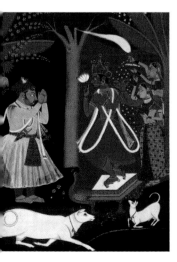

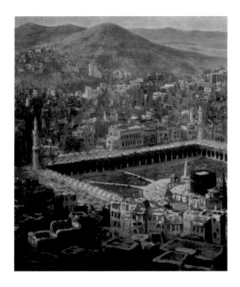 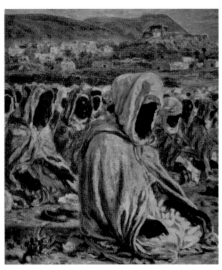

▲ A view of Mecca by Etienne Dinet (1861–1929) for the book, *The Life of Mohammed, Prophet of Allah.* Symbolic light falls across the scene.

▼ A woodcut from 1853 shows Sufi Muslims in Constantinople experiencing God through a meditative dance known as the dervish, or *mawlawiya*.

▲ Worshippers at prayer in Mecca. A scene of quiet devotion by Etienne Dinet (1861–1929).

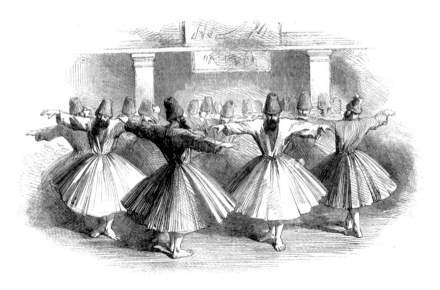

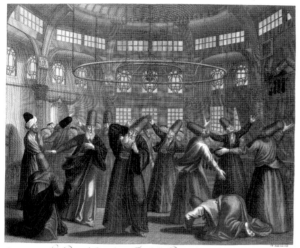

Les Dervichs dans leur Temple de Pera, achevant de tourner

◄ A 19th-century French print of Sufi dervish-dancers. According to belief, dancing in this way allows the soul to communicate with the Divine and blocks out any external distractions.

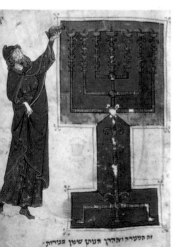

◄ **Clockwise from Left**
'The Wailing Wall' painted by Wassilif Ivanowitsch Navosoff (1798–1865). This is the remains of the temple destroyed by the Romans in 70AD, and is the most holy place in the Jewish world.

This 11th-century marble pillar comes from a Jain temple in India. It is richly sculpted with deities and dancers, allowing a structural necessity to become a thing of beauty.

'Aaron Lighting the Menorah', c 1280, from the North French Miscellany. The pattern for the Menorah was given by God to Moses. Here it is painted and annotated in Hebrew by Benjamin the Scribe.

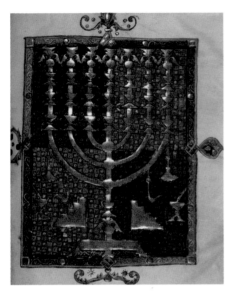

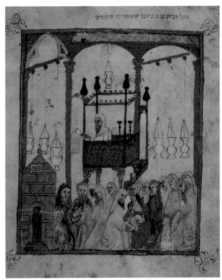

▲ Left to Right

This carpet page from the Duke of Sussex Catalan Bible, c 1350–1375. depicts the seven-branched menorah.

Inside a synagogue, c 1350. A view of the service in a book to be read on Passover Eve.

▶ Angels pour gold over the Taj Mahal at Uttar Pradesh, India. The building holds a marble screen bearing the 99 names of Allah. Persian text and floral decoration add to the richness.

▼ The Helan Jingu shrine, a Shinto temple in Japan.

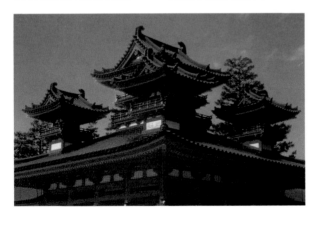

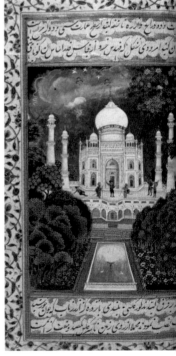

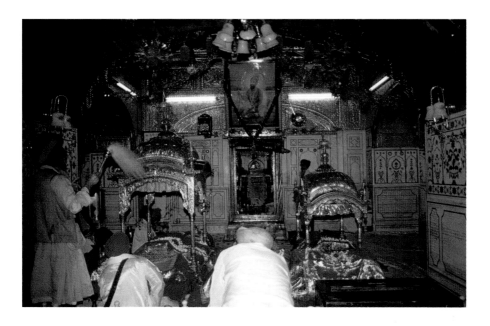

▲ Worship inside a richly decorated Sikh Guruwara temple in India.

▼ The Golden Temple, or Darbar Sahib, in Amritsar, India. This is a Sikh holy place.

▼ This nine-sided Baha'í temple in Illinois, USA, is decorated with elaborate carvings.

▼ A Baha'í temple looks splendid in the sunshine. Baha'í religious life centres around personal acts of devotion, often in the home.

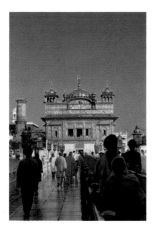

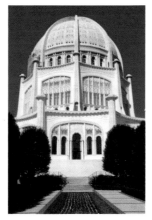

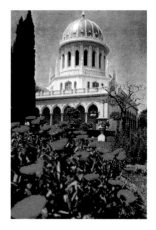

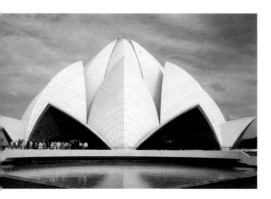

▲ Left to Right
The lotus symbol is used in the
architecture of a Baha'í temple
in New Delhi, India. In Hinduism
the lotus represents beauty and
nonattachment; in Buddhism it
signifies spiritual purity.

▶ Opposite
An 11th- or 12th-century
figure of Avolokiteshevara,
the Bodhisattva of compassion.
Known as Guanyin in China, it is
a symbol and an expression of
total serenity.

▼ A 19th-century Burmese
folding book tells the life of
Buddha; in this scene of deities
one god holds a shell, which
stands for a conqueror.

▼ Here an enthroned Buddha
is accompanied by two
attendants holding tiered
parasols, showing spiritual
power and protection.

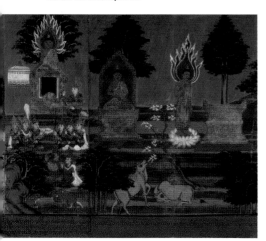

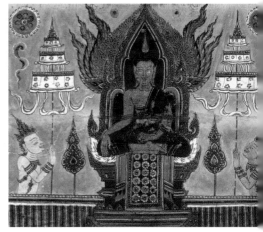

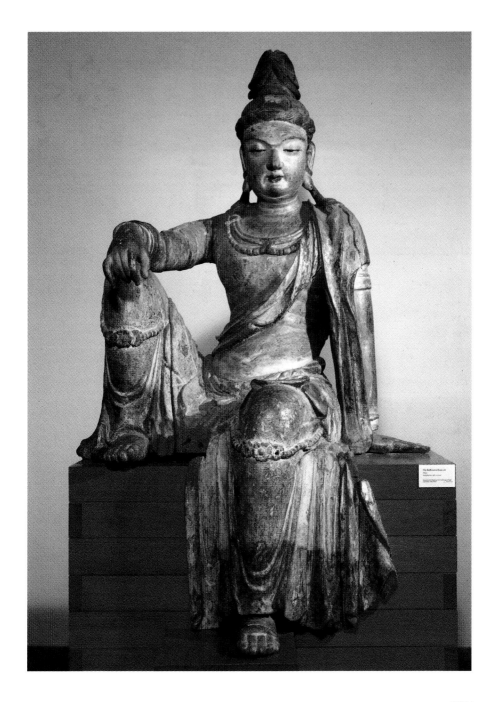

◄ A portable shrine from 19th-century Tibet. Monks on the move use it as a focus for prayer and meditation. The open doors reveal the Buddha, along with various deities.

▼ This massive reclining Buddha in Rangoon, Burma, dwarfs the child in the foreground.

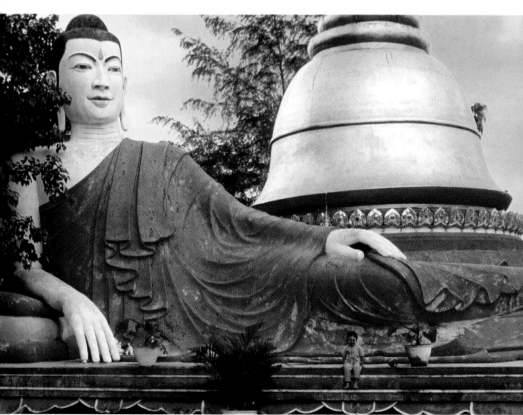

▲ A brightly coloured Buddha carved into a rock face in Tibet.

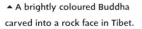 A carved relief in Borobudur, Java, which is the world's greatest Buddhist monument.

▲ An artist's impression of the world's biggest Buddha, under construction in India. Its size is intended to have an immense impact on those who see it. The figure is shown with his feet in a lotus flower, symbolic of those who attain enlightenment.

▲ A Golden Buddha of Sukhotal in Wat Trimitir, Bangkok. The *Lakshana Sutra*, an Indian text, lists 32 distinguishing features marking a Buddha; one states that his complexion is golden, another that no dust can adhere to his body.

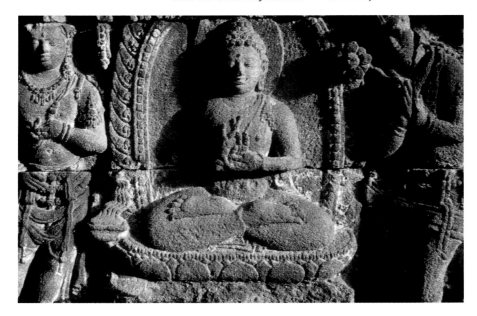

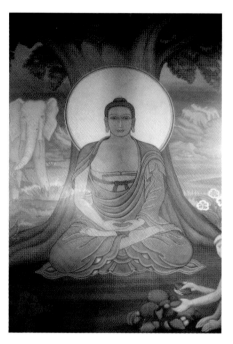

▲ This painting from India shows offerings being made to the Buddha as he sits beneath the Bodhi tree, a place of enlightenment.

▲ Worshippers bring lotus flowers, symbols of purity, to honour the Buddha.

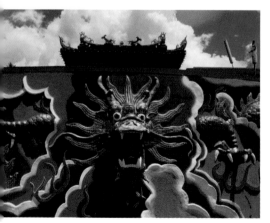

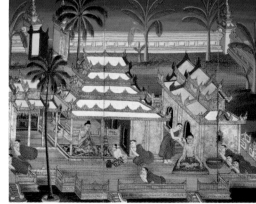

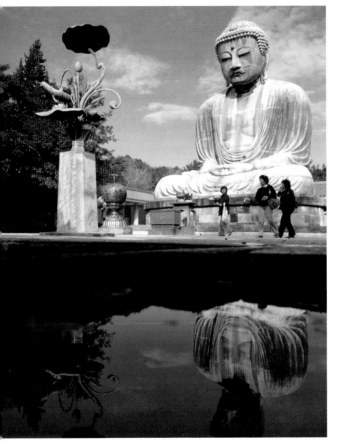

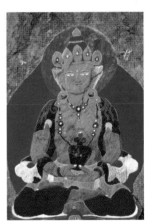

◀ **Opposite Left to Right**

Tua Pek Kong Taoist Temple in Sarawak, Malaysia, built in 1876. The design shows a Chinese influence.

This page, from a 19th-century book of Buddhist cosmology, shows monks at prayer and deep in meditation.

▲ A statue of the Buddha in Honshu, Japan, is reflected in calm water. The head tilts slightly forwards in a reflective pose.

▲ **Top to Bottom**

This bronze face of the Buddha, from Bangkok, is polished to a highly reflective surface and the gaze is contemplative.

A roadside painting on stone, near Lhasa, Tibet, marking pilgrim routes. It shows the Buddha's head like a royal turban and a mole between his blue eyes.

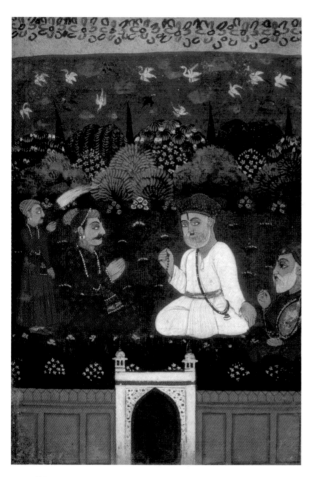

◀ Guru Nanak, founder of Sikhism, sits with prayer beads, while Mardana, the musician with his mandolin, and King Shivanabh kneel in the gesture of devotion.

◀ A c 1760 depiction of the marriage of the Hindu gods Vasudeva and Devki in the presence of a group of holy men. From the Bhagavata Urana, Pahari and Sikh School.

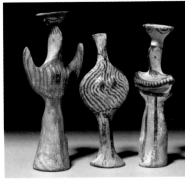

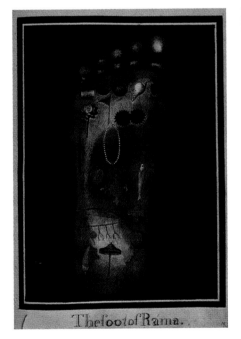

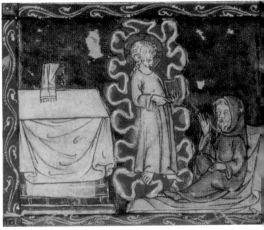

▲ 'The Foot of Rama', from the Hindu epic *Adhyatma Ramayana*, based on the original *Ramayana* by Valmiki. Some of the signs depicted here are among the Eight Auspicious Symbols of Buddhism – the parasol, fish, treasure vase, lotus, conch shell, endless knot, victory banner and wheel. The footprint of a holy person is a treasured mark.

⬥ **Left to Right**
This artwork shows a 19th-century seance, an attempt to communicate with the spirit world.

Three Mycenaean figurines from Greece, *c* 1400–1200BC. The flattened headdresses, called *poloi*, indicate they may be goddesses, perhaps for a local or domestic shrine.

▲ From a manuscript *c* 1300–1350. Christ appears in a cloud to a monk, who is clearly astonished; he was meditating before the altar when the very object of devotion appeared, book in hand.

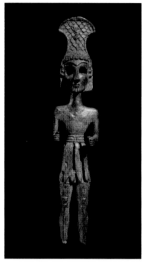
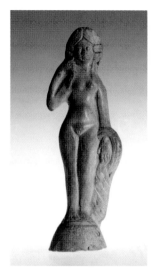

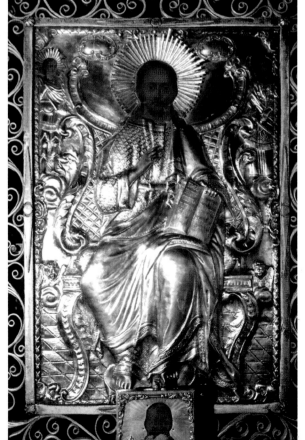

⌃ Left to Right

Sacrificial gifts would have been
hung on this Lapp idol, or *seide*.
Seide were oddly shaped pieces
of natural material. From the
Nordiska Museum, Stockholm.

A bronze Canaanite figure
of a warrior, *c* 2000–1700BC,
thought to have been either a
deity or a votive offering given
when asking a god's favour.

A clay votive figurine of Venus,
given as payment to the deity,
and possibly connected with the
cult of the water goddess.

◄ A Romanian icon serves
as a focus for devotion, aiding
in prayer and meditation.
Here Christ is shown giving
His blessing.

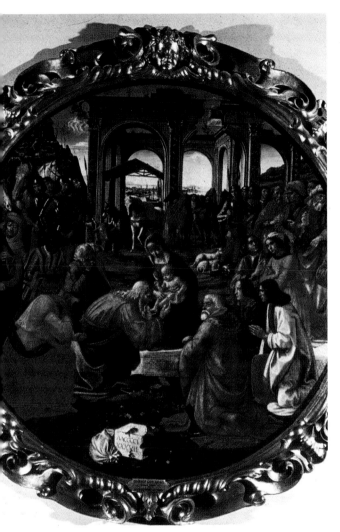

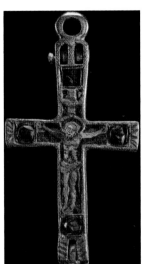

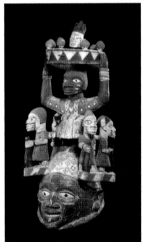

▲ 'Adoration of the Magi',
1488, by Domenico Ghirlandaio
(1449–1494). By painting this
scene, the artist has used his
talent as an act of adoration; the
viewer participates in adoration
by looking at the work.

▲ **Above Right**
Wearing a pendant such as this
medieval crucifix proclaims
one's faith and reminds the
wearer of God's presence.

▲ This wooden mask from
Nigeria, representing hierarchy,
would have been used in a
ceremony to worship gods
and ancestors.

Cosmology of God

Cosmology is the concept of the world as a meaningful whole and implies an underlying force that keeps all in order. To people of faith, the idea of pleasing God and being judged as good is all important if we are to earn our place in paradise, achieve salvation, enlightenment, *moksha* or nirvana. All religions believe that we are responsible for our thoughts and actions and that how we behave has bearing on our future. Therefore, the sections here are 'God's Displeasure and Judgement', followed by 'Images of Heaven'.

FROM THE GARDEN OF EDEN

We begin 'God's Displeasure and Judgement' with a return to the Garden of Eden. In the opening picture we see the fruits of creation as envisaged by the Abrahamic faiths, the garden is complete, peaceful and beautiful. Adam and Eve have received their instructions from God, but already they have met the snake and been tempted into disobedience and risking God's displeasure. A blackened corpse in the foreground acts as a stark warning and makes the message clear: to disobey God is to invite terrible consequences.

The faiths have various ideas about the process of judgement and many of them involve coming before God to account for our actions. Weighing scales play a symbolic role in the judgement process and have done so since the ancient Egyptians weighed the heart of a departed person against the mass of a feather! In early Judaism, judgement was exercised on people as a whole, not on individuals. This developed into the eschatological idea of judgement at the end of time with the coming of the Messiah. Christians furthered this and consider Christ to be the agent of God's

judgement, while the Qur'an, too, is clear about there being a judgement and uses the analogy of weighing scales. Similarly Baha'is believe that God's attributes are present in our immortal souls, which must be pure enough to allow fruition, leading to heaven; failure will be hell. According to tradition, hell may be thought of as loss of contact with God or it may be a place of punishment.

Zarathustra brought the idea of ethical dualism to the Zoroastrian faith. Ahura Mazda is the 'Wise Lord' and Angra Mainyu the destructive spirit. Those whose good deeds and thoughts outbalance the bad in them will be allowed to cross the Bridge of Judgement into a paradise, but wrongdoers will fall off and land in a stinking pit of torment. This is not unlike a 12th-century icon, where sinners are pulled off a ladder by demons but the righteous reach heaven at the top. These images of judgement and hell tend to be vividly descriptive and one cannot help feeling that the artists took their cautionary work very seriously indeed.

In Asian religions there is a belief in karma, which dictates that actions have ongoing consequences affecting rebirth or reincarnation. In Hinduism, at reincarnation a person is allocated to one particular caste by Shiva and to change caste would be seen as going against that judgement. In Buddhist cosmology, hell is the lowest of the Six Realms, in the never-ending cycle of rebirth called *samsara*. A wicked life can result in rebirth occurring in one of the levels of hell – the deeper the level, the worse it is for you. In some Buddhist traditions such as those in China, Korea and Japan, a Bodhisattva has the power to rescue souls from hell, while in others prayers of loved ones bring release.

TOWARDS PARADISE AND ENLIGHTENMENT

And so we come to 'Images of Heaven', and on the opening page we can clearly see common ground between religions in the visual representations of circles within circles. However, closer inspection reveals the differences. The Buddhist Wheel of Life shows the realm of the deities where celestial beings enjoy freedom and health, but as we move around the wheel we come to other areas where existence is not so wonderful; images of hell are seen within the same picture as heaven. The whole is held by a demon who represents impermanence.

Across the page we see a mandala, a cosmological diagram used by Hindus, Jains and Buddhists as an aid to spiritual enlightenment, by representing the sacred dwelling places of the enlightened ones or deities, and then we move on to see Dante's illustration of Paradiso, where a swirl of angels moves around a fixed point of light. These pictures set up an almost hypnotic effect that is conducive to meditation. This is not unlike the idea of icons, although a different form of visual language is used by icon painters. Long used to gain a spiritual insight into heaven, the English painter Brother Aiden says of icons, 'They mediate between heaven and earth, the visible and the invisible. They are a window to Paradise.' This means that we can be pulled into the image and through to a new awareness. Elsewhere in this section we see Buddha in *parinirvanasana*, which indicates his death and release from the cycle of rebirth, and we see Christ enthroned in heaven, surrounded by angels and greeting the souls of the righteous; clearly here is a place of reunion, not isolation.

God's Displeasure and Judgement

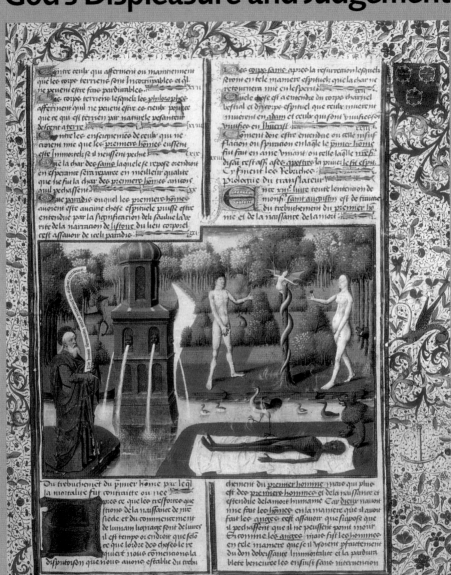

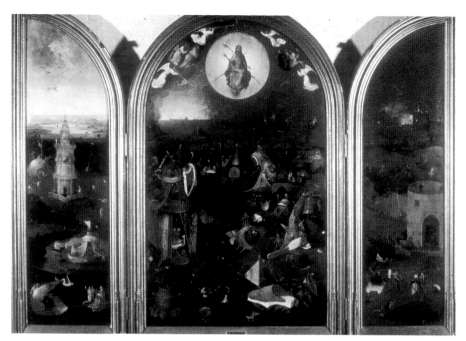

▲ In 'The Last Judgement' by Hieronymus Bosch (1450–1516), Christ is throned in glory in the centre but the side panels show the folly and evil of mankind.

▶ A 1716 engraving shows that although God is angry with most of His people, He spares those with whom He is pleased.

◀ **Opposite**
Adam and Eve provoke God's displeasure in a 16th-century French manuscript, while He points to a corpse – a warning of what will befall them if they cross the boundary that has been set for their own good.

LA NOUVELLE JÉRUSALEM.

Si tu hais le péché, de la croix charge toi,
Marche avec courage, soutenu par ta foi,
Suis-moi sur le chemin pierreux, plein d'épines,
Qui te conduit au Ciel aux délices divines.

Si tu crains ici-bas, les soucis, la fatigue,
Et tu ris des conseils, que fait Dieu te prodigue,
Prends le chemin facile des plaisirs matériels,
Qui te mène à l'Enfer aux tourments éternels.

▲ A popular lithograph shows Christ waiting to welcome the saved into heaven, while the sinners make their way to hell.

▶ A'isha and the dogs of Al-Haw'ab. A'isha, a wife of the prophet Mohammed, disobeyed him and rode off on a camel, causing the dogs to bark. She is shown hidden in the howdah.

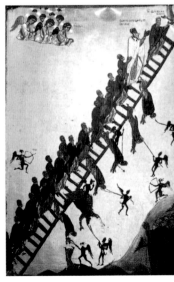

▶▶ An icon with the heavenly ladder, from the late 12th century. The sinners fall foul of demons, waiting to pull them away from the path to salvation.

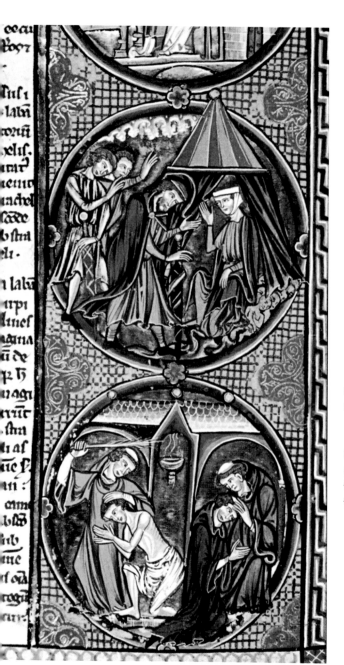

▲ The Philistines offer Saul's
armour to a false God in this
illustration from a Bible, c 1804.

◀ Laban searches his daughter
Rachel's tent for household
goods she had stolen. Taken
from a French manuscript dating
from the 13th century.

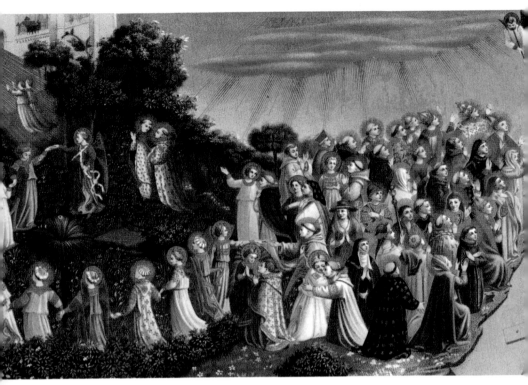

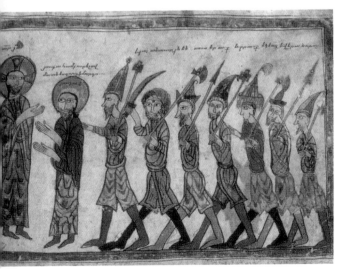

▲ A lithograph after a fragment of 'The Last Judgement' by Fra Angelico (1395–1455).

◄ An Armenian Gospel, dated 1306, describes Judas's betrayal of Jesus with a kiss, in the Garden of Gethsemane.

▶ **Opposite**
A mid-12th-century Shaftesbury Psalter portrays the archangel Michael carrying souls to Christ.

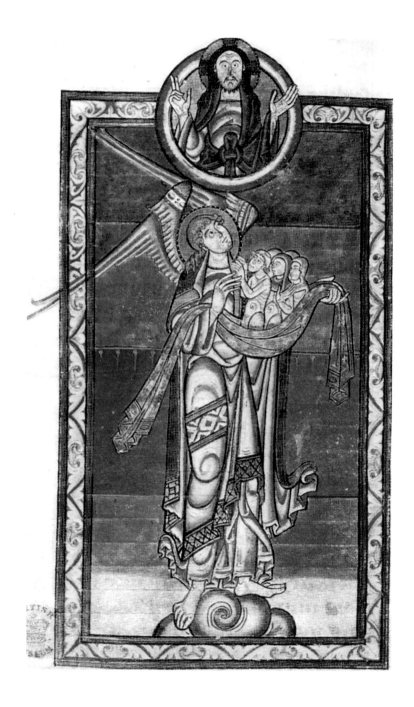

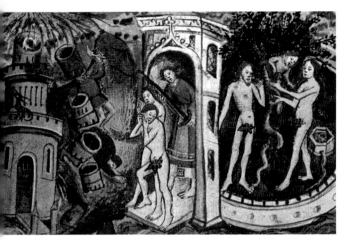

▲ **Left to Right**

This miniature from an English manuscript, dating from *c* 1450, shows Adam and Eve being sent from Eden after they had disobeyed God and eaten of the forbidden fruit.

God the Father and the Lamb wait in heaven to greet the righteous. After a 14th-century Armenian Bible.

▶ Angels regard those in limbo, who are the just who died before Christ. From the 'Natural Philosophy' section of *The Philosophical Pearl*, edited by Gregor Reisch, *c* 1503.

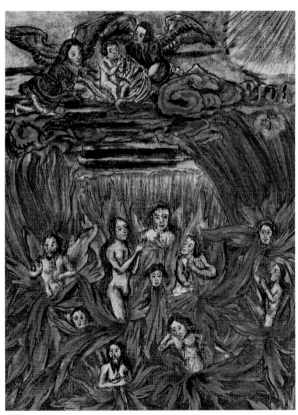

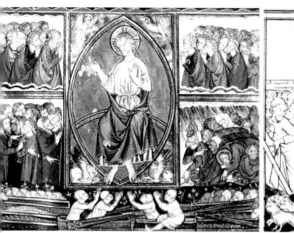

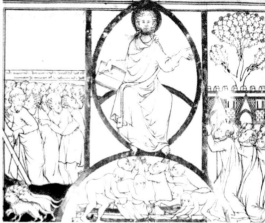

▲ Left to Right

A 13th-century English manuscript shows the dead reaching for heaven while God sits in judgement.

The just greet the words of Christ with enthusiasm but the sinners in this 13th-century English manuscript appear fearful of them.

▶ A 16th-century Arab manuscript shows an Islamic angel physically weighing the souls of the dead.

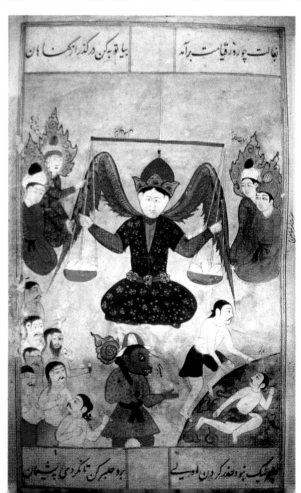

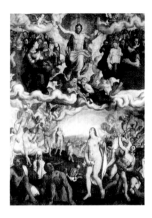

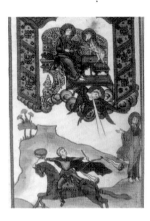

▲ 'The Last Judgement' by Pierre Porbus (c 1523–1584). The righteous enter glory but unrepentant sinners are turned away.

▲ The Judgement scene in the Holkham Bible, c 1350, paints an unhappy future for the sinners.

▲ Bearing the scales of justice for use in the Last Judgement, a horseman gallops to God the Father and God the Son. From an 18th-century Russian Bible.

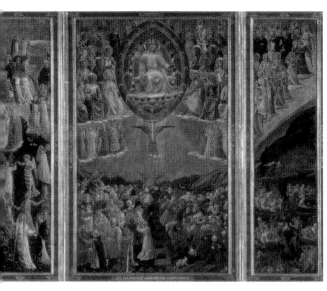

◀ In a triptych of the 'Last Judgement' by Fra Angelico (1395–1455), hell occupies one side, Christ is in the middle and heaven is on the other.

▶ 'Death before God the Judge', by the Rohan Master (c 1418–1425), the anonymous illustrator of *The Rohan Hours*. At the top, the archangel Michael is evicting Lucifer (the Devil) from heaven.

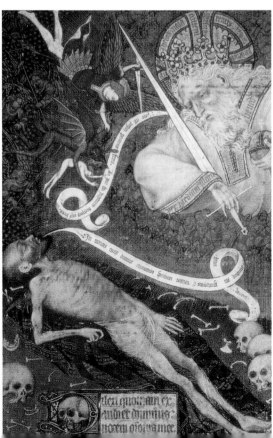

◀ **Opposite**
A detail from the window of the Good Samaritan at Chartres Cathedral, France, where the 13th-century stained glass describes God's announcement of the Redemption of the world.

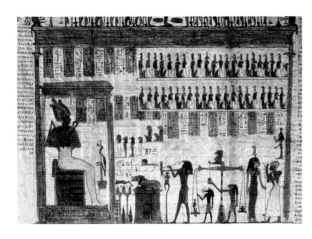

◀ Here, in the Egyptian Book of the Dead, 332–330 BC, souls are being weighed.

▼ **Left to Right**

In a 13th-century psalter, the scales of justice are shown in one panel and the righteous in paradise in another.

'The Universal Judgement' from Michelangelo's ceiling in the Sistine Chapel.

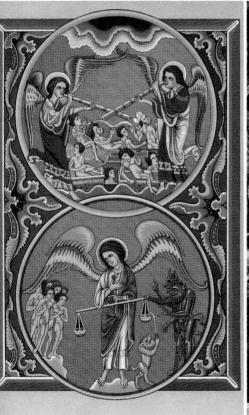

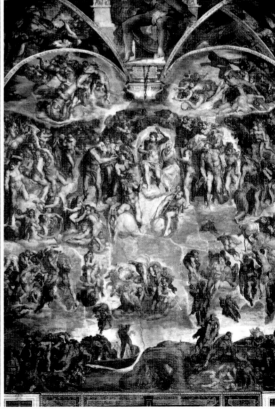

▸ A 14th-century interpretation of two scenes from the Old Testament: in the first Lamech kills his son, while in the other Noah is warned of the Flood. From the Holkham Bible, *c* 1350, at the British Library.

▾ Left to Right

Christ sits in a mandorla, within a rainbow, establishing His place in the heavens. Below Him are the sinners, unhappy at being separated from Him. From a late 13th-century Bible illustration.

This depiction of Noah being spared the harsh judgement meted out on the rest of the world comes from a 19th-century French woodcut.

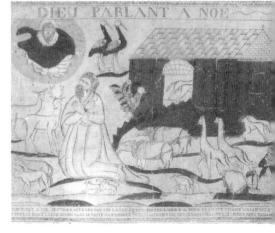

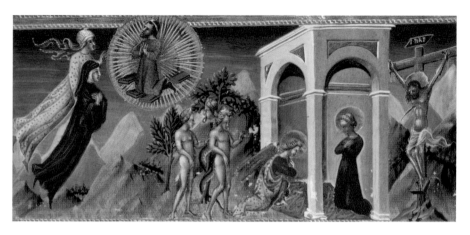

▲ The 'Mystery of the Redemption', from Dante's *Divine Comedy*, c 1309–1321. God is within a sphere of light addressing two figures, Adam and Eve, with the Tree of Knowledge and the Serpent. To the right, an Annunciation scene with Jesus hanging on the Cross.

◀ God warns Adam and Eve about ignoring His word and causing His anger, in a section from the 13th-century 'Good Samaritan' window at Chartres Cathedral, France.

◀◀ God sends an angel to expel a cowering Adam and Eve from the Garden of Eden in an illustrated Bible scene.

◀ In this 19th-century Bible illustration an angel bearing a glowing sword expels Adam and Eve from Eden.

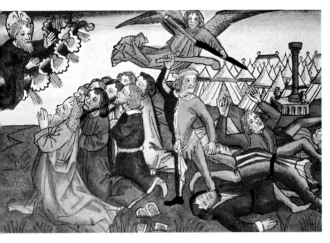

◀ The downfall of the figures on the right in this scene from the Nuremberg Bible, *c* 1439, has been caused by idolatry. Those to the left, meanwhile, turn to ask God's forgiveness.

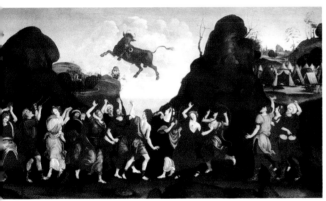

◀ 'The Worship of the Egyptian Bull God' was painted by Filippino Lippi, *c* 1500. The god Apis, identifiable by a crescent moon on his shoulder, disports himself above the music and dancing of those who idolize him – worship that was in direct conflict with God's law as given to Moses.

◀ An 18th-century print shows the worship of false gods as the source of God's displeasure. The golden calf, fish-tailed dragon and fire demon are among the offending objects of attention.

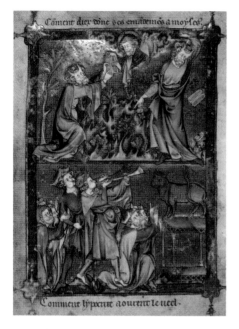

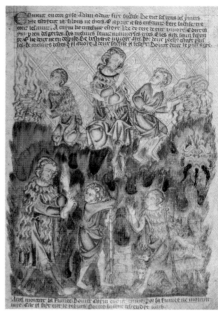

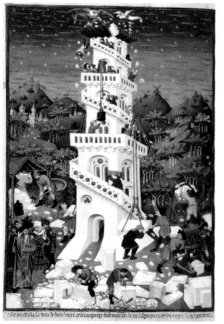

▲ Left to Right

From the illuminated manuscript, *La Somme le Roy*, *c* 1295. Moses is shown receiving the Ten Commandments from God, and then breaking them by worshipping the Golden Calf – no wonder he is portrayed with horns.

Event and outcome are shown on the same page of the Holkham Bible, *c* 1350. Look at the inverted evil face in Cain's fire, and then see him being admonished by God.

◀ 'Building the Tower of Babel', from a French miniature, *c* 1300. Here, God sees the people building the tower and decides to confound their vainglory.

◄ The construction of the Tower of Babel, as seen by van Cleve, (c 1525–1589). The building of the tower prompted God to scatter the people who built it and jumble their language.

▼ **Left to Right**
Made in Ceylon during the 18th century, this enshrined Buddha shows the right hand with thumb and finger touching, indicating discussion.

A depiction of the martyrdom of St Andrew, which took place c 70AD, from a Spanish Book of Hours. God's judgment awaits, as He watches from on high.

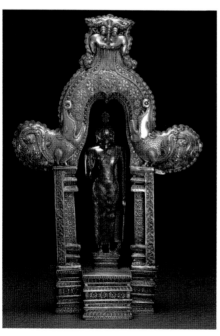

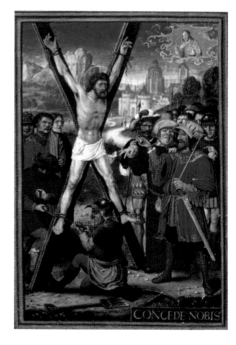

143

▲ This 14th-century illustration of the Apocalypse shows God looking on, upper left, as Satan is defeated and cast back down into hell.

▲ Loki, the Scandinavian god of mischief and destruction, tricked Hoder, the blind god, into causing the death of Balder, son of Odin, resulting in the twilight of the gods.

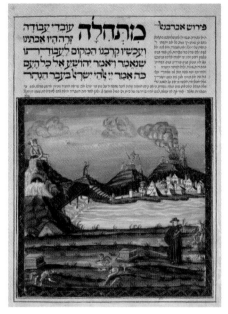

▲ In this early 18th-century manuscript, devils interfere with the confession of the penitents. Notice how a woman in the bottom picture has her mouth stopped by a devil's hand.

◀ **Opposite Left to Right**
The sinister scene of a witch's sabbath is the subject of this engraving, after David Teniers the Younger (c 1610– 1690) .

The Tower of Silence in central Iran. It is a place where the Zoroastrian dead were thought to defile neither earth nor fire.

▼ **Below Right**
A clay mask of the demon Huwawa from Iraq, dating from 1800–1600BC. In Mesopotamia, the future was predicted by studying the shape and colour of animal organs. Records were then compiled of the omens and the events they predicted. According to a cuneiform inscription on the back, this mask records the form of some intestines.

▲ The destruction of idols is shown here in a Hebrew service book dated c 1740, copied and illustrated by David Leipnik.

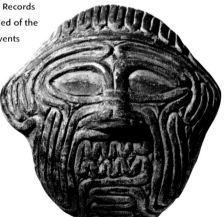

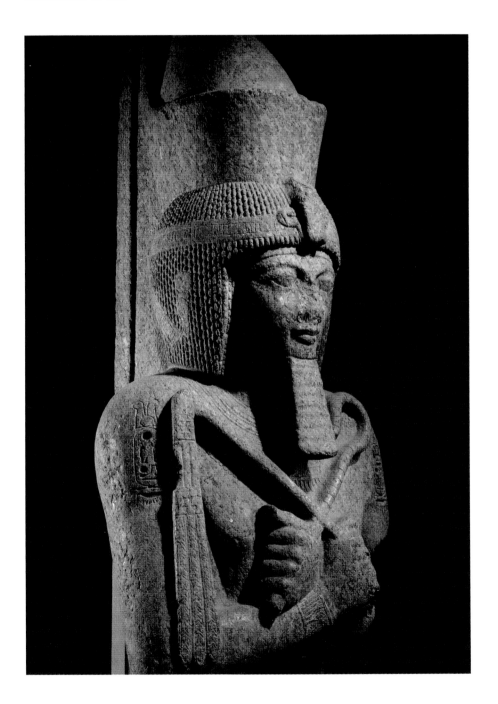

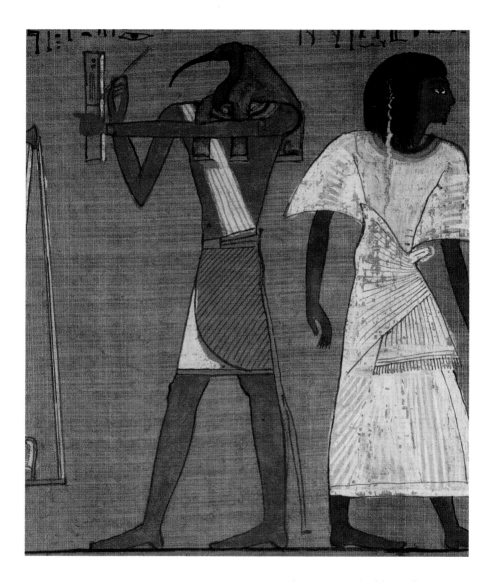

◄ **Opposite**

Ramses II, c 1250BC, wearing the two crowns
of Upper and Lower Egypt. He holds a crook and
flail, which represent power over his subjects,
while the cobra, or *uraeus*, on his brow will attack
anyone who opposes him.

▲ From the Egyptian Book of the Dead, c 1275BC,
the Ibis-headed god Thoth, who would attend
the judgement of the deceased. To the left of the
picture it is possible to see part of the scales on
which the heart of the deceased would be
weighed against a feather.

Images of Heaven

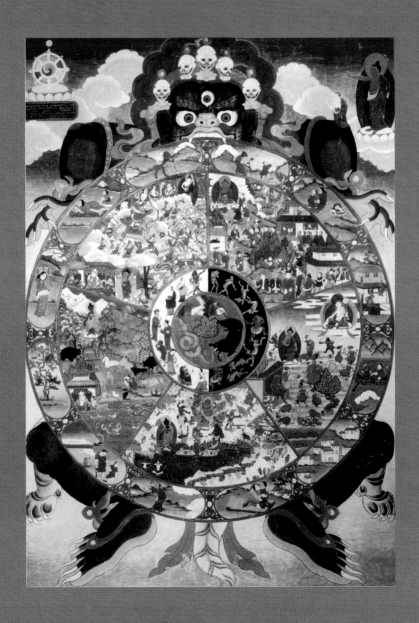

▸ A 20th-century Tibetan Buddhist mandala. Representing the universe, every mandala follows a precise pattern of symbolism deemed by Buddhists to be auspicious. The circular design is an aid to ceremony and to meditation.

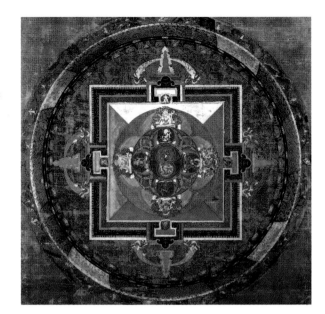

▸ 'Paradiso', Dante's description of the circles of heaven in *Divine Comedy,* is represented here by the famous illustrator Gustave Doré (1832–1883) as a vast swirl of light and angels.

◂ Opposite
The Wheel of Life represents the cycle of *samsara* – rebirth and, ultimately, liberation. Here the Wheel is held by Shinje, the Hindu Lord of Death. The pattern includes the god-realm at the top, a place of luxury and sensual delight.

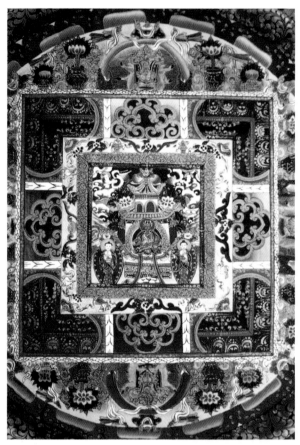

◀ A Buddhist Wheel of Life from Kathmandu. People with good karma will be on their way to Nirvana, a state of absolute blessedness and complete non-attachment that marks a release from reincarnation and existence.

▼ **Left to Right**
A gilt bronze mandala from China, from the 17th–18th centuries. Being in the form of a lotus flower, which reaches above the pond to air and sun, it represents those who float free of ignorance to attain enlightenment.

A stone sculpture of Buddha, from Dazu, China, dating from the 9th–13th centuries. Here we see Buddha entering Nirvana in a state of bliss.

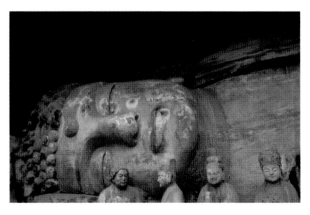

▸ The death of Buddha brings monks with their heads bowed in prayer, while women attend with flowers and banners.

▾ Left to Right

This figure was made in China in the early 15th century. The Buddha's pose indicates that he has just overcome temptation and gained peace and truth.

Cave 26 at Ajanta, India, known as Nirvana of the Buddha, is where this Buddha rests his head on a pillow. His expression is peaceful – an outward manifestation of perfect spiritual enlightenment. The sculpture is dated 485–500AD.

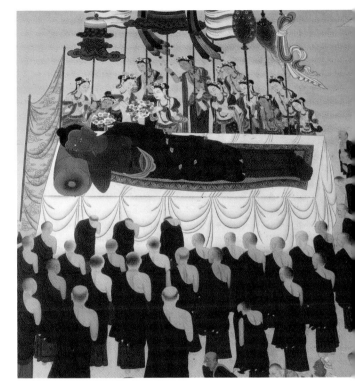

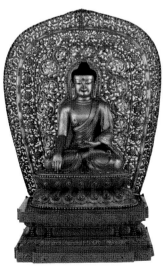

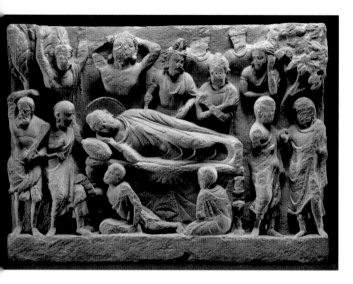

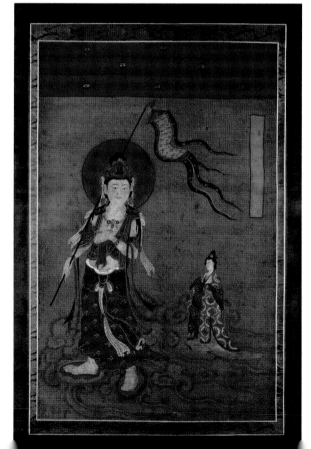

A panel relief, dating from the second century, shows Buddha's passing from this world. His haloed head rests gently on a pillow in a pose known as *parinirvanasana*.

'The Paradise of Shakyamuni', an early ninth-century vision of the seated Buddha, wearing the sun and moon on his robes, and with his hands in the gesture of preaching, while all around him are musicians and dancers.

◀ An early 10th-century depiction of Avalokiteshvara (the Buddhist who 'looks in every direction' and the guide of souls). It is he who leads the faithful on their way towards Nirvana.

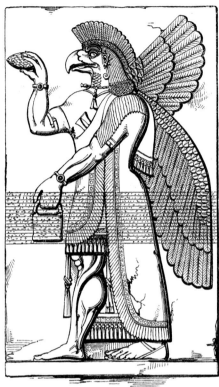

▲ A 10th-century portrayal of Vaishravana, a protective guardian-king of the Buddhist faith, patrolling his domain with heavenly troops. He lived in the Heaven of the Four Great Kings.

▲ This engraving is based on a relief excavated at Nimrud, Iraq. It shows the Assyrian god Nisroch – the human-bird – holding a pine cone, which symbolizes regeneration.

▶ The death of Buddha, as illustrated on an 18th-century Japanese manuscript.

◄ A jade mountain scene from 18th-century China shows the world in miniature. In Taoist thought the mountains are home to the Immortals; thus they represent paradise and everlasting life.

◄ This vase shows heavenly figures walking in the clouds. It comes from the Zhejiang Province in China and dates from some time after 960AD.

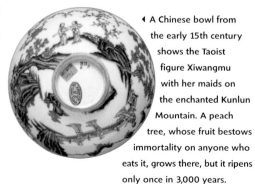

◄ A Chinese bowl from the early 15th century shows the Taoist figure Xiwangmu with her maids on the enchanted Kunlun Mountain. A peach tree, whose fruit bestows immortality on anyone who eats it, grows there, but it ripens only once in 3,000 years.

▲ A 14th-century Japanese mandala scroll painting shows a gathering of Buddhist deities and shrines.

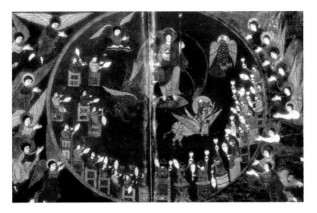

▲ In this 11th-century Latin manuscript, from the *Apocalypse of St Sever*, Christ is shown in heaven, surrounded by evangelists, angels and elders holding chalices.

▼ 'The Saviour', a detail from an early 15th-century Svenigorod Ikon, by Andrei Rublev. Looking directly into the face of Christ like this can be seen as a gateway to meditation and elicit a vision of heaven.

▲ From a family Bible, dated 1907, this scene shows angels leading the righteous to heaven, where they will join the Holy Trinity in paradise.

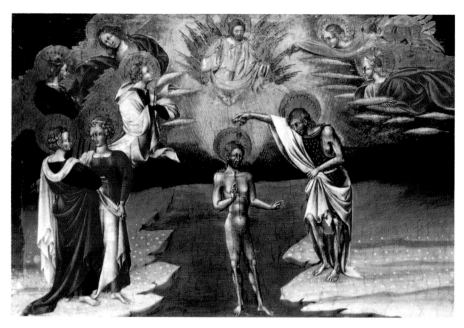

▲ The 'Baptism of Jesus', c 1500, describes an earthly event, but locates the scene in a heavenly setting, implying that the baptism had far-reaching implications.

◀ A sixth-century glass mosaic in the cupola of the Baptistery of the Orthodox, Ravenna, Italy. The central scene is the Baptism of Jesus – once again set in a heavenly realm.

⬆ Christ ascends to heaven,
supported by angels, after an
Armenian manuscript c 1287,
with calligraphy by Ovannes.

▲ A 19th-century depiction
of the Seven Charitable Deeds.
Christ appears at the bottom in
earthly form and at the top as
the Risen Lord.

⬆ Christ in splendour between
angels, from the 13th-century
Good Samaritan window at
Chartres Cathedral, France.

▲ 'The Triumph of Orthodoxy',
an icon c 1400. The Virgin and
Child are shown above the
earthly figures, with angels.

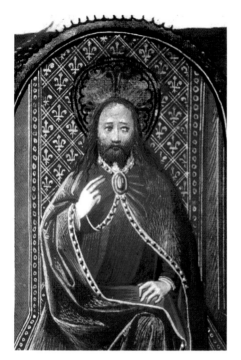

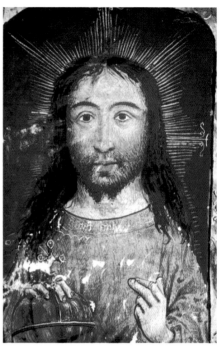

▲ A 15th-century manuscript depiction of Christ enthroned as king, wearing rich robes, and with an elaborate halo.

▼ The celestial garden from Dante's *Divine Comedy*. Here the heavenly choir sing praises to the Virgin and Child.

▲ This fresco, *c* 1400, presents a humble image of God – with a direct gaze, a halo, and carrying the orb.

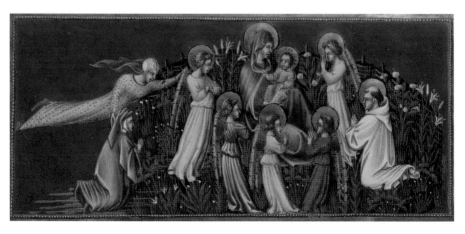

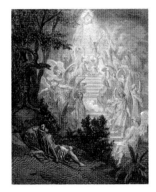

▲ 'The Adoration of the Lamb' from Gustave Doré's 1865 *Bible Illustrations*. Here God is shown with Jesus, the Lamb, at His feet.

▲ A page from the Bedford Book of Hours, *c* 1423, shows the two-faced god Janus (see centre right), the Roman god of doorways and keeper of the gates of heaven.

▲ Dore's Bible illustration of Jacob's dream, in which Jacob saw a stairway leading to heaven, lined with light and angels, and with God waiting at the top.

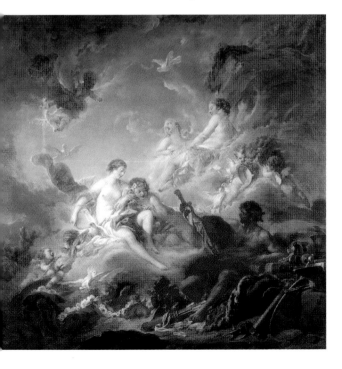

◄ 'Vulcan Presenting Venus with Arms for Aeneas' by François Boucher, 1757. The god of fire and metalworking comes under the spell of the goddess of love. In this swirl of doves and cherubs, Boucher panders to the bourgeois desire to acquire a 'heaven on earth'.

▸ In this painting, after a mosaic in Constantinople, we see Christ enthroned under the blue dome of heaven.

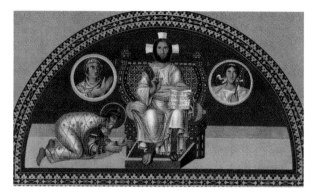

▸ Dante at prayer before Christ, who is encircled by rings of blue sky. From the *Divine Comedy*, c 1350–1360.

▸ In this scene from the Apocalypse, c 1290–1299, St John kneels before God, who reaches out to touch his hand, while guardian angels look on.

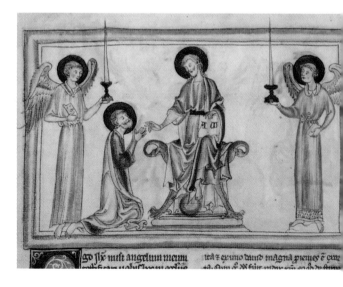

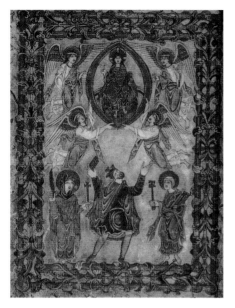

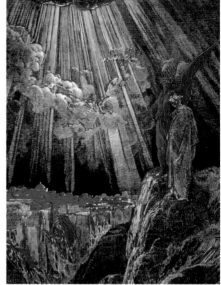

▲ In this 15th-century painting the Virgin and Child are shown in a heavenly setting above the mortals and among the angels, with the Father and the Holy Spirit above them.

▼ This 15th-century painting shows the penitent David with God sitting in heaven above him, as demons languish in hell, to the right.

▲ St John is shown a vision of the Holy City by one of the archangels in this 19th-century engraving after Doré.

▼ The 'Mural of Black Jesus' in Michigan, USA, by Devon Cunningham, 1995. Jesus is shown flanked by angels in heaven above the righteous' faces in the clouds.

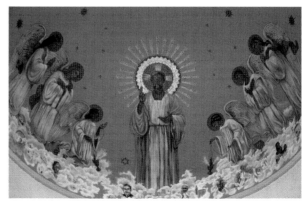

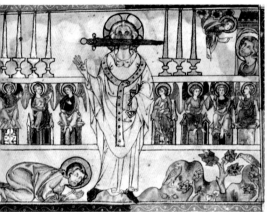

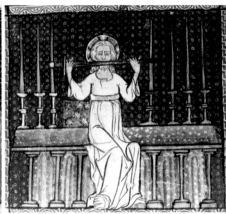

▲ Christ is shown here in a 13th-century representation of the Apocalypse. There are seven candles on the altar and Christ has a sword in His mouth, as described in the Book of Revelation I:1–16.

▼ A rich vision showing God in a blaze of glory with adoring saints and angels in attendance, dated *c* 1450.

▲ This interpretation of Christ, as described in the Book of Revelation, comes from the Seldon Apocalypse, *c* 1300.

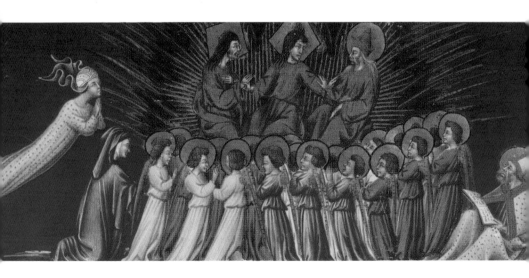

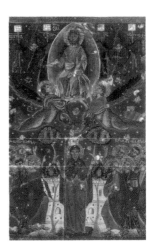

▲ In this 18th-century Russian miniature, angels with trumpets praise God the Father and God the Son.

▲ In the Silos Apocalypse, c 1109, we can see Christ enthroned in a heaven full of angels, colour and pattern. The Lamb, symbol of Christ, is venerated at the circle's centre.

▲ The Virgin Mary and the apostles are shown ascending into heaven with Christ, supported by angels. This copy, after an Armenian manuscript of 1356, is by Arakel and Karapet.

▼ After an Armenian manuscript of 1261, by Toros Rosline, the title page of this Gospel of St John shows the Ascension of Christ.

▼ A detail from 'Christ Glorified in the Court of Heaven' by Fra Angelico (1387–1455), displayed at the National Gallery, London. Forming only part of the Fiesole Altarpiece, which was painted from 1428–1430, it shows saints, angels and priests all facing the same direction.

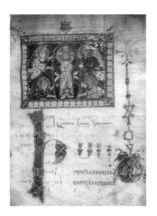

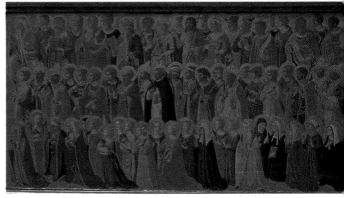

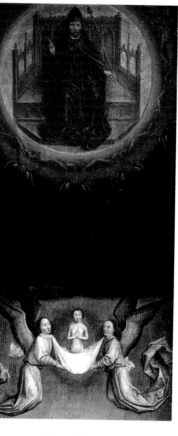

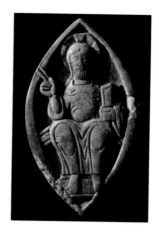

◀◀ A detail of 'The Soul of St Bertin Carried up to God', attributed to Simon Marmion, 1459. The saint, hands together in prayer, is lifted in a linen sheet by angels to the enthroned Father above.

◀ An Anglo-Saxon plaque carved from walrus ivory, dating from the mid-11th century. Christ sits in Majesty, on a rainbow.

▼ **Left to Right**
A gloriously colourful vision of Christ ascending into heaven, after an Armenian manuscript from 1356.

A gentler colour scheme is used in this view of the Ascension.

A scene from the Seldon Apocalypse, c 1300, shows the Book sealed with seven seals.

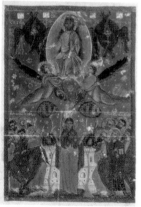

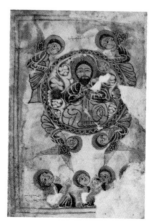

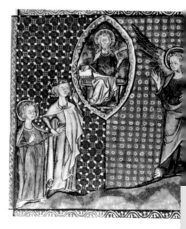

▶ **Top to Bottom**

A fresco in the Church of Chora, Constantinople, shows Christ helping Adam and Eve from their graves and into heaven.

In 'The Assumption of the Virgin' by Botticini, 1475–1476, the Virgin enters heaven while below the apostles marvel at her lily-filled tomb. Heaven is ranked with choirs of angels, and Christ holds a book with the characters for Alpha and Omega.

A late 13th-century view of heaven with the symbolic Lamb representing Christ. The whole picture, set out as a triptych, echoes the Holy Trinity.

▼ A page from the Silos Apocalypse, 1109, depicts God enthroned with the symbols of the four evangelists: the angel, eagle, bull and lion.

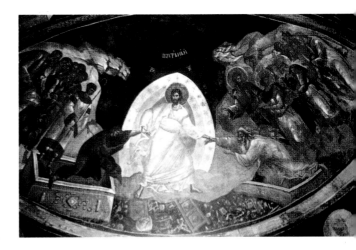

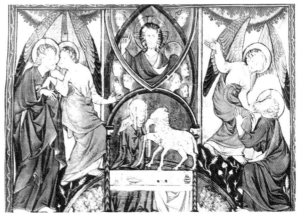

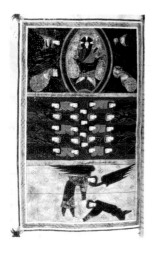

▲ The picture space is divided into three to echo the Trinity. Angels adore God, who is seated in a mandorla. From a Bible illustration, c 1350.

▲ An 18th-century Slavonic miniature shows God enthroned with the Lamb, attended by sun and moon, angels and elders.

▲ An 18th-century Slavonic miniature shows an angel appearing with a book to St John on earth, with Christ above in a mandorla with angels.

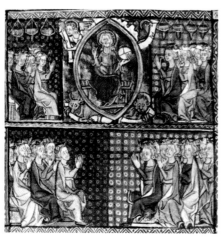

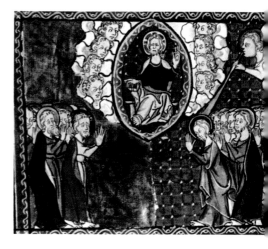

▲ From the Seldon Apocalypse, c 1300, a scene showing 24 elders surrounding the One who is seated, as described in Revelations. The seven lamps represent the seven spirits of God.

▲ This scene from the Book of Revelation, from a 14th-century illuminated manuscript, shows the seventh trumpet sounding in heaven and the 24 elders praising God.

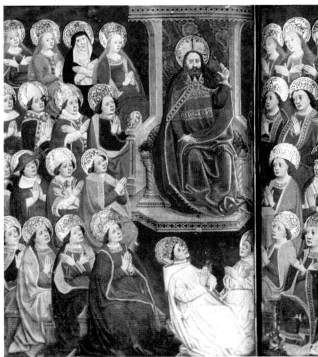

▲ God the Father sits enthroned and surrounded by saints, bishops and monks. The rich coloration and gilding gives an impression of heaven as being a place of grandeur and glory. From a Bible illustration, c 1400.

▶ Dante's glorious 15th-century vision of heaven shows God in the centre of a host of angels. They form a floating, flower-shaped structure, which is encircled by yet more angels.

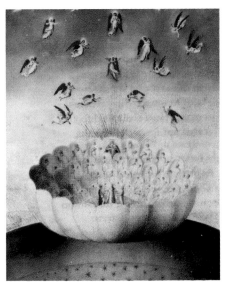

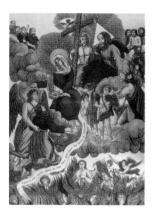 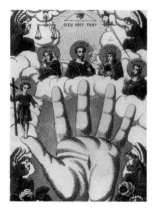

▲ In this 19th-century woodcut, souls released from purgatory are led by angels and welcomed into heaven.

▲ 'The Powerful Hand', a 19th-century woodcut, shows Christ's nail wound and, above, the Eye of God within a triangle of light.

▲ A 19th-century French print of Christ, the good shepherd, carrying a lost sheep, symbolic of a lost soul being saved.

▶ The *Nuremburg Chronicle*, c 1493. The earth is at the centre, while the universe and ranks of angels lead to God enthroned.

▼ By Hildegard of Bingen (1098–1179). Man is embraced by God and the macrocosm.

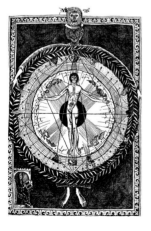

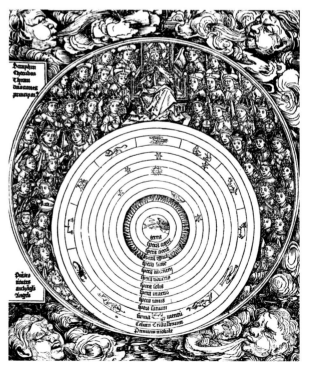

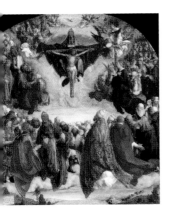

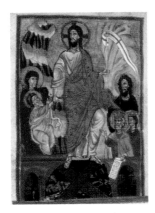

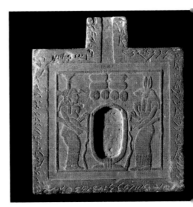

▲ 'The Adoration of the Trinity', painted by Albrecht Dürer in 1510, is a feast of colour and a dynamic composition.

▲ From a 13th- or 14th-century Armenian Gospel, Christ descends into purgatory to save the souls of the patriarchs.

▲ This sandstone offering table, from first- or second-century Sudan, shows a goddess and Anubis, the jackal-headed Egyptian god, pouring water on behalf of the deceased, to offer sustenance and refreshment.

▼ This Persian miniature shows Mohammed ascending into heaven. An angel points out the way for Buraq to take his master, and the earthly figures seem to be exchanging gifts.

▼ This Egyptian funerary headrest dating from c 1225BC is decorated with the god Bes, who would drive away night demons. His form is hideous and he is armed with a spear.

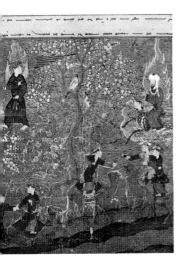

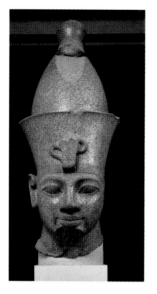

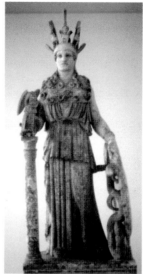

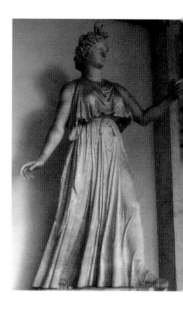

▲ King Ahmenhotep III, c 1350 BC. One of many statues the king commissioned of himself for his mortuary temple, for he believed that if the form were preserved, the life might be too.

▲ Pheidias, the fifth-century Greek sculptor, had a figure of Athena made for her shrine in the Parthenon; it was covered with precious materials. This is a copy made in marble.

▲ Juno, queen of Heaven, protected women and marriage. Here her figure is sculpted from pure white marble.

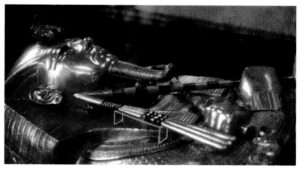

▲ Akhenatun, the Egyptian king, moved his court out of reach of the polytheist priests to focus instead on Aten, the solar god.

▲ Being richly adorned and well provided for in death assured the Egyptian god-king Tutankhamen of a comfortable afterlife. His gold sarcophagus illustrates the elaborate extent of this provision.

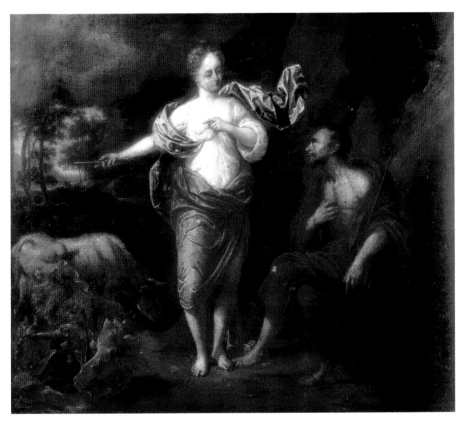

◀ Janus, keeper of the Gate of Heaven, looks both ways at the same time in his vigilance. His two faces, one looking forward and one back, watch over entrances, and his name is lent to the month January, the beginning of a new year. From a 1798 copperplate engraving.

▲ Juno, Roman queen of heaven, painted by the Dutch painter Arnold Houbraken (1660–1719). The jealous Juno asked Argos, man of a hundred eyes, to spy on ten beings who caused her envy. In other faiths, this action would not qualify her for heaven.

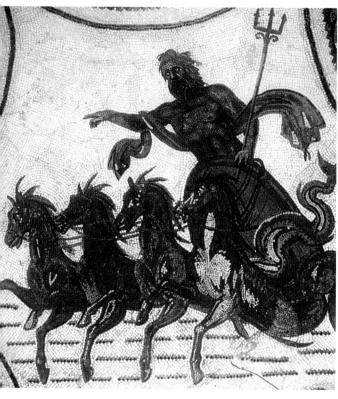

◄ This second-century Tunisian mosaic shows a triumphant Neptune, the Roman god of the sea, in a chariot drawn by horses with dolphin tails.

▼ **Left to Right**

Here, in a page from Keulen's *Chart Atlas*, c 1682, is King Neptune's coronation with people and creatures from all around the world.

In his 1847 fresco at Osborne House, Isle of Wight, Scottish artist William Dyce (1806–1864) shows Neptune handing his underwater empire to Britannia.

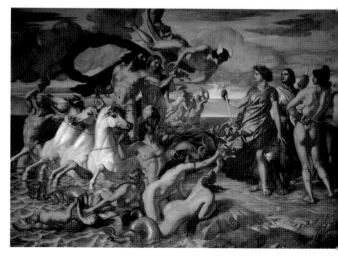

A WORD TO THE MERMAIDS.

▲ Neptune shouts orders to the mermaids. This print was produced in 1858 when the first transatlantic cable had been laid from Britain to America. Perhaps this intrusion into his realm has disturbed Neptune?

▼ Thetis, king of the Nereids (sea nymphs), appears here in his watery element, drawn by Hans Burkmair (1473–1531).

▲ Neptune creates the white horse, encouraged by mermaids and fishes, in this 16th-century miniature from 'Des echecs amoureux et des echecs d'amour' – 'The lovers pitfalls and the pitfalls of love'. Dolphins carry gods' souls and trumpets announce a ruler.

▼ This 15th-century manuscript displays the sun god – Helios to the Greeks and Apollo to the Romans – standing proudly in his realm.

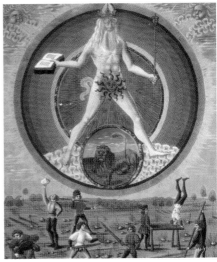

Forms of
the One

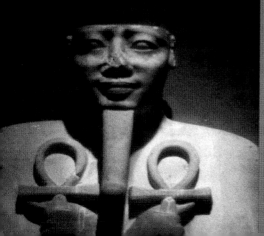

This section examines the many ways in which artists have expressed the variety of God's manifestations. 'The Unpersonifiable' considers the intangible aspects of the Divine. The power of the spirit is beyond human reckoning and thus artists have worked with the synecdoche, the part that represents the whole. In 'Words of God' we study His communication down the ages, in written and spoken forms – and in the purely visual.

GOD IN THE WORLD

Perhaps the easiest to grasp is 'God Among Us', which illustrates God made manifest in tangible, earthly form. The ancient Egyptians viewed their kings as divine beings who, at death, would return to the realm of the gods from whence they came. Christians believe that Jesus Christ took human form, came to earth and lived among us. The images that describe His story, from birth through His ministry and beyond death to Resurrection, cover a broad range of human emotion. Some of the work is simply descriptive narrative, while other more spiritual pieces deeply touch the soul.

Of course, the Buddha is of 'this' world, but as one who wants to align the minds of the faithful with things of the highest spiritual value. Born as a Hindu prince, Siddhartha was raised among riches and luxury, but driven by curiosity to look beyond the palace walls he saw the realities of poverty and hardship. On a later excursion he met a band of ascetics and, intrigued by their lifestyle, he slipped away from the palace and joined them in a life of meditation. He kept the Hindu notion of karma and finally reached a state of perfect enlightenment. From that point on he became known as Buddha, the Enlightened One.

THE UNSEEN ONE

Although the omnipresent spirit of God cannot be pinned down in palpable form, artists through the centuries have been inspired to invent ways of seeing that allow us to visualize the Unpersonifiable. Thus we find God's presence expressed as a face unconsumed by fire, or in shafts of light, or as represented by His prophets. In images of the Christian Holy Trinity of Father, Son and Holy Spirit, the Father is generally portrayed as an elderly man while the Son is either a younger man or, sometimes, a lamb. The Holy Spirit, however, having no physical form of its own, has had to be represented in other ways. In the New Testament at the time of Jesus's baptism, we read in Luke 3:22, 'The Holy Spirit came down upon him in bodily form like a dove', and indeed the dove has been extensively employed as a symbol for the Holy Spirit. At its simplest, the Holy Trinity is represented as a triangle or as a trefoil.

The Hindu trimurti comprises Brahma, Vishnu and Shiva and, as they can take on various avatars or earthly manifestations, they offer artists plenty of scope. Krishna is the most popular avatar of Vishnu who, as will become obvious, may also manifest himself in non-human form. Other Hindu gods, too, whose job it is to distil the essence of their culture's belief into a legible visual language, allow artists much creative leeway, with often astonishing results.

Shamanic images are included in this section because the shaman has the ability to tap into a potent but inexplicable source of spiritual power within himself. Shamanism is, and has been, present in many cultures, past and present, and manifests itself in numerous ways, usually as a protective or medicinal

asset. Also included are cylindrical seals and boundary stones. Whether from Mesopotamia or present-day Iraq, they function as symbols of a divine presence. Bearing cuneiform script, they asserted the protection and endorsement of those indicated; thus they served a practical purpose and brought the gods among the everyday.

THE WORDS OF GOD

God's words are the foundation of faith. In 'Words of God' we begin by considering the Book of Genesis, which contains God's first recorded words for the Abrahamic faiths. In the New Testament the Gospel of St John tells us that 'Before the world was created, the Word already existed, he was with God and he was the same as God.' Words are thus highly charged with power and meaning; the preciousness of their content demands careful presentation. This is why the scriptures of every faith are prepared with such devotion.

The pages of the Qur'an bear wonderfully interlaced patterns, which go beyond being merely decorative. The manuscripts work as icons, leading us away from the mundane and into a spiritual frame of mind. The radiating patterns on some of the pages can be seen to act as metaphors for spiritual illumination; the arched forms echo the arcades found at the gateway to paradise. Sometimes the calligraphy is so elaborate that a page will bear only a few lines of text. The words are not yielding to the decoration; rather the majestic presentation establishes the status accorded to the words. In some cases the words themselves may assume the role of a pattern: words roll into a sphere, alluding to cosmology, and occasionally scrolls tumble through the picture plane.

God Among Us

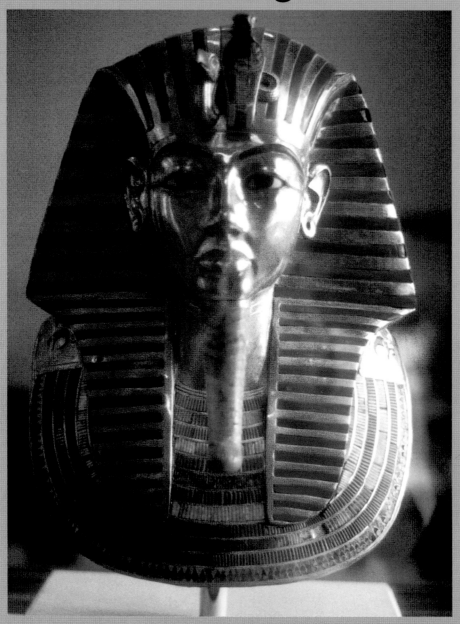

▶ Tutankhamen and his wife, Ankhesenamen, beneath the rays of the god Aten.

▶ King Akhenaten was the first Egyptian to focus on just one god: Aten. He had Aten represented as a disc of sun, each ray extending a 'hand' to earth, c 1345BC.

▶▶ A figure of Zoser, from the Mastaba, near the Step Pyramid, c 2700BC. Having his likeness preserved in sculpture would ensure his immortality.

▶ The tomb of Horemheb, who reigned c 1348–1320BC. The likeness of the king not only ensured against decay, it also enabled his ascent to the gods from whence he came.

◀ **Opposite**
A funerary mask of gold and lapis lazuli for Tutankhamen, who reigned from 1361–1352BC.

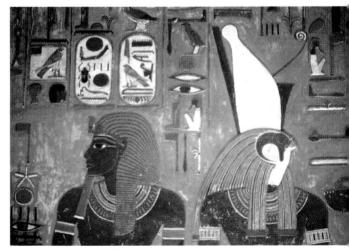

▲ The Egyptian word for 'sculptor' can be translated as 'he who keeps alive', hence the statue of Ramses II in front of the temple at Abu Simbel.

▼ A Sphinx and pyramid at Giza. Kings were deemed divine and at death they returned to the heavens; pyramids helped to send them on their way.

▲ This view of Ramses II makes obvious both the scale of the work and the care of the sculptor – a huge investment in time and talent.

▼ A painting of the Ibis-headed god Thoth, from the temple of Ramses II (1292–1225 BC).

▸ The golden crown of the high priest of the cult to Serapis, the Ptolemaic form of the Egyptian deity Apis, lord of the underworld. From the second century AD.

▸ Deity of the sun, moon and celestial bodies, the goddess Nut supports the sky in a painting in the tomb of Horemheb, who reigned 1348–1320BC.

▸ Regarded as divine by the ancient Egyptians, the scarab beetle, carved here in relief into limestone, is shown with vulture's wings and topped with a sun disc.

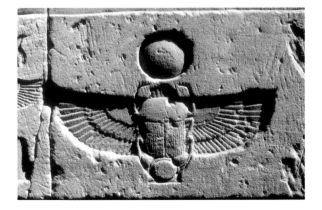

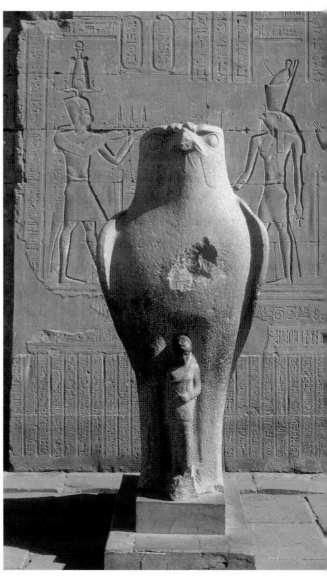

▲ A figure of Osiris, Egyptian god of the underworld and the dead, carved in wood and painted in polychrome.

▲ A giant statue of the falcon-headed god Horus, the son of Osiris, who is often represented by the one-eye 'wedjat'.

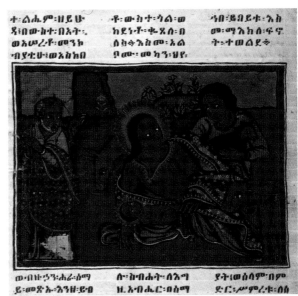

ተ፡ልሒም፡ዘይሁ
ጸብወ፡ከተ፡በእት፡።
ወእሠረ፡መንኽ
ብየቲሁ፡ወእክብ

ቶ፡ውክተ፡ጎል፡ወ
ክደነተ፡ቅጸሰ፡በ
ለከቀእስመ፡እል
ዖመ፡፡መ ኽን፡ህየ፡

ኃበ፡ጄብደተ፡እ ከ
መ፡ማእክስ፡ፋኖ
ተ፡ተወልደቀ

ወ፡ብዙኈን፡ሐራ፡ሰማ
ይ፡መጽ ኡ፡እንዘ፡ይ፡ብ

ሱ፡ክብሐት፡ሰእግ
ዚ፡አብሐር፡በሰማ

የተ፡ወሰሳም፡በም
ድር፡ሠምረተ፡ሰስ

▲ The holy family depicted on an Ethiopic text, c 1730–1755.

◀ An ivory carving of the Virgin and Child dates from 14th-century France.

⤒ A fifteenth-century Nativity of Christ, in enamel on copper gilt. Time is often compressed in icons, with the same figure appearing twice in a picture but at different occasions or events.

▲ Scenes from the Nativity are seen here on a 13th- or 14th-century Armenian manuscript.

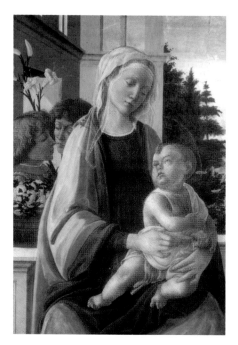

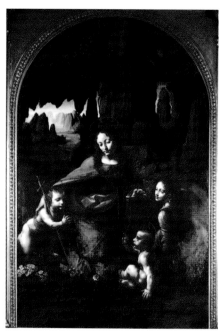

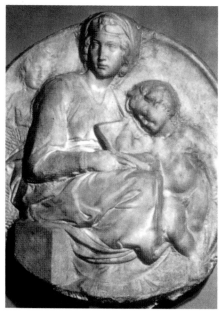

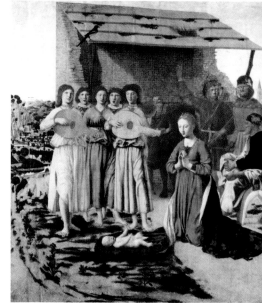

◄ **Opposite**
Clockwise from Left
'The Virgin and Child with
Apostles', 1498, by Filippino
Lippi (1457–1504). It is also
known as 'The Virgin with
the Pomegranate'.

'The Virgin of the Rocks', c
1503–1506, by Leonardo da
Vinci (1452–1519). It was
originally meant to form the
central panel for an altarpiece.

'The Nativity', painted c 1470
by Piero della Francesca
(1422–1492). The heavenly
figures speak of Christ's divinity
even as He has come among us.

'The Virgin and Child' by
Michelangelo (1475–1564) –
a harmony in marble.

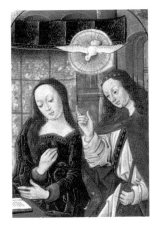

▲ The Holy Spirit takes the form
of a dove, as the Angel Gabriel
tells Mary she has been chosen
to bear the son of God.

▼ Part of the 12th-century
stained-glass cycle in Chartres
Cathedral, France, the Virgin
and Child are flanked by angels.

▲ This 17th-century icon of the
Russian School places Jesus and
His mother among everyday
scenes, yet one stage removed,
hence in an exalted position.

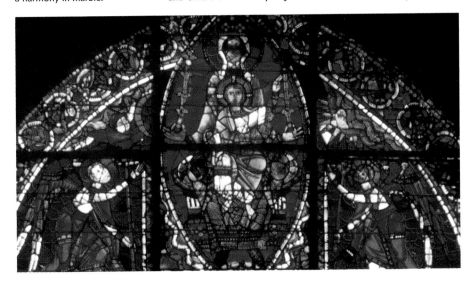

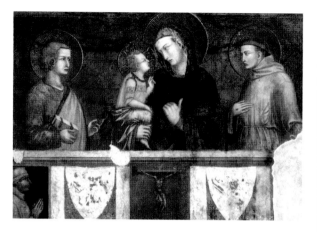

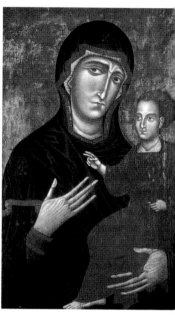

▲ 'The Virgin and Child with St Francis and St John the Evangelist', by Pietro Lorenzetti (1280–1348). The Child is flanked by figures from the future.

▶ 'Madonna and Child' by the Berlinghieri school, early 13th century. While Christ gives His blessing, his mother's anxiety seems to anticipate the future.

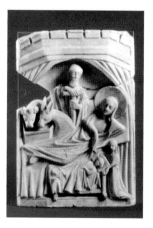

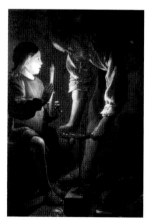

▲ In a fairly typically composed donor portrait, the Virgin and Child are attended by the saints while the figure of the painting's patron kneels on the left. By Piero della Francesca, c 1445.

▲ This 14th-century alabaster relief is a charming depiction of the holy family with an ox and an ass – God among us and among the animals.

▲ 'St Joseph the Carpenter', by Georges de la Tour (1593–1652), describes the Christ Child's tender relationship with His earthly father, but the candlelight in the workshop is spiritual.

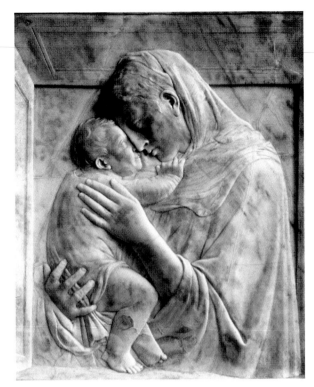

◀ In 'Pazzi Madonna' Italian Renaissance artist Donatello (1386–1466) shows Mother and Child engrossed in a very human familial love. Unusually for the time, haloes do not appear over the figures.

▼ Left to Right

'The Madonna of the Meadow', c 1500, by Giovanni Bellini (1430–1516). The figures are unaware of our gaze and have been placed within a working rural landscape.

Bramentino's (1450–1536) 'Madonna and Child' seem to glow amid a crowd of admirers, spiritually lit from within.

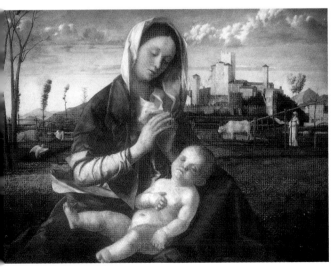

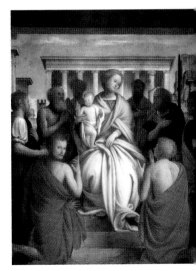

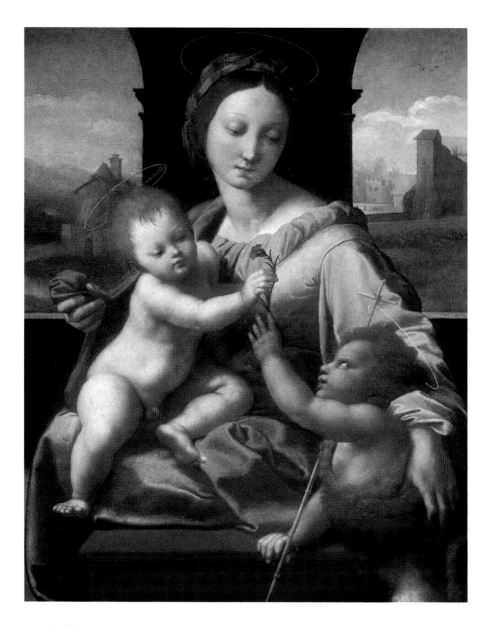

▲ Raphael's (1483–1520) 'Madonna and Child with the Infant Baptist',
painted *c* 1510, catches the deeply symbolic moment when Christ
takes the carnation from the Baptist's hand.

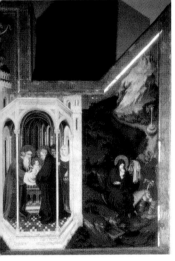

◀◀ 'Rest During the Flight to Egypt', painted by Jean Restout (1732–1797). Having been warned to flee to Egypt, the holy family set off; here Mary and her infant rest on the way, in a relaxed setting that belies the difficult circumstances.

◀ A 13th-century Armenian manuscript representation of 'The Boy Jesus in the Temple'. Jesus was found by his parents in the temple, listening to the teachers and asking questions.

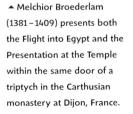

▲ Melchior Broederlam (1381–1409) presents both the Flight into Egypt and the Presentation at the Temple within the same door of a triptych in the Carthusian monastery at Dijon, France.

▲ A very young-looking Mother places her Child in the hands of Simeon in 'The Circumcision' (1511), produced by a follower of the Bellini family.

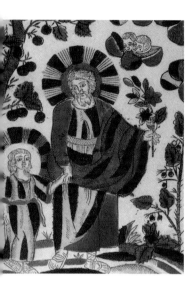

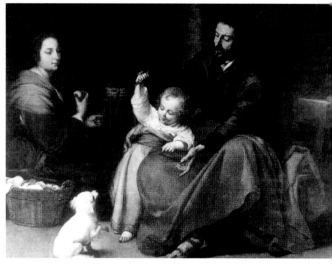

▲ In a French woodcut of the 18th or 19th century, St Joseph and Jesus walk hand in hand.

▲ 'The Holy Family of the Little Bird', 1650, by Spanish artist Bartolome Murillo. The earthly colours help to confirm that the Christ Child is truly among us.

▼ Sir John Everett Millais' 'Christ in the House of His Parents', 1850. A workshop injury foretells the Crucifixion, as blood falls from palm to foot.

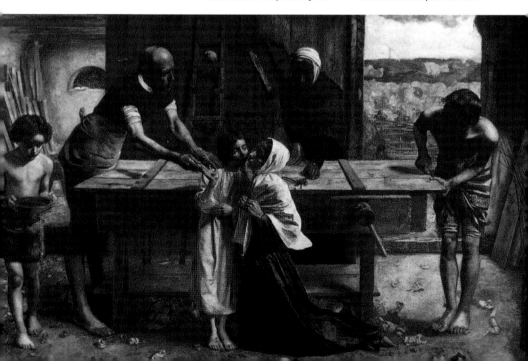

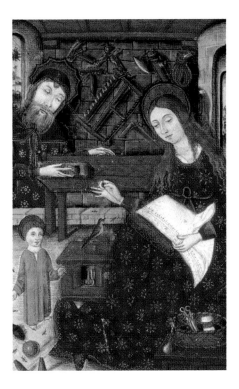

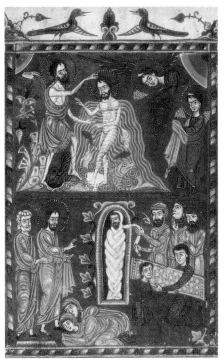

▲ Christ is very much the human child in this 15th-century Spanish Book of Hours – at home with his parents amid the paraphernalia of everyday life.

▲ 'The Baptism of Jesus by John the Baptist'. After an Armenian Evangelistery, 1350.

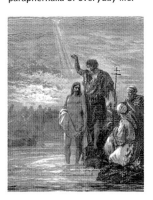

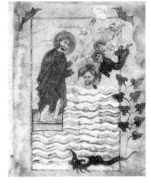

◄◄ 'John the Baptist', an 1865 wood engraving by Gustave Doré. As Jesus is baptized, the Holy Spirit descends in the form of a dove.

◄ In this 20th-century copy by Simon Artchichetsi from a 1350 Armenian Evangelistery, Jesus is shown totally immersed in the waters of baptism.

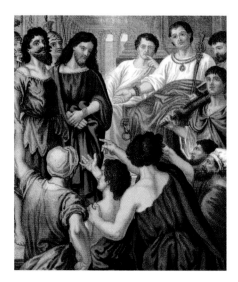

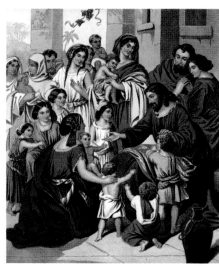

▲ As Jesus appears before Pontius Pilate, a lictor bears a bundle of sticks with an axe inside, symbol of a magistrate.

▲ Jesus welcomes children and advises adults to follow their humility. From a 19th-century Kronheim lithograph, as left.

▲ In 'The Woman Taken in Adultery', by Il Guercino (1591–1666), Christ teaches His people about forgiveness.

▶ 'Our Lord Jesus Christ', 1897, by society portrait painter James Tissot, with Christ dressed like those with whom he dwelt.

▲ Left to Right

'St Martin's Dream', by Simone Martini, (1284–1340). The saint gave half his cloak to a beggar, then dreamt he saw Christ in the piece he had parted with.

A 19th-century representation of Christ walking on the water, painted by Alexander Ivanov (1806–1858).

▶ 'The Tribute Money', painted by Titian (Tiziano Vecellio, 1488–1576), c 1560. Knowing that they were trying to trick Him, Christ tells the Pharisees to give to Caesar what is Caesar's and to God what is God's.

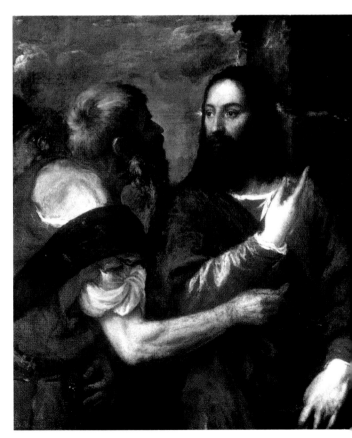

▲ James Tissot's interpretation of the 'tribute money' incident. Jesus told those attempting to trick him that they must give to the emperor what was his and to God what was God's (Mark 12:17).

▲ An Armenian Gospel of 1357 illustrates Jesus's triumphant, yet humble, entry into Jerusalem.

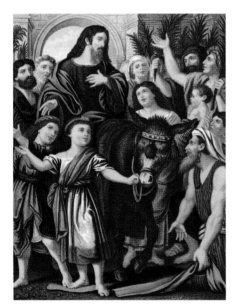

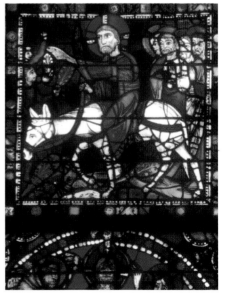

▲ A print, dated 1860, emphasizes the throng of welcoming, palm-waving crowds as Christ enters Jerusalem on a lowly donkey.

▲ This 13th-century stained glass from Chartres Cathedral, France, shows Christ amid the crowds, entering Jerusalem on a donkey.

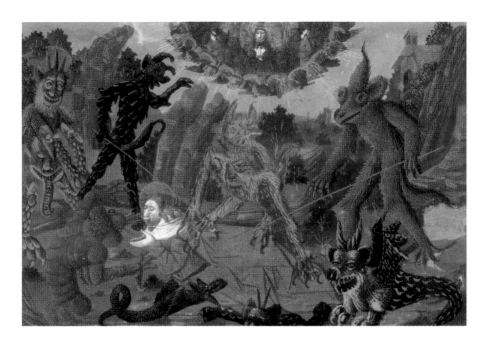

▲ From the 15th-century *Legenda Aurea* (*The Golden Legend*) by Jacobus de Voragine, which condensed the Bible stories and the lives of the saints. The image of Christ in the wilderness, tormented by beasts and monsters, serves as a reminder that He was not exempt from trials.

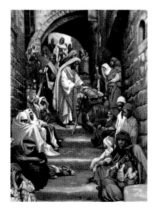

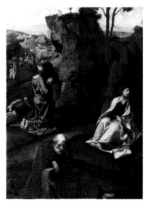

▲ An Armenian gospel, dating from 1211, illustrates Christ's entry into Jerusalem.

▲ Christ healing a lame man, part of Tissot's 'The Life of Our Saviour Jesus Christ', c 1890.

▲ 'Jesus on the Mount of Olives' by Pieter Coecke van Aelst, (1502–1556).

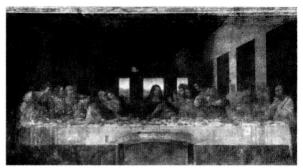

▲ 'The Agony in the Garden', c 1460, by Andrea Mantegna. As Judas approaches and Jesus prays, angels reveal to Him the instruments of His passion.

▲ Leonardo da Vinci's vision of the Last Supper (c 1495) is highly charged with meaning and symbolism. Try to read the gestures of those in the picture.

▼ Gustave Doré's illustration (1865) of the moment of Jesus's betrayal by Judas.

▼ In this scene from Tissot's 'The Life of Our Saviour Jesus Christ' the wounds on Jesus's hands are marked as points of light.

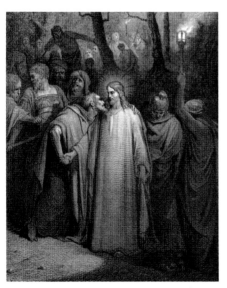

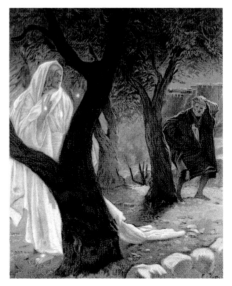

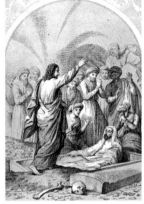

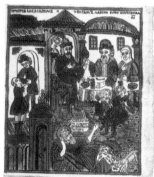

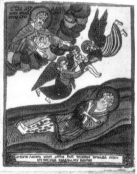

▲ Vincent Sellaer (c 1500–1589) painted Jesus as being truly at home among these mothers, while the children trust and revere Him.

▲ In this wood engraving c 1880, Jesus is seen raising his friend Lazarus from his tomb, to the general astonishment of those watching.

◄ A 19th-century woodcut shows scenes from the life of Christ, including the raising from death of Lazarus.

▼ An image of Christ engraved in rock crystal and set with precious stones. Wearing a symbol like this Byzantine one is both a way of recalling His closeness and an act of worship.

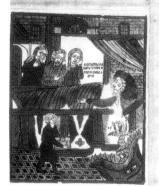

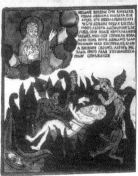

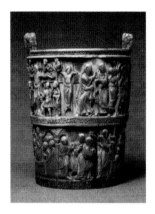

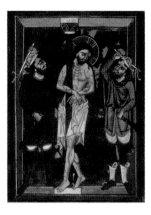

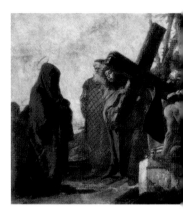

▲ Scenes of Christ's trial and Crucifixion are carved in ivory on this Basilewsky situla, dating from c 980.

▲ A depiction of the flagellation of Christ by the Romans. From a German manuscript.

▲ 'Christ Meets His Mother', 1749, by Giovanni Tiepolo. There is a sense of foreboding in Mary's hidden face and Christ's red robe.

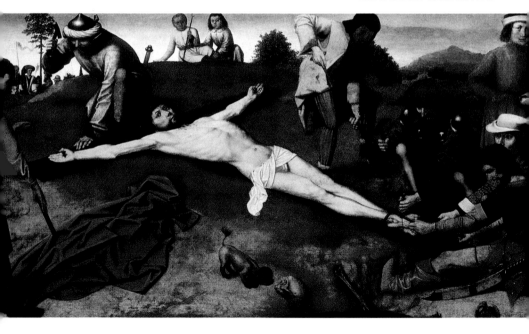

▲ 'Christ Nailed to the Cross', c 1485, by Gerard David. Christ looks at the viewer as the workmen fulfil their duties. The skull may symbolize Adam, who is said to be buried at the spot.

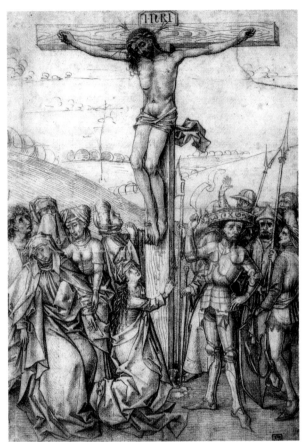

⬆ 'Christ with the Instruments of His Passion', as interpreted by Hans Baldung (1484/5 – 1545).

▲ 'The Crown of Thorns' by Dieric Bouts (1415 – 1475) serves as a meditation on Christ's suffering and sacrifice.

▲ 'Christ on the Cross' by the Master of Nuremberg, c 1480.

▶ In a Spanish woodcut the figure of Christ – as Ecce Homo, the Man of Sorrows – gazes above the dice, the instruments and the cockerel.

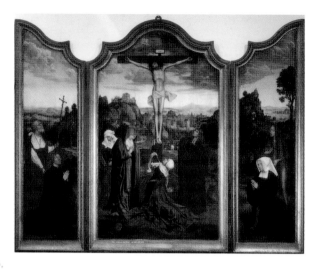

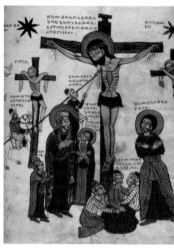

▲ A triptych of the Crucifixion by Quentin Metsys (1466–1531).

▼ The figure glows with light despite the surrounding darkness in this 14th-century Portuguese Crucifixion scene.

▼ With saints to one side and soldiers on the other, the souls of the thieves are taken, one by an angel, the other by a demon.

▲ Ethiopic text accompanies this depiction of Christ being scourged after His Crucifixion.

▼ A brutal Crucifixion scene from Gustave Doré's *Bible Illustrations* of 1865.

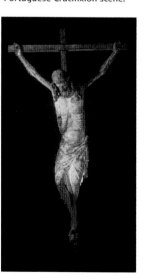

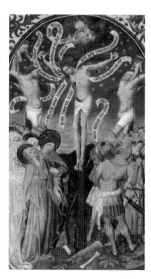

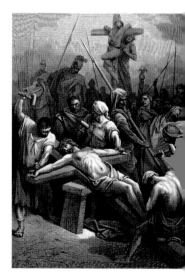

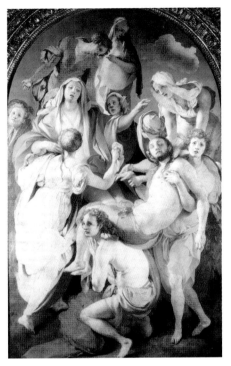

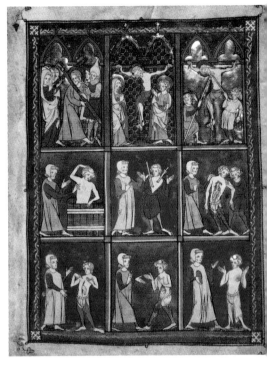

▲ Left to Right

The figures in the 'Deposition from the Cross' by Jacopo Pontormo (1494–1556) fill the canvas with heavenly colour.

In Rogier de Salerne's 14th-century *A Book on Surgery*, a rendering of the Crucifixion appears alongside images of a physician with the sick.

▶ This page of a Latin text, dated 1170, illustrates Christ's sacrifice at the top, with an animal – perhaps a lamb – being sacrificed below.

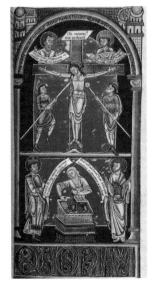

▲ The scene of the Crucifixion is at the centre of this triptych by the Master of Bologna.

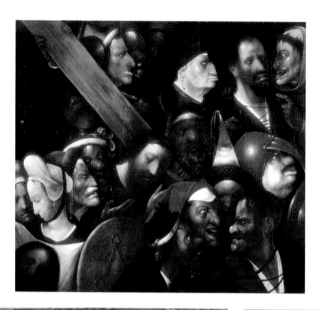

◄ The crowd's ugly faces are used by Hieronymous Bosch (1450–1516) to express the horror of the Crucifixion. Strangely, at the bottom left, Christ's face appears on a cloth.

▼ **Left to Right**

From a 15th-century manuscript, *L'Histoire du Graal*. Joseph of Arimathea can be seen collecting Christ's blood in the Holy Grail.

In 'The Crucifixion' by Giovanni Bellini (1430–1516), Jesus asks John to take care of His mother, as a son would.

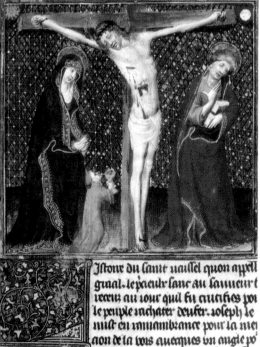

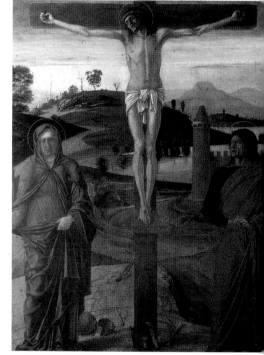

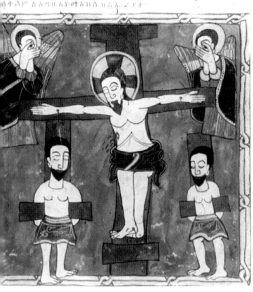

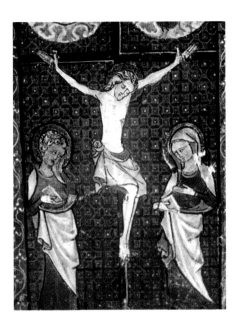

▲ In this Ethiopian manuscript painting, the angels' hands are so held that we know they are weeping at the Crucifixion of Christ and the two thieves.

▲ Women, probably Mary Magdalen and Jesus' mother, carrying books (indicating that they will live by the Word of God), stand at the foot of the Cross.

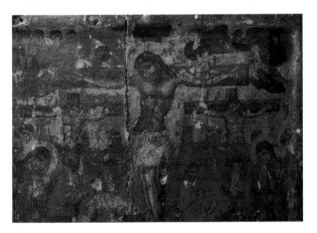

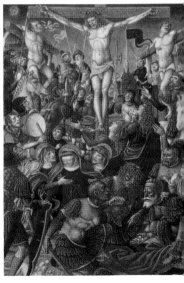

▲ Part of a 13th-century crucifix icon from a Coptic Orthodox monastery in Egypt.

▶ A frantic scene of colour, chaos and Crucifixion from the Sforza Hours, c 1490–1500.

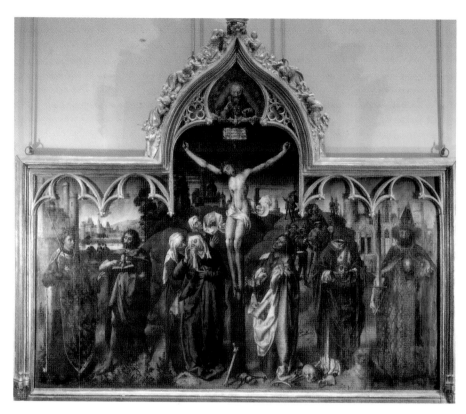

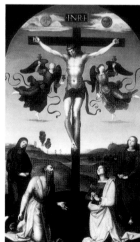

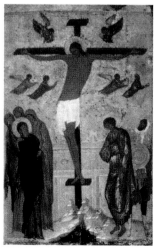

▲ An anonymous 15th-century Parisian altarpiece, a grieving Mary and various saints ranged at the foot of the Cross. The martyred St Denis, patron saint of Paris, carries his own head in his hands.

▶ Painted c 1503, 'The Mond Crucifixion' by Raphael shows two angels catching the blood of Christ in chalices.

▶▶ A quiet Crucifixion scene by Dionissi (1440–1502).

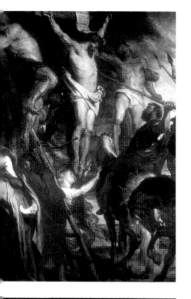

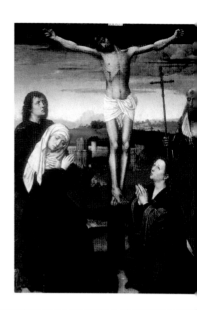

◀ 'Le Coup de Lance' by Peter Paul Rubens (1577–1640). The combination of the strong diagonals of the ladder and lances with the swathes of red drapery creates a dramatic, dynamic composition.

▶ In contrast, this Crucifixion by Gerard David (1460–1523) is very still and brooding. A dark beam at the top of the Cross adds to the weight of the stormy sky.

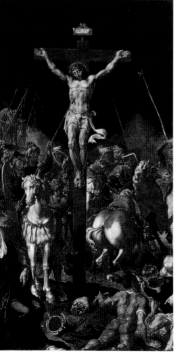

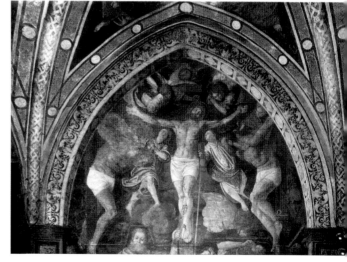

◀ In this central panel of a triptych by Maerten van Heemskerck (1498–1574), a soldier's lance pierces Christ's side and Mary swoons.

▲ This fresco, painted by Gaudenzio Ferrari (c 1470–1546) in 1512, forms part of a vault in the Church of St Mary of the Graces, Milan.

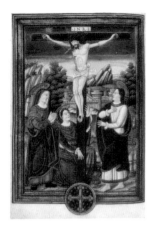

▲ The Virgin Mary with Mary Magdalene and St James are gathered at the foot of the Cross in this miniature from the 1545 Lyons Missal.

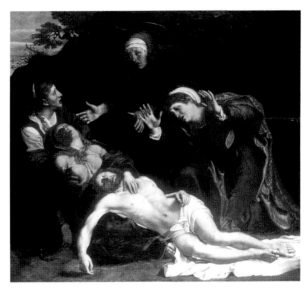

▲ 'The Dead Christ Mourned', 1604, by Annibale Carracci (1560–1609). The composition pulls the eye diagonally from the bottom right to the patch of blue sky on the left – like light at the end of a tunnel.

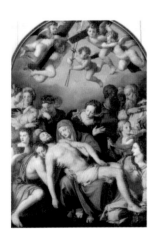

▲ 'The Deposition from the Cross' by Il Bronzino (1502–72) is a mass of intertwining figures, earthly and heavenly.

▲ A 13th-century interpretation of the 'Descent from the Cross' from an Armenian manuscript of the Gospels.

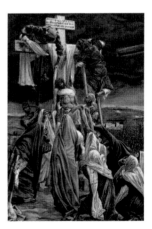

▲ Tissot's 'Descent from the Cross' shows the struggle of earthly practicalities.

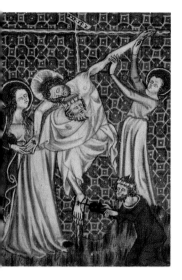

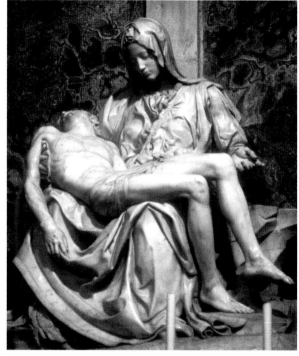

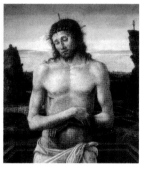

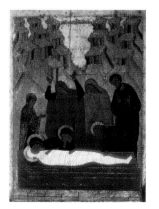

◀ Top to Bottom

John the Apostle, Joseph of Arimathea, Nicodemus and Mary take Jesus from the Cross. From the Taymouth Book of Hours, dating from the early 14th century.

'Christ in the Tomb' painted by Giovanni Bellini in 1460. The figure is alone in a harsh, desolate landscape.

The jagged rocks emphasize the pain of grief in this image of 'The Entombment'. From a 15th-century Russian icon.

▲ 'Pietà' by Michelangelo, sculpted *c* 1498–1500. The weight of Mary's burden – physical and emotional – is eloquently described in marble.

▲ **Left to Right**

In this Resurrection scene by an imitator of Andrea Mantegna, the tree is a sober reminder of the Cross.

In 'Nol mi Tangere', Dosso Dossi (1490–1542) describes the scene when Christ appears to Mary Magdalene and tells her not to touch him because, he says, 'I am not yet ascended to my father.'

▲ A late 15th-century depiction of Christ rising from the tomb and walking upon earth. Three women can be seen approaching from the town and an angel watches from above.

▲ From Tissot's 'The Life of Our Saviour Jesus Christ', 1890. On seeing Christ, the guards were so afraid that they 'trembled and became like dead men', according to Matthew 28:4.

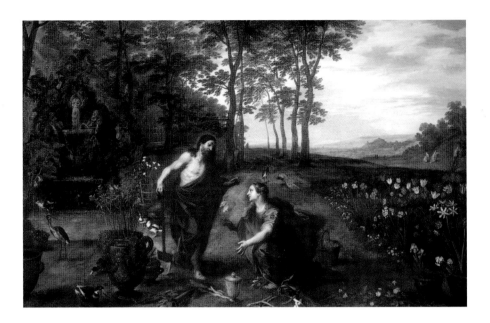

▲ By Jan Bruegel, the Younger (1601–1678),
'Noli me Tangere' shows the Garden of
Gethsemane filled with spring flowers.

▼ In this painting by Toros Roslin, c 1268, after an
Armenian gospel, we see Thomas touching the
nail wounds in Christ's hands and feet.

▼ 'The Incredulity of Thomas' by Rembrandt van
Rijn (1606–1669). Thomas must see and touch the
wounds before he will believe in the Resurrection.

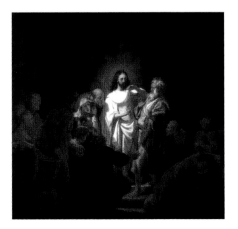

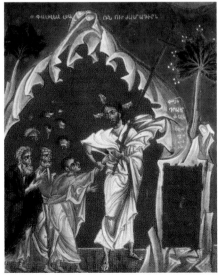

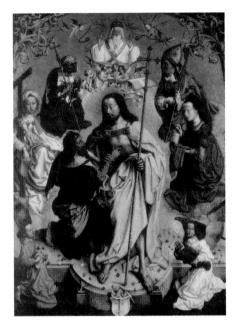

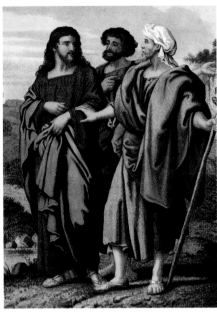

▲ The master of the altarpiece of St Bartholomew painted this version of Thomas testing Christ's wounds, c 1499.

▼ Christ is among his disciples in 'The Supper' by Vincenzo Cantena (1480–1531). The dog below symbolizes fidelity.

▲ A Bible illustration dating from c 1860: Christ appears to two disciples on the road to Emmaeus.

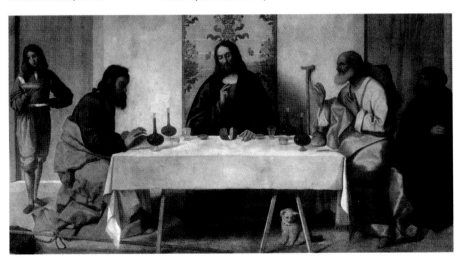

▲ St Luke describes the Supper at Emmaeus as enlightening, but here Jan Vermeer's (1632–1675) interpretation is dour.

▲ 'The Supper', 1879, by Gaston de la Touche (1854–1913). The scene is illuminated by Christ's figure.

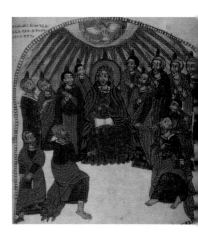

▲ Christ fills his disciples with the Holy Spirit and it rests upon them like fire. From an Ethiopian manuscript.

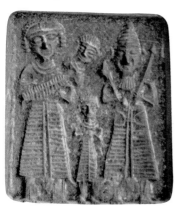

▲ This is a mould for making a terracotta plaque and facilitating the production of multiple devotional images. It contains images of a god, a goddess and two children in traditional Anatolian dress. From the Ankara Museum, Turkey.

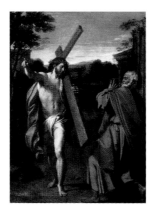

▲ In the Medieval text The Golden Legend, Peter had a vision, while fleeing Roman persecution, of Christ carrying his cross. Annibale Carracci, in 'Christ Appearing to St Peter', 1601–1602, vividly describes this revelatory event.

▲ A portable altar, such as this one from Germany, dating from c 1200, allows the faithful to feel that God truly is with them wherever they choose to travel.

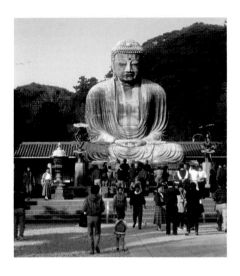

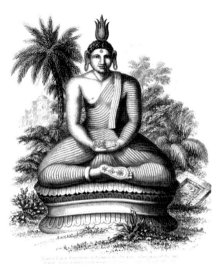

▲ Among the many: large crowds are able to see this Great Buddha in Japan due to its sheer size.

▲ An 1880 engraving portrays the Cotama Buddha. The figure's gaze engages the viewer directly.

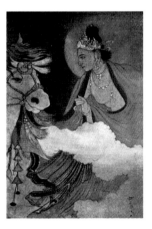

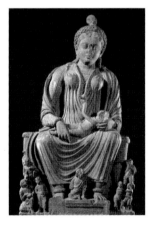

▲ Looking like a picture of a common beggar, this in fact portrays Prince Siddhartha (563–483BC) after he had been made supreme Buddha and had come to depend on his fellow men for sustenance.

▲ In this painting, Prince Siddhartha leaves his sheltered life in a palace to join the ascetics and solve the problems of human suffering.

▲ A schist sculpture of Hariti from India. Hariti vowed to devour the infants of Rajgir, but when the Buddha hid one of her own children, she repented, and became a Buddhist and the protectress of children.

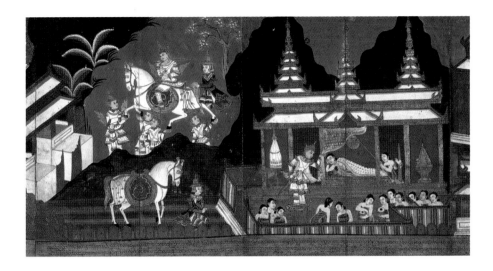

▲ The gods muffle the hooves of the future Buddha's horse so he can
depart the palace unheard and leave behind his life of sheltered luxury.

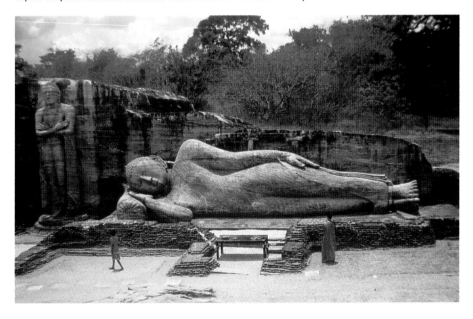

▲ The Buddha leaves this earthly life in the lying position, or *paranirvanasana*.
A 12th-century stone sculpture in Polonnaruwa, Sri Lanka.

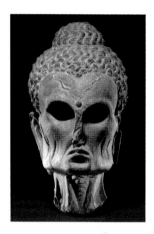

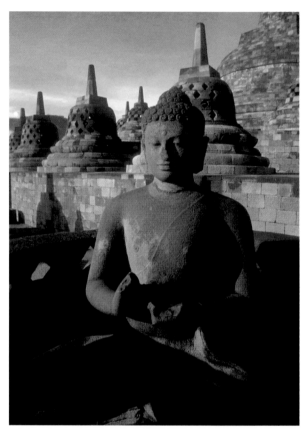

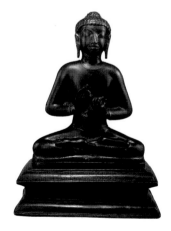

⤒ Having fasted almost to death, Siddhartha decided to follow a moderate way to enlightenment – the 'Middle Way'. This fasting Buddha from Pakistan dates from the second or third century.

▲ A Chinese 'Laughing Buddha', or Budai, dating from 1486. Budai is sometimes regarded as the incarnation of the Buddha of the future.

▲ This statue dating from c 800AD resides inside the great Buddhist monument at Borobudur, 'the monastery on a hill', in Java. It is an image of peace and tranquillity.

▶ A Buddha statue from fifth-century India. Here he sits in the meditative lotus position with his eyes closed and his thumbs and index fingers touching.

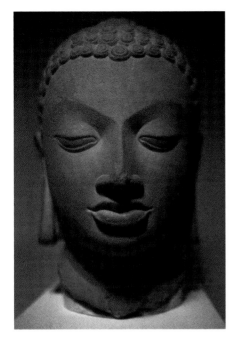

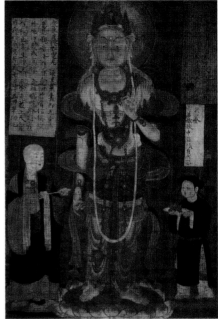

▲ The stone head of the fifth-century Buddha at Uttar Pradesh, India, is approachable and calm.

▲ From the Dunhuang Caves in China, this picture, c 910AD, is of Avolokiteshvara, the lord who looks in every direction and embodies compassion.

▼ Krishna, an avatar or incarnation of Vishnu, is the subject of this 18th-century Indian miniature. He is with a monkey god and winged attendant.

▼ Here making offerings to a bear, the Ainu people in Japan have an animistic belief in spirits.

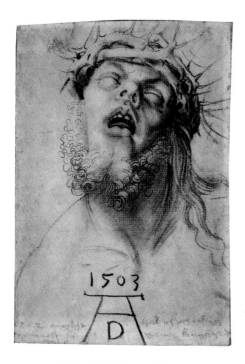

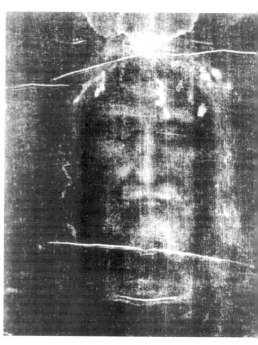

▲ Albrecht Dürer's 1503 'Head of the Dead Christ'. The head hangs in agony, thorns piercing the skin.

▲ The Shroud of Turin is reputed to be Christ's burial cloth; it is said to bear the imprint of His face.

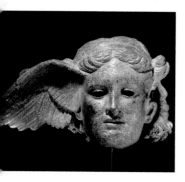

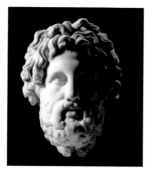

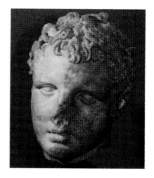

▲ A copy of an original bronze head of Hypnos, the god of sleep, found near Perugia, Italy. It dates from the first or second century.

▲ Dating from 325–300 BC, this head comes from what would have been a colossal statue of Asklepios, the Greek god of healing.

▲ A beautifully carved portrayal of a young god, the 'Aberdeen Head' (325–280BC) is quite rare and distinct from pieces based on copies of Roman work.

▶ Impressive in its dignity and solidity – if a little over-large – this bronze head of Apollo is known as the 'Chatsworth Head' and dates from 460BC.

▶▶ A bronze Dionysius from Greece, dating from 200BC–100AD. The tangle of curls, leaves and berries has been created by inlaying the bronze with other coloured metals.

▶ A terracotta Dionysius dating from 350BC. The god is easy to identify because the cockerel and the egg were popular offerings to underworld deities as signs of fertility.

▶▶ Ahura Mazdah, the Lord of wisdom and Zoroastrian God. The Farohar, or Fravashi, is the symbol of Zoroastrianism, and is man's guardian angel.

▶ Piero della Francesca's (1410/20–1492) 'Head of Christ'. Christ gives His blessing, while His gaze creates a close, direct relationship between spectator and the subject.

▶▶ This stone relief of the head of Christ from Chichester Cathedral, dating from c 1140, has a sorrowful countenance.

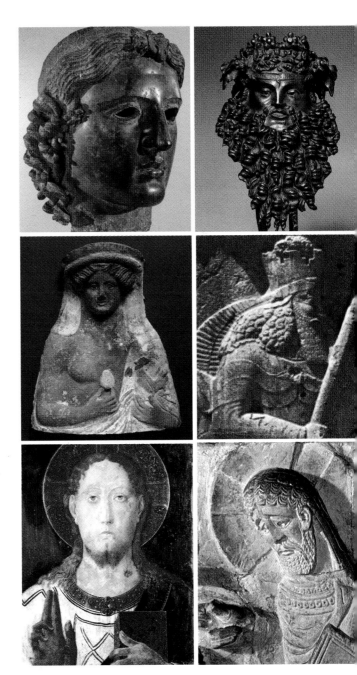

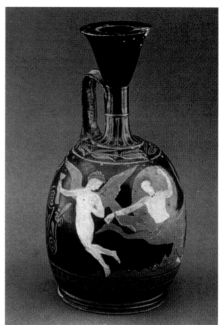

▲ Greek gods adorn this vase from c 420–400BC. Aphrodite sits with her son Eros on her shoulder.

▲ Eros and Cupid appear on a Greek vase that has been dated to 4000BC. Doubtless, the gods at play were role models for people of the time.

▼ A late 16th- or early 17th-century dish, decorated with a scene of Apollo on Mount Helicon, with muses making music. Pegasus, Cupid and other mythical creatures are in the distance.

▼ The abduction of Europa by Jupiter (in the guise of a bull) is depicted on this mosaic floor, c 100AD. It was unearthed in a Roman villa in Kent, England.

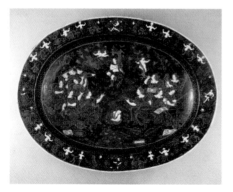

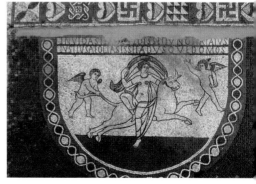

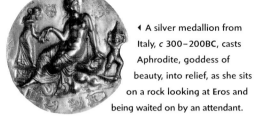

◄ A silver medallion from Italy, c 300–200BC, casts Aphrodite, goddess of beauty, into relief, as she sits on a rock looking at Eros and being waited on by an attendant.

▶ Here Minerva, goddess of wisdom, is seated and resplendent. Such statues were highly decorated with gilding and coloured stone eyes.

▼ **Left to Right**
Apollo in marble, dating from 400–323BC, represents the absolute ideal of youthful manhood.

A 1655 engraving by Michel de Marolles describes pictorially how Daphne becomes a laurel tree in her bid to escape Apollo's attentions.

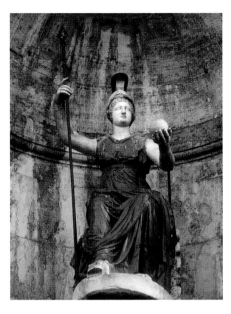

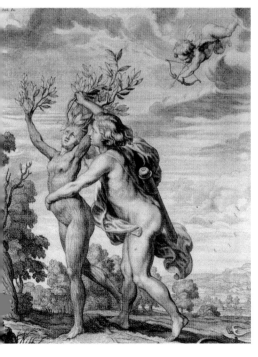

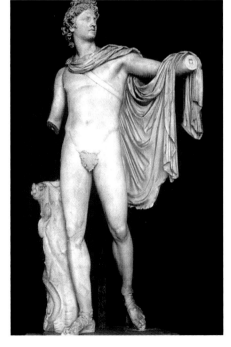

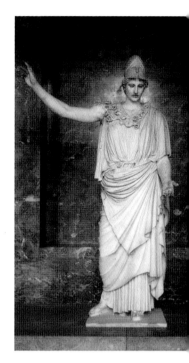

◀ A statue of Harpokrates dating from sixth century BC. The Greek version of the Egyptian child-god Horus, he was often shown sucking his finger.

▶ Minerva in marble: a beautifully draped goddess.

▼ Left to Right
'The Triumph of Pan', by Nicolas Poussin (1594–1665), is a colourful scene of turmoil.

In this 1938 painting, the Hindu goddess Bishahari holds lotus flowers in both hands.

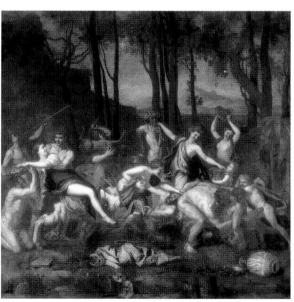

▶ The face of God on the page of an illuminated manuscript from the mid-14th century. Pages such as this allowed an intimate look at the Lord, but only for the literate few.

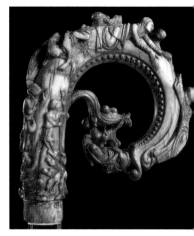

▶▶A detail of a late 12th-century bishop's crosier, carved in ivory and decorated with a Nativity scene. The bishop, who represents God on earth, carries the story of Christ among the people.

▲ Here a sick man is being swung through the air, ringing a bell. Gods of sickness commanded respect, which explains why Mariatale, the Hindu goddess of smallpox, is being honoured at this ceremony.

▲ God is shown here among the workers: the Holy Spirit embellishes the 1851 British Trade Union Scroll of the Amalgamated Society of Engineers, Machinists, Smiths, Millwrights and Pattern-Makers.

▲ According to this illustration for the Russian classic, *The Tale of the Host of Igor* (1151–1202), the image of Christ's face appears on Igor Svyatoslavich's banner.

▼ Painted by the Master of the Legend of St Catherine, a 15th-century Flemish artist, this triptych relates many of the Biblical tales about Christ's time on earth.

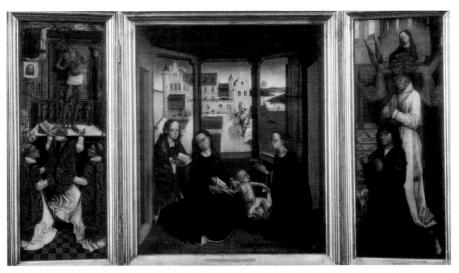

▲ This woodcut, dating from the 16th or 17th century, shows a landscape in which Samoyed idols have been given offerings of reindeer antlers. The Samoyed lived in Northern Siberia.

▶ In this shamanistic painting from northern Siberia, a brave man is shown riding a stylized tiger god.

▼ A scene from the first book of the *Ramayama* by Valmiki, in which the army of the Hindu deity Rama (shown centre) goes riding into battle on elephants against ferocious monkeys.

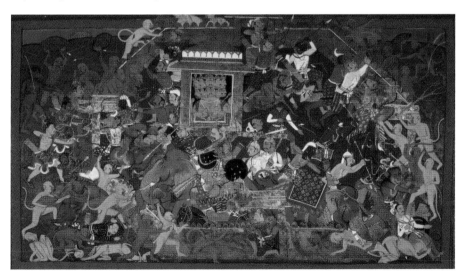

The Unpersonifiable

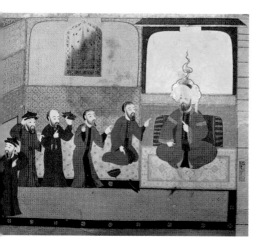

▲ Ezekiel, prophet of God, with the elders of Israel on a 16th-century Turkish Islamic manuscript.

▲ The Magi arrive at the Nativity. From *Historiale Universalis Omulum Cometarum*, Holland, 1666.

◀ The figure of God is clearly visible in this 15th-century image of Moses and the Burning Bush.

▼ In this 19th-century engraving, God reveals himself to Moses in the form of the Burning Bush.

▼ Moses beholds the Burning Bush ablaze, but not consumed by the flames. From a Book of Hours.

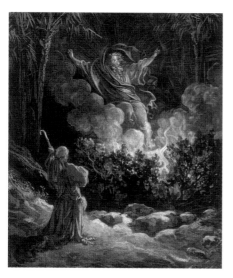

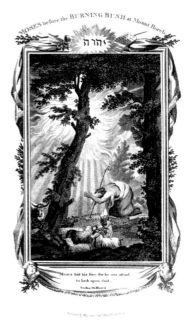

◄ An elaborate endpiece from a Qur'an made in North Africa in 1568 and later copied. It is richly decorated with intricate geometrical patterns.

▼ A print of unknown origin depicting a mosque full of people and dotted with crescent moons.

▶ **Opposite**
J Martin (1789–1854) painted 'The Seven Plagues of Egypt'. The drama of the painting is created by the focus on Moses as he sees the Nile's water turn blood-red.

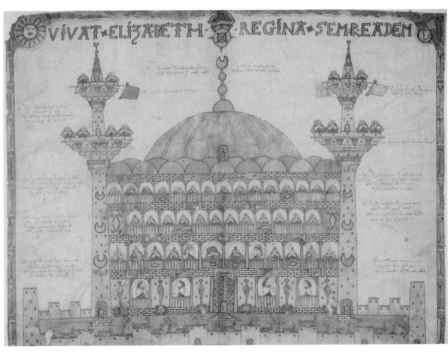

VIVAT ELIZABETH REGINA SEMP EADEM

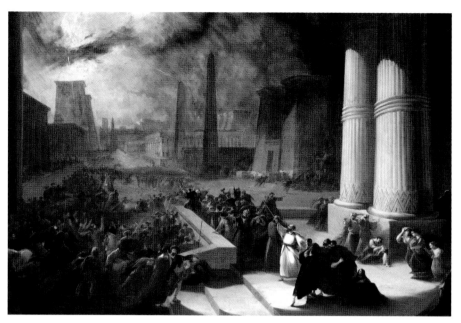

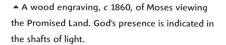

▲ A wood engraving, c 1860, of Moses viewing the Promised Land. God's presence is indicated in the shafts of light.

▲ 'The Conversion of St Paul', from Gustave Doré's *Bible Illustrations*: God strikes Paul with a blinding light from the heavens.

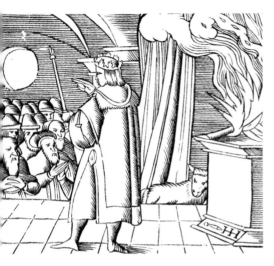

▲ A woodcut from Germany, dated 1557: a *ner tamid* (eternal light) burns before the Ark of the Covenant to mark the Scrolls of the Law.

▼ An angel and a ram save Isaac, and the dove brings a sign of dry land to Noah.

▲ As King David gives thanks to God for delivering the Israelites from plague, Jehovah appears in the clouds.

▼ In this 1493 woodcut, God's presence is almost palpable: blinding light falls on St Paul as raindrops.

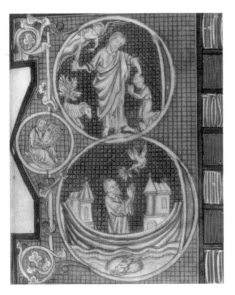

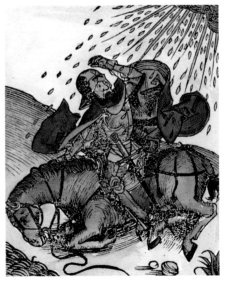

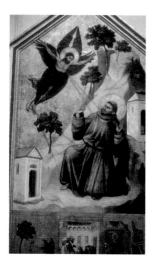

▲ The 'Stigmatization of St Francis', painted by Giotto di Bondone (1267–1337) in 1300.

▲ The 'Seated Figure of God' by William Blake (1757–1827) has a metaphysical quality, even in its simplicity. It is a sketch to accompany his collection of poems.

◄ A page from the Lyonnaise Missal, 1545: God is enthroned in an unearthly arrangement of scrolls, clouds and banners.

▲ The Eternal Father on a ceiling vault of the Basilica of St Mary the Great in Milan.

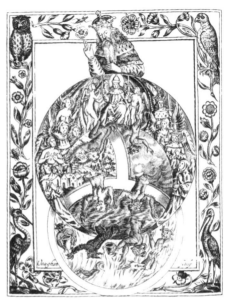

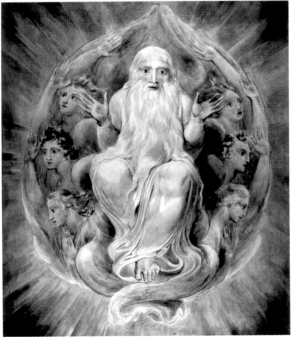

◀ **Opposite**
Clockwise from Left
God's presence is but one stage removed from the earthly beings below.

Elias Ashmole's (1617–92) 'Theatrum Chemicum Britannicum' (1652) shows the hierarchy of the Church in overlapping spheres.

A three-dimensional description of God the Father, dating from c 1400–1425. The ivory lends an ethereal quality to the form.

William Blake's (1757–1827) painting entitled 'God Blessing the Seventh Day'. Radiant light and a swirl of angels express God's glory.

▶ **Top to Bottom**
A German woodcut, dated 1557, describes Ezekiel's vision of God: He saw a chariot within a storm cloud and lightening flashing from it.

God often speaks through dreams, as evident in many Bible stories and in this sequence of illustrations from a 13th-century woodcut.

Galahad wins his spurs in a tournament while God watches from above (upper left). From a 15th-century French manuscript.

▼ In William Blake's (1757–1827) 'God Creating Adam', God forms Adam's figure from mud with His golden touch.

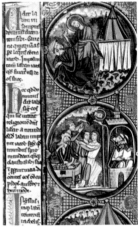

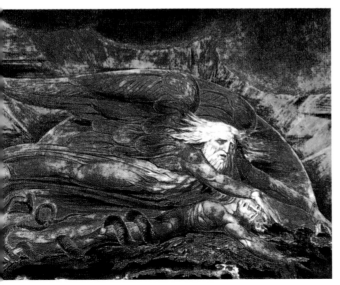

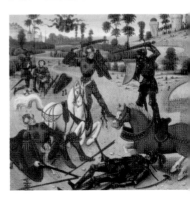

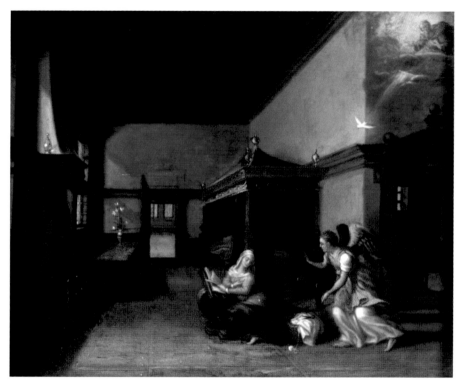

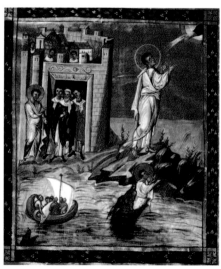

▲ In this anonymous Annunciation, God is unseen by everyone in the room, but the dove will make His presence felt.

◄ The figure of Jonah appears in several places in the picture, 'Prayer of Jonah' (c 14th century), which describes a number of events. At the end, Jonah communicates with God, who is indicated in the top right of the painting.

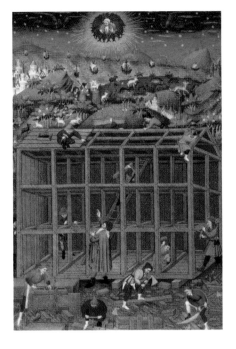

▲ In this painting, which dates from 1423, God oversees the construction of Noah's Ark from a blaze of red light in the heavens.

▲ Images of the Father, Son and Holy Spirit are repeated within the flowery border of this 19th-century French woodcut.

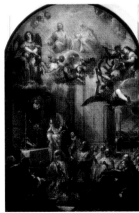

◀◀ Members of the Christian Holy Trinity are represented by the Eucharistic bread, the dove and the hand from heaven in this French manuscript dating from 1323–1326.

◀ A painting by Carreno de Miranda (1614–1685). As the priest (see left) holds a mass, the Holy Trinity look down in blessing from among the angels.

231

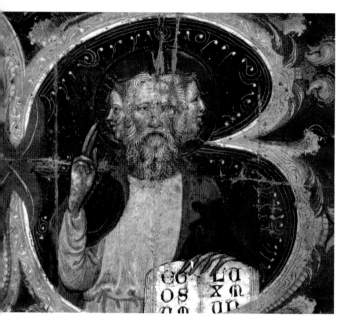

◀ Three heads on one body show God as Three in One.

▶ **Opposite Clockwise**
The French painter Jean-Baptiste Jouvenet (1641–1717) describes how the Holy Spirit descended upon the Apostles.

A page from *The Gospel of Henry Lion*, illustrating a coronation scene in which the presence and strength of the Trinity is obvious.

In Fra Angelico's (1400–1455) 'Annunciation', a shaft of light strikes the Virgin as the Angel's news is told.

▲ This Slavonic miniature from the 18th century shows Father and Son enthroned with the Holy Spirit above them.

▲ In a miniature from a 15th-century prayer book, the adult Christ appears the size of a child in front of God the Father. A dove symbolizes the Holy Spirit.

▲ The Virgin and Child in the company of playful angels in a chalk drawing, c 1512–1517. The Holy Spirit is present as a dove that radiates with divine light.

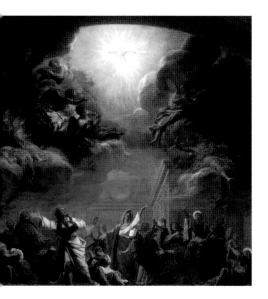

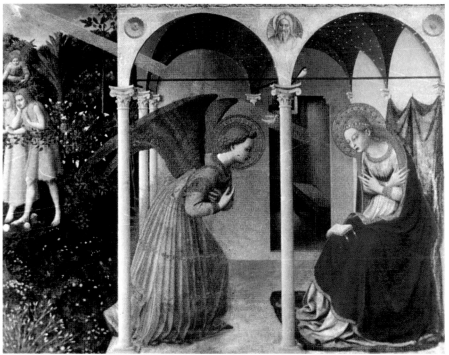

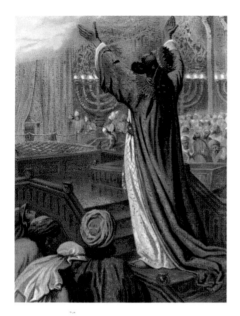

▲ In a Bible illustration, c 1870, King Solomon prays to the Lord at the consecration of the temple that he has built for Him 'to live in forever'.

▲ Unseen but omnipresent, God closed the mouths of the lions to protect Daniel. A Bible illustration, drawn c 1860.

▲ People shown at prayer in a synagogue in a 17th-century Italian painting.

▶ Man's relationship to the universe is defined in a 17th-century print; God is the triangle at the top.

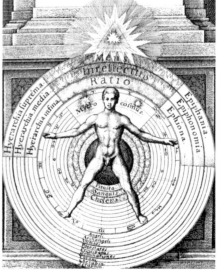

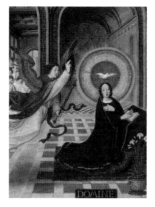

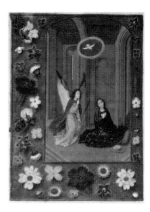

▲ A beam of light is sent by the triangular, all-seeing eye of God to the future mother of God in a 19th-century French woodcut.

▲ In this Annunciation scene, Mary's head is surrounded by an aura – with the dove of the Holy Spirit at its centre.

▲ Flowers associated with the Virgin Mary surround this Annunciation, while butterflies are symbols of the Resurrection.

▶ Francesco Solimena (1657–1757) describes how God sent His message to St Joseph through an angel in a dream.

▼ After an Armenian manuscript of 1323, copied by Toros Taronatsi. The dove appears encapsulated by a solid-looking ray of light.

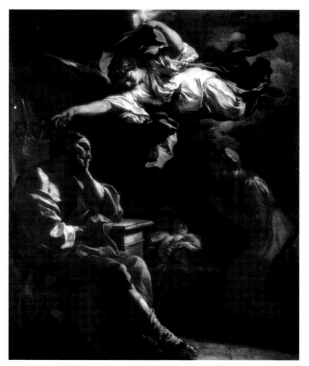

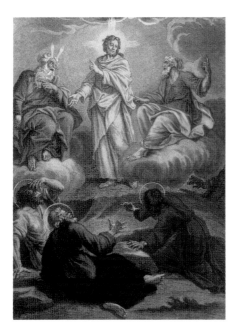

▲ An illustration of the Transfiguration, when three of Jesus' friends saw Him transfigured into a shining white dove – from a family catechism, c 1900.

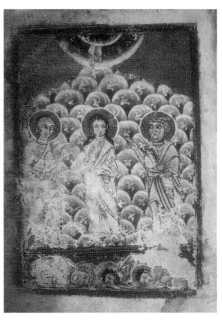

▲ The Transfiguration, from an Armenian manuscript painting by Momik, 1302. When the time came, Moses and Elijah appeared from nowhere and the voice of God was heard.

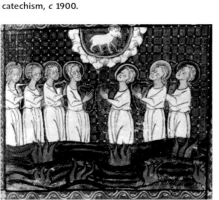

▲ In the Book of Revelation, the Lamb is a symbol for Christ; in this illustrated manuscript, c 1300, the Son of God is depicted as an innocent lamb.

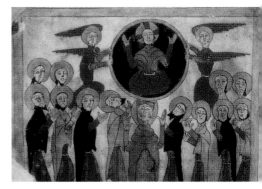

▲ Jesus, surrounded by angels, in an interpretation of the Transfiguration from an Armenian Gospel copied by Melkisedek from a 1338 original.

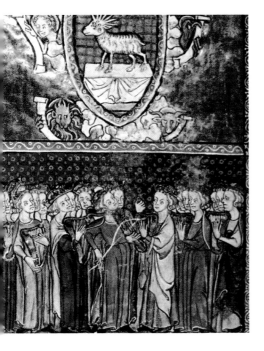

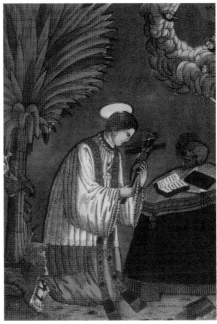

▲ The Selden Apocalypse interpretation (c 1300) of a scene from the Book of Revelation: the Lamb stands upon the throne, flanked by four beasts.

▲ The cloud framing heaven, upper right, defines God's presence in this 19th-century French woodcut of a devotional scene.

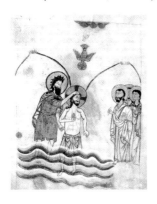

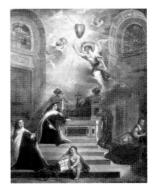

▲ God releases the Holy Spirit as a dove as Jesus is baptized. Copied by Vardan, c 1319.

▲ Jesus being baptized, beneath God the Father and the Holy Spirit in this c 1268 painting.

▲ A sacred heart representing Christ is pierced with a sword in this 20th-century painting.

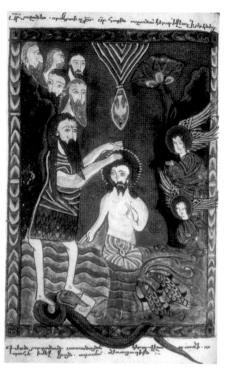

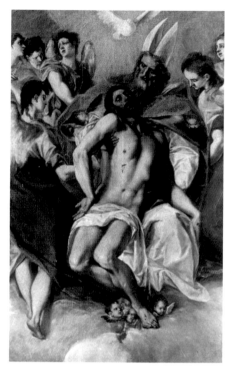

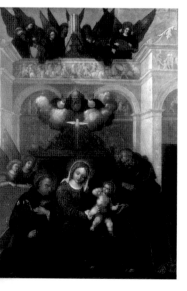

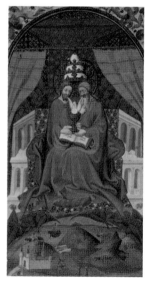

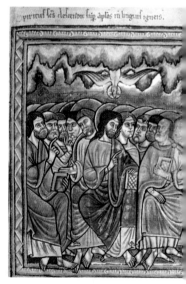

◀ Opposite

Clockwise from Left

The serpent on the riverbank in this baptism scene alludes to Christ's temptation in the desert by Satan.

In a painting of 1577, El Greco (1541–1614) portrays the Holy Trinity at the time of Christ's death: God the Father supports God the Son while God the Holy Spirit hovers above.

The Holy Spirit, once again represented by a dove, flies above Christ and His disciples in an illuminated manuscript dated *c* 1300.

Father and Son share the same cloak in this picture from the Bedford Hours, dated 1423. The Holy Spirit flies between them, with a chalice and book.

'The Holy Family with St Nicholas of Tolentino', painted by Ludovico Mazzolino (1480–1528) between 1515 and his death. The setting is formal; there are angels in attendance and the presence of music is implied by the organ pipes.

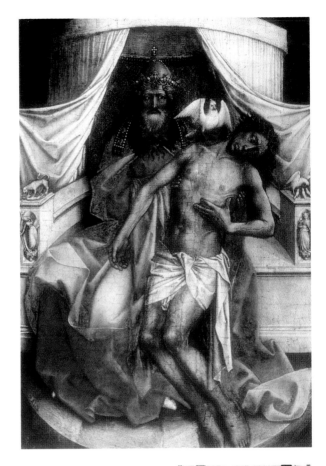

▲ This intimate look at the Holy Trinity was painted by Robert Campin (1375–1444). God the Father holds the dead Christ and, for once, the dove of the Holy Spirit is perching, rather than flying.

▶ An 18th-century Slavonic miniature, with the Holy Trinity surrounded by saints, including Matthew, Mark, Luke and John.

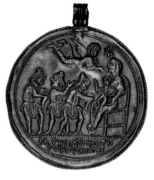

▲ An early 20th-century French woodcut: the Christ Child is held by St Stanislas de Kostka; the Madonna lily alludes to His mother, the Virgin Mary.

▲ The Magi come to worship the Christ Child on this gold medallion, from Byzantium (Istanbul), c 600. The angel represents God the Father.

▲ Made in Italy, c 1860, this micro-mosaic brooch uses a haloed Lamb as a symbol of Christ.

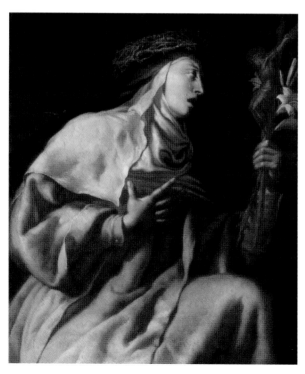

◀ The crucifix, a reminder of Christ's sacrifice, is used as a focus for worship in this painting by Guido Cagnacci (1601–1681). The lily is associated with the Virgin Mary and the Annunciation.

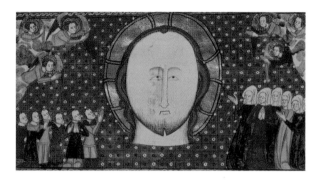

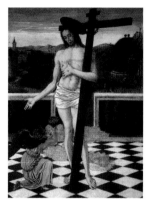

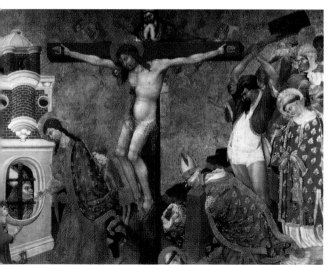

◄ **Clockwise**
The head of Christ, flanked by angels and ranks of ordinary mortals, from a 14th-century encyclopedia of canon law.

'The Blood of the Redeemer', painted between 1460–1465 by Giovanni Bellini (1430–1516). An angel catches Christ's blood; the frieze behind Him portrays figures from faiths superseded by Christianity.

In 'The Martyrdom of St Denis', painted by Henri Bellechose in 1416, the body of Christ is shown both physically (on the Cross) and symbolically (in the sacrament being administered in the bottom left of the picture).

By an imitator of Mantegna, 'The Resurrection' shows Christ standing tall, having risen from the tomb. The strong triangular composition is a subconscious reminder of the Trinity. Painted between 1460 and 1550.

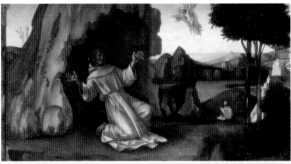

◀ St Francis formed the Franciscan Order of monks. Francesco Raibolini's (1450–1517) 'St Francis Receiving the Stigmata' shows the moment in 1224 when St Francis received the wounds of God.

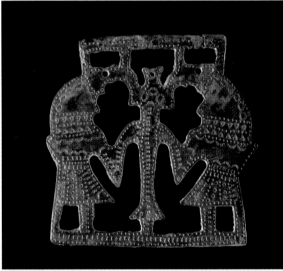

◀ A seventh-century Châtelaine plate which, when viewed at the correct angle, shows a fish between two eagles. While a fish is a common Christian symbol, the eagle may come to represent Christ.

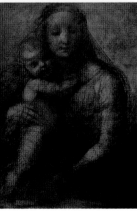

◀◀ An ethereal image of Christ has been worked into a leaf skeleton, a symbol of growth and the cyclical, from 1839.

◀ Raphael Sanzio's (1483–1520) 'Virgin and Child', c 1510, is a sensitively expressed portrayal of a loving and trusting relationship.

▸ With His left hand on an orb, Christ gives a blessing in 'The Devotion of the Holy Face', from a German 15th-century Book of Hours.

▸▸ Christ seems to catch the spectator's eye in this mosaic from 12th-century Turkey, inviting him or her to make the link between heaven and earth.

▸ Stained glass emphasizes Christ's radiance – while the dense colours of the background obscure the light, the paler tones comprising the figure admit it.

▸▸ A 14th-century stone carving of Christ in His tomb. The figures on the side are the Roman soldiers who fell asleep guarding the tomb.

▸ A lithograph from *L'Inde Française*. Brahma is the first god of the Hindu trinity. He appears here with five heads but often he is pictured with four; there are various accounts of what happened to the fifth.

▸▸ Trimurti, the Hindu trinity, comprises Brahma, Vishnu and Shiva. This is a 10th-century bust of a five-headed Shiva.

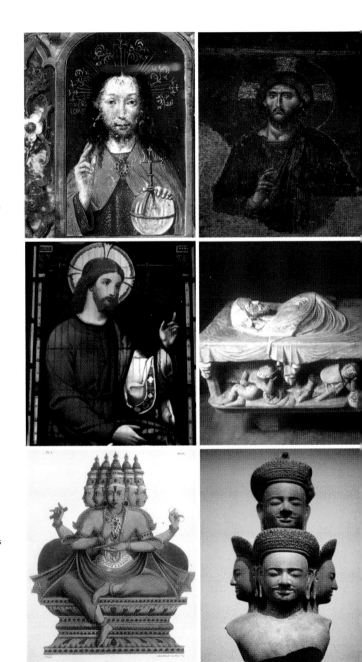

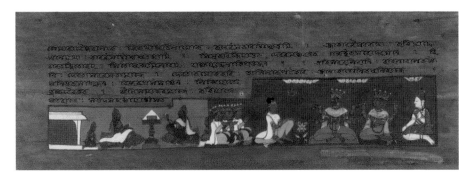

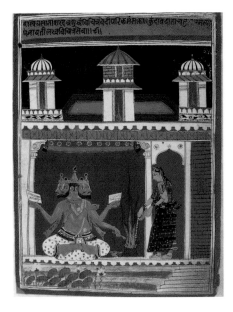

⤒ From a manuscript dated 1839, the Hindu trinity – Brahma, Vishnu and Shiva – grant an interview in heaven to members of the faithful.

▲ **Left to Right**

Krishna is a Hindu deity and an avatar (incarnation) of Vishnu. This is a 17th-century illustration for an epic poem, the *Mahabharata*, and shows Krishna on a horse.

The trimurti sit together in an Indian engraving from 1880. Brahma embodies the passion that creates; Vishnu symbolizes balance; and Shiva signifies the fire that destroys.

◀ A painting, made after an Indian miniature from the 18th century, shows an offering being made to Brahma, the 'Absolute'.

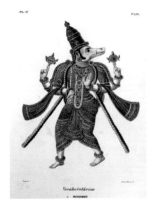

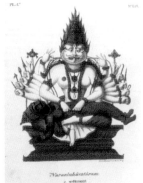

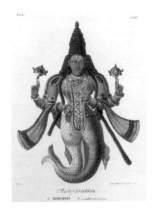

Shiva et sa femme Parvati.
८ शिव: पार्वती ए हिरवर पारवति १

▲ Left to Right

In a lithograph of 1828, *L'Inde Française*, we see Vishnu in his third avatar.

Also from *L'Inde Française*, a lithograph of Vishnu in his fourth avatar, Narashima, the man-lion. Although a bloodthirsty figure, he is sometimes portrayed in yogic posture.

A third lithograph from *L'Inde Française* presents Vishnu in the form of a fish, Matsya, his first avatar.

◄ Shiva is seen here with his wife, Parvati, whose name means 'daughter of the mountain'. From *L'Inde Française*, 1828.

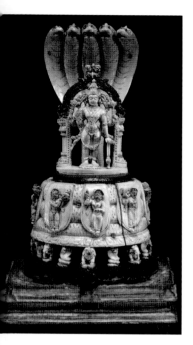

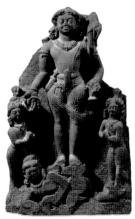

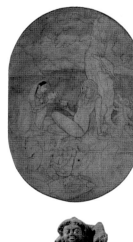

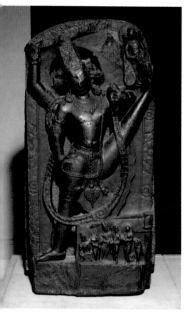

◀◀ An Indian ivory carving of Vishnu sheltered by Ananta, the cosmic snake. This elaborate figure, produced in the 18th century, would have been for use in a domestic shrine.

◀ 'Shiva, Parvati and their Children on Mount Kailash', an Indian drawing from c 1800. A snake coils around Shiva's neck and Parvati pours him a drink.

◀ This stele from India, carved c 700, shows Shiva breaking the back of Apasmara, the demonic dwarf who personifies ignorance and also epilepsy.

◀◀ A 10th-century Indian panel in which Vishnu appears as Trivikrama, or Vamana. In this avatar, Vishnu tricked the demon king Bali into restoring the world to the gods.

◀ In this stone carving, Shiva and Parvati are relaxing, attended by a number of smaller figures.

◄ A painting from India, dated 1865, of the goddess Lakshmi in a lotus plant. When shown with four arms, Lakshmi is the Hindu goddess of wealth, and when she has two, as here, she is regarded as the embodiment of beauty.

▼ **Left to Right**

Vishnu in the form of Rama, hero of the Hindu epic *Ramayama*, in a lithograph from *L'Inde Française*, 1828.

From *L'Inde Française*, 1828, a portrayal of Vishnu in his avatar as a turtle.

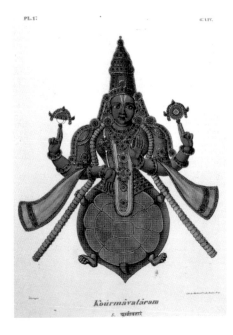

Kourmâvatâram
s. कुर्मावतारं

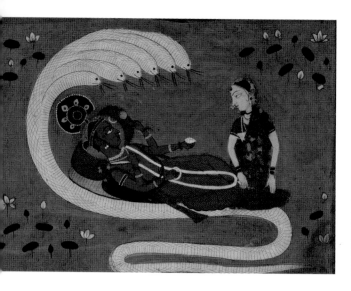

 ▲ In the *Bhagavata Purana*, 1780, Vishnu reclines on the cosmic serpent Ananta, while Lakshmi kneels at his feet.

 ▼ These bronze figures of Vishnu and his voluptuous consorts Bhu and Shri are from India and were cast *c* 1000AD.

 ▲ A 10th-century stele presents Vishnu as protector of spiritual, temporal and moral order.

▼ Goddess Parvati sits with her elephant-headed son, the god Ganesh, in her arms, *c* 1865.

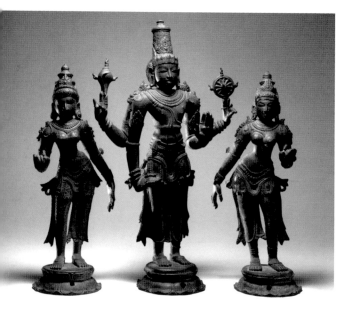

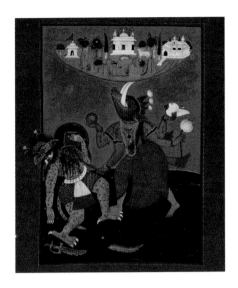

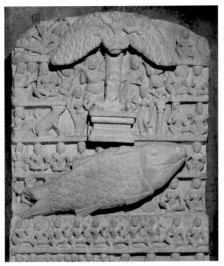

▲ Vishnu, with his attributes – the discus, conch, lotus and a club, attacks a sea demon in the form of a boar. From northern India, c 1740.

▲ On this ninth-century stele, Vishnu is portrayed as Matsya . In times of instability, Vishnu descended in one of his avatars to restore balance.

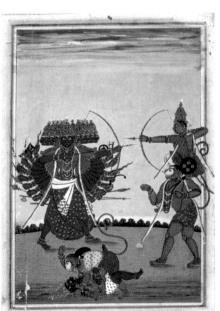

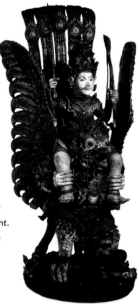

◄ A 19th-century depiction of Rama (an avatar of Vishnu) on Hanuman's shoulders, fighting Ravana in the epic *Ramayama*.

▶ Important Hindu gods have animals as vehicles. Vishnu has Garuda, which can be summoned by thought. This is a 20th-century Indonesian figure.

◀ This Hindu mother goddess, or matrika, is from sixth-century India. The goddess, her divinity confirmed here by the halo, appears tender and voluptuous, but she can take on many forms and characters.

▼ A statue of the Hindu goddess Kali in Tamil Nadu, southern India. Kali is the ferocious aspect of Devi and consumes time.

▲ The goddess Durga's nature is aggressive, as can be surmised from the weapons she carries. Usually, her vehicle is a tiger or lion symbolizing that fierceness.

▼ In a relatively modern painting from Orissa state in eastern India, dated 1960, Krishna attacks the crocodile-like Makara.

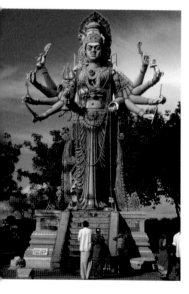

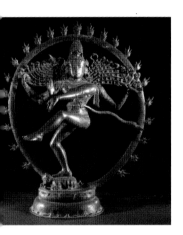

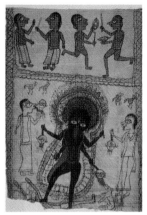

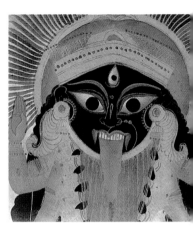

▲ Shiva in the form of Nataraja, the cosmic dancer. A bronze from southern India, dating from *c* 1100,

▲ Kali, often depicted with human heads and looking frenzied, holds two bloody heads while her companions hold, and devour, even more.

▲ The goddess Kali stands for the realities of death and the inevitable passing of time. She is portrayed on this occasion with four arms and a lolling tongue.

▶ A Hindu deity from a temple in Tamil Nadu, southern India. Temples are homes for the gods who are invoked by the prayers of the faithful.

▶▶ From Tamil Naduc in southern India, and dating from *c* 950, this man–lion sculpture is Narasimha, an avatar of Vishnu.

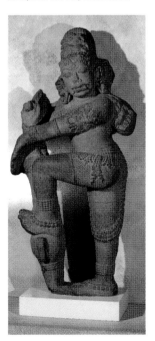

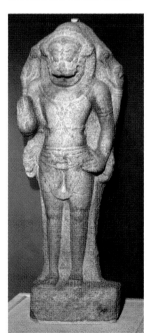

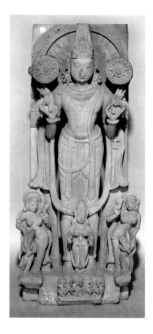

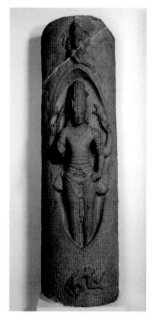

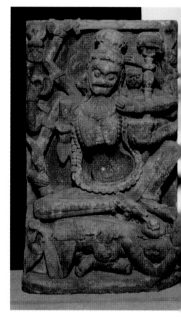

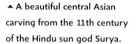

▲ A beautiful central Asian carving from the 11th century of the Hindu sun god Surya.

▲ Shiva, with a falling figure below him. From Tamil Nadu, southern India, c 900.

▲ A ninth-century carving from eastern India of Chamunda, the fierce and protective form of Devi, with a fearsome face and eight arms.

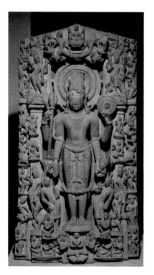

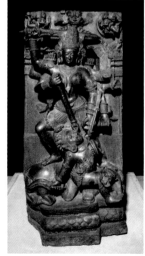

◀◀ The Hindu deity Hari–Hara is a combination of Vishnu and Shiva. At one time this 10th-century carving would have decorated a Hindu temple.

◀ Durga is beautiful, divine and hard to approach, as the weapons bear witness. In Hindu mythology, she killed a water buffalo demon that threatened cosmic order. A 13th-century sculpture from the Orissa state, eastern India.

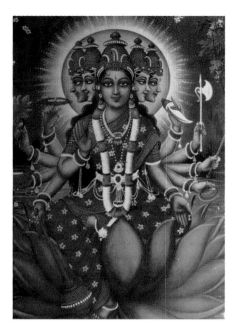

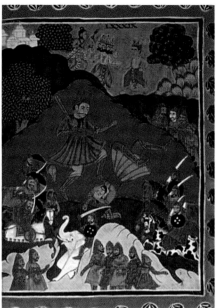

▲ In this 20th-century image, the Hindu goddess Lakshmi sits in one lotus flower and holds another in one of her eight arms.

▼ Gods, princes and ordinary Hindus approach Rama for a blessing in the *Ramayama*. Painted in India, in 1713.

▲ In a scene from the epic, the *Mahabharata*, Krishna, Brahma and Shiva watch as Bhima goes into battle with Duryodhana.

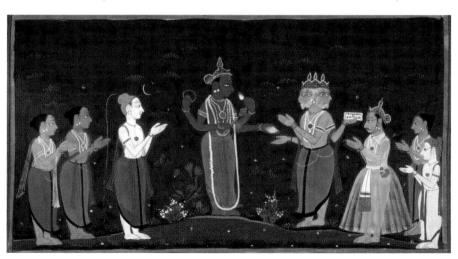

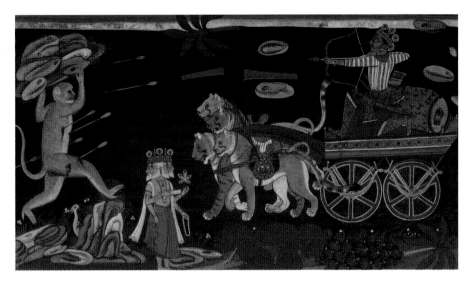

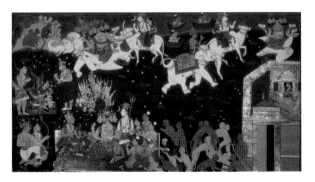

▲ An Indian illustration from 1653 of the epic *Ramayana*, in which Hanuman, the monkey king who helped Rama, can be seen fighting with Indrajita.

◀ In this scene from the *Bhagavata Purana*, Rama and Sita sit in the cosmic serpent with a large lotus flower. Painted in India, 1863.

◀ Painted in India in 1713, this lively, festive scene, with many deities, monkeys and elephants, comes from the *Ramayama*.

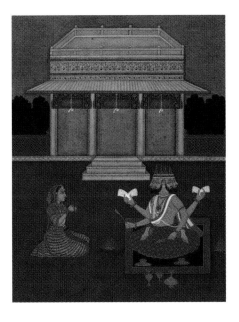

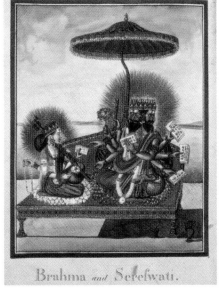

Brahma and Saraswati.

▲ A peaceful scene of worship of the Hindu god Brahma. From the 1760 'Ragamala' series of paintings, which celebrate poetry and music.

▲ Brahma and his consort Saraswati, who is the patron of learning and the arts, are seen here in this 1802 version of *Adhyatma Ramayama*.

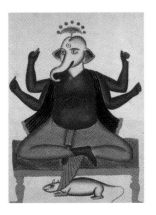

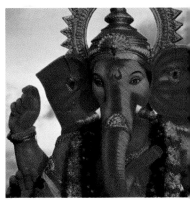

▲ This stone carving from the 13th century is of Ganesh, the elephant-headed son of Shiva and Parvati.

▲ Ganesh is routinely invoked because he removes obstacles and brings success. The rat in this c 1900 image is his vehicle.

▲ A lavishly decorated Ganesh, with human eyes and multiple hands, is the subject of this 20th-century poster.

▲ Sacred to the Ainus of northern Japan, a young bear is reared in captivity. The whole community then takes part in its sacrifice and the deification of the carcass.

▼ In North American shamanism, the war gods are invoked through ritual dance and prayer.

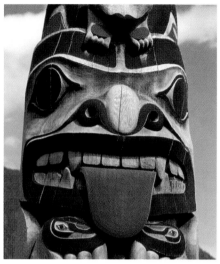

▲ The word 'totem' comes from the Ojibwa of Canada 'dotem', meaning 'he is a relative'. Ojibwa clans identify with animals and hence the use of animal masks and features in their own totems.

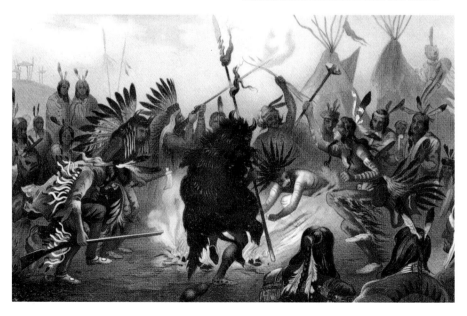

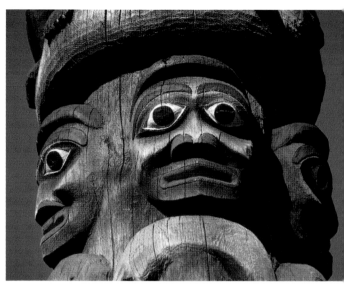

▲ Left to Right

Katsina are benevolent spirits who live among the Hopi of New Mexico during the winter months. A lightening katsina doll such as this one embodies the spirits and expresses the benefits of the rains.

A detail of the Thunderbird Park Totem Pole in Canada. In 1940, a number of old totem poles were erected in Victoria to preserve them as a collection, but by 1950 they had begun to deteriorate. A restoration programme was then initiated and the totems can be visited today.

◄ Painted in North America in the 20th century, after Gordon Wain, this is a shaman dressed in traditional costume, with horns and feathers.

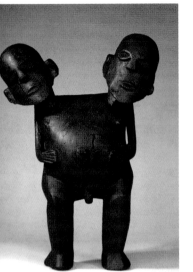

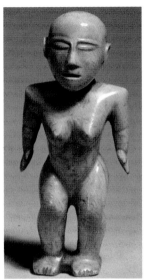

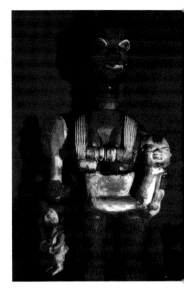

▲ A witch doctor from Turkana, East Africa. Because he draws on the unseen spirit world to exercise his powers, a witch doctor's powers are considered innate.

▲ **Left to Right**

Figures such as these from French Polynesia may have been lesser gods in pre-Christian times, but with the spread of Christianity, they were appropriated by sorcerers to invoke harmful spirits.

An 18th- or 19th-century ivory figure from Tonga, Polynesia. It is thought to represent a goddess, possibly Hikuelo, who stood for the afterworld. Such figures were either worn as pendants or hung in a temple.

The Yoruba people in West Africa make Abbiamo magical figures. This is a woman with a child and a magic mirror, full of mystery and power.

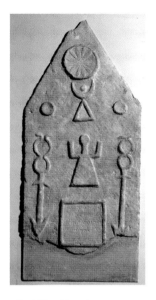

▸ **Clockwise from Left**
A limestone stele from Carthage (Tunisia), dating from 200–100BC. The sun disc, crescent moon and triangle form one representation of the goddess Tanit, while the anthropomorphized (human-shaped) version forms a more earthbound one.

A 19th-century beaded crown from the Yoruba. The crown, or orisha, would be worn by kings whose ancestry can be traced back to Odudua, the mystic first king of the Yoruba people. The veil occludes the king's face and draws attention to the crown, a deity and centre of power itself.

Representing an ancestor within the ceremonial house, this wooden mask from Micronesia would be appeased for the protection of crops. Probably 19th century in origin.

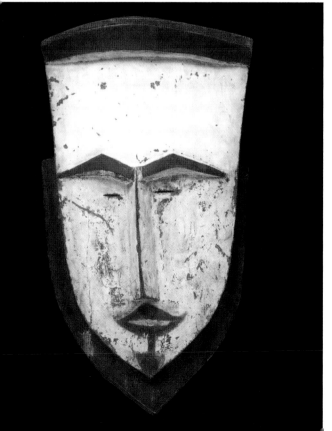

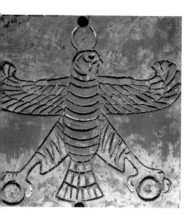

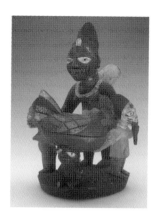

▲ The birdlike symbol of the Zoroastrians, one of the smallest of the world's major religions. It represents their god, who has no physical form. The religion has had significant influence on other faiths.

▲ Ivory armlet made by the Edo peoples of Benin, Nigeria. This is worn by the king, who is represented by the figure with arms aloft and legs of mudfish – it is thus connected to the sky and to Olokun, god of the sea.

▲ An 'Adjella-ifa' ritual bowl from the Yoruba, used to find the cause of illness. The bowl shows a hen supported by figures including the trickster god Eshu, who carries human sacrifices to Ifa in the ceremony.

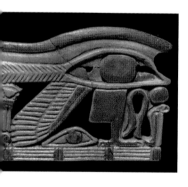

▲ A wedjat eye amulet, from Egypt, 1068–661BC, made of faience. The turquoise colour represented regeneration to the Egyptians. The word 'wedjat' means 'the sound one' and refers to the left eye of Horus, plucked by his rival Seth.

▲ The Egyptian god Bes, from Cyprus, 600–500BC. The figure first arrived in Cyprus in the late Bronze age and shows an Egyptian influence.

▲ Quartzite head of Egyptian King Amenhotep III, c 1350BC. While most statues show the king as ageless, he is portrayed here looking young, possibly following a Sed festival when his powers were meant to have been symbolically rejuvenated.

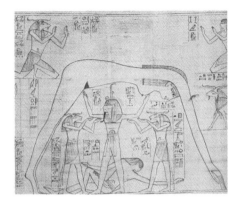

▲ From the Greenfield Papyrus, c 970BC. The cosmos is represented by the Egyptian goddesses Nut (sky), Qeb (earth) and Shu (air).

▶ Dated to after 600BC, this stele shows Horus standing on crocodiles and holding snakes. The god Bes oversees the healing of bites and stings.

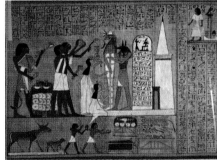

▲ From Hunefer's Book of the Dead, c 1300BC. The mummy of Hunefer stands supported by a god or priest in a jackal mask, while the family mourns and other priests perform funeral rites.

◀ An Egyptian relief, dated c 2050BC, showing Mentuhotep II embracing the god Montu, the supreme deity of the Theban region at the time.

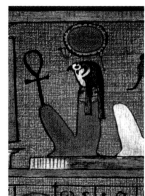

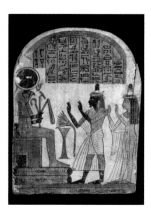

▲ A wall painting at the Temple of Ramses II in Egypt. Thoth, the secretary of the Egyptian gods who lists births and deaths, is shown holding a wand.

▲ The ankh, a cross with a looped top, symbolizes eternal life. In this Egyptian Book of the Dead, we can see one with a Horus-headed god.

▲ On a wooden stele from Egypt, c 900BC, Re-Horakhty, the god of the horizon, is revered by Nakhtefmut and his daughter Shepeniset.

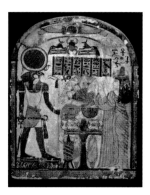

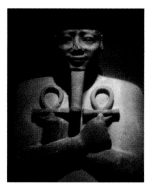

▲ Deniuenkhons (the figure in the diaphanous robe) makes offerings to Re, the Egyptian sun god. Re was believed to be able to restore life to the dead. Here he is in composite form as Re-Horakhty-Atum, embracing aspects of the sun and the horizon.

▲ From Egypt, c 1450BC, this is the bearded figure of King Thutmose III holding two ankhs, the symbol of life.

▶ On a four-sided sculpture, dated c 1450BC, are King Thutmose III, the god Montu-Re and the goddess Hathor.

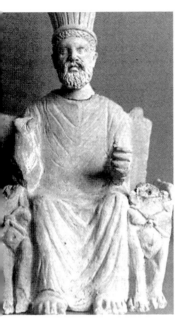
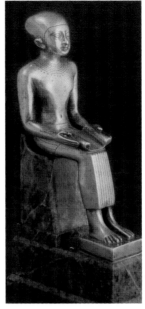
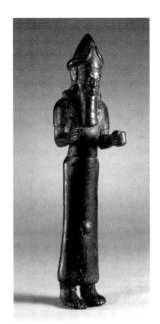

▲ Left to Right

Baal Hammon was the principal god of Carthage, the Phoenician colony in North Africa. He would have been guarded by the beasts at each side of his throne.

Imhotep, physician and adviser to King Zoser, came to be regarded as a sage and worshipped as the life-giving son of Ptah, god of Memphis. Here, we see him in a statuette with a scroll, from 600–500BC.

This Urartian god is from Urmia (Iran) or Van (Turkey), during the 800–700BC. The horned headdress is probably of Mesopotamian influence.

▶ From the Trois Frères cave in France, *c* 14000BC, this wall engraving shows a sorcerer or medicine man with stag's horns, wolf's ears, an owl's face, bear's forelegs, and a horse's tail. This composite figure combines various attributes for the maximum potency.

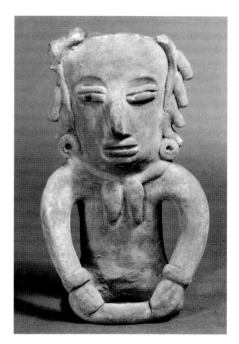

▲ An Inuit shaman depiction shows the inner and outer forms of an armed figure. Inuits believe that our world is linked with others superimposed upon one another and the shaman can move between them when they are in trance states.

▼ This shaman charm represents a killer whale.

▲ Probably a minor domestic deity, this vulnerable-looking figure is now in the Totonac Abbey Museum in Mexico.

▼ Voodooists celebrate Ogoun, the spirit of war, at an annual festival in Haiti. Ogoun's Catholic counterpart is St Jacques.

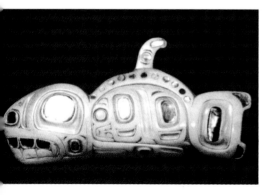

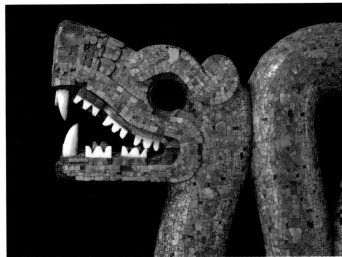

▲ Left to Right

From Charles Leadbeater's *Man, Visible and Invisible* (1909). The crown of radiance shows spiritual activity, as revealed by clairvoyance.

A mosaic serpent from Mexico, 15th–16th century. The word for serpent in Nahuatl, the Aztec language, is 'coatl', which lends itself to many place names, such as Coatepec, 'The Hill of the Serpents', birthplace of principal Aztec god Huitzilopochtli.

▶ This seated Aztec figure, c 1450, is carefully formed with headdress, leg-wear and sandals. He may have come from a temple but is now in the Reissmuseum in Germany.

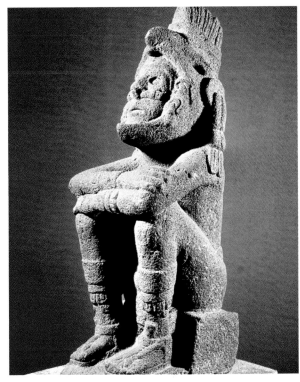

▲ Two spirit drawings made through the medium William Eglington. The figure of Christ bears the signature of Wilhelmina Nichols, who had died 13 years earlier in 1883. From *Twixt Two Worlds* by John S Farmer.

◀ This chromolithograph shows a spirit hand materializing during a seance conducted in 1884 by William Eglington. The illustration is also from *Twixt Two Worlds* by John S Farmer.

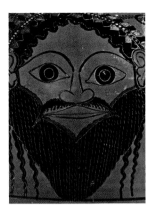

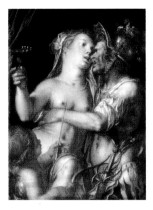

◀◀ A bold and upbeat interpretation of Dionysus, the Greek god of wine, on an amphora.

◀ Here, we see the union of War and Love as the Roman gods Mars and Venus share a wine cup and an embrace. Painting 'Mars and Venus surprised by Vulcan', by J Wittwael (1566–1638).

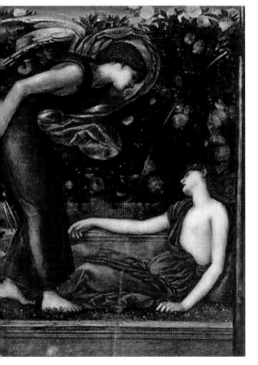

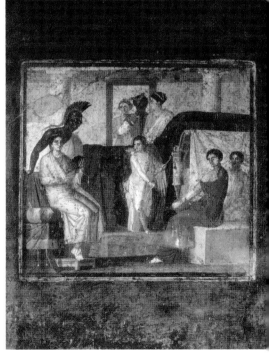

▲ 'Cupid Finding Psyche', painted in 1866 by Sir Edward Burne-Jones (1833–1898). Cupid falls in love with Psyche (representing the yearning of the human soul), having been sent by Venus to destroy her.

▲ The marriage of Mars and Venus, shown here on a first-century painting from Pompeii, is a rich depiction of the incongruous – the coming together of the god of war and goddess of love and beauty.

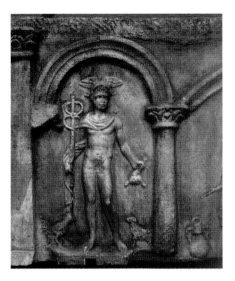

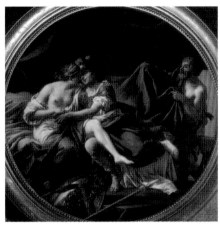

▲ Mercury, god of travel and commerce, appears here in relief on the sarcophagus of a Roman wine merchant.

▲ 'Mars and Venus Surprised by Vulcan'. Vulcan was the Roman god of fire and metalworking. By Louis Jean François Lagrenée (1725–1805).

◄ A depiction of the underworld by François de Nome (1593–1644). The artist's idea of the underworld is clearly one of gothic doom, where the light is bloody and sinister.

▼ 'The Introduction of the Cult of Cybele to Rome', by Andrea Mantegna (1431–1506). Cybele, Eastern goddess of victory, fell to earth as a meteorite. She is represented here with her sacred stone.

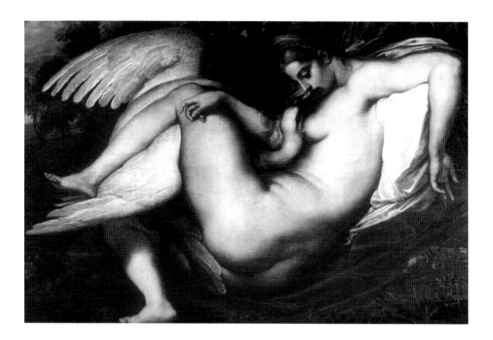

▲ An abstract concept is described here by Rubens, c 1598, in 'Leda and the Swan'. The Greek god Zeus, in the form of a swan, seduced Leda while she was bathing. She produced two eggs, inside which were the twins Castor and Pollux.

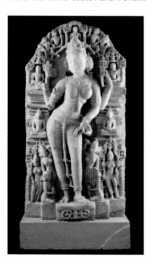

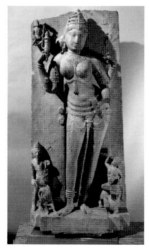

◄ **Left to Right**

A Jain goddess of knowledge, Sarasvati, from central India, early 11th century. Knowledge plays an important part along the road to salvation for Jains, and Sarasvati is often found in libraries. She is attended here by Tirthankaras and other figures.

Ambika, like Sarasvati, is known to Hindus as well as Jains. In this Jain depiction, she is in the company of her mount, the lion (bottom right), and her two sons. An inscription dates this to 1034AD.

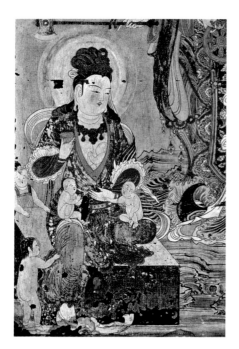

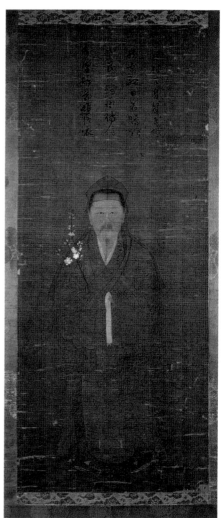

⤒ Kishimo-Jin is a Japanese goddess and mother of demons. This painting came from the shrine of Kishijoten, the goddess of luck and beauty.

▲ A 19th-century depiction of a king and his retinue honouring Buddha, who is attended by priests and monks. European visitors look on.

▲ The Japanese Sugawara-no-Michizane, the patron of scholarship, is shown here in Chinese dress and holding a plum blossom, the sign of a Chinese gentleman scholar. This cross-cultural styling may be a reference to his legendary posthumous study of Zen, after he became a Shinto deity and was renamed Karai Tenjin.

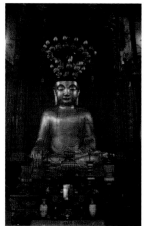

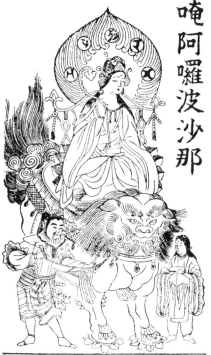

唵
阿
囉
波
沙
那

堂珠文立橋ノ天後丹

▲ Left to Right

In this 19th-century painting, Buddha contemplates the flame as a symbol of life, while standing in a simplified landscape.

Offerings have been brought to honour this representation of the Buddha at a temple in Guangdong, China.

The cheery, woodcut figure of Daikoku, just one of seven Japanese gods of luck, wealth and happiness.

◀ A Japanese Buddhist woodcut celebrates Monju-Bosatsu, the symbol of wisdom and female enlightenment. She rides a lion and has attendants to her left and right.

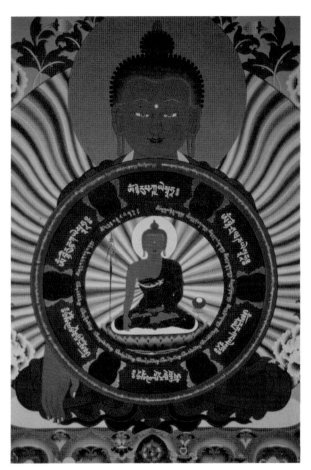

▸ **Opposite**
Clockwise from Left
A 14th-century scroll painting of Avolokiteshavara, Bodhisattva of compassion. Bodhisattvas pursue enlightenment to help others and he tried to save others from suffering in this life.

The Buddha Amitabha, 'He of Immeasurable Light', from Hebei, northern China, c 585AD. Buddhism's adaptability and inclusiveness meant it used local motifs in places where it was alien to indigenous tradition – this statue is far more Chinese in appearance than Indian.

This seventh-century bronze Amitabha Buddha comes from Silla in Korea. Buddhism reached Korea through China.

These expressive Buddhist sculptures are from the Kabul Museum in Afghanistan.

▲ Found in the Dzongsar Buddhist monastery, India, this painting represents the dynamics and cycles of inner and outer existence.

▸ A Tibetan statuette from the 19th century. In Tibetan Buddhism, dakinis ('sky walkers') possess supernatural wisdom and power. Sarvabuddhadakini, shown here, holds a curved dagger and a skull-cup of blood.

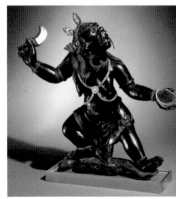

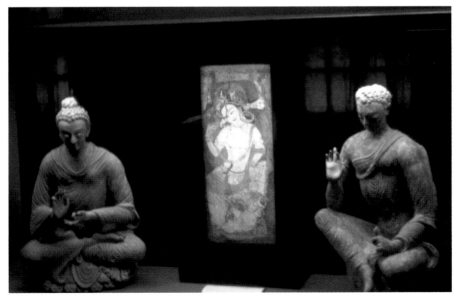

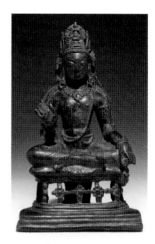

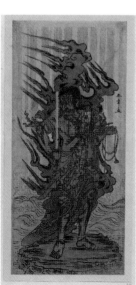

▲ 'The Great Renunciation', an 18th-century Korean painting on hemp cloth. The future Buddha saw 'four sights': a sick man, an old man, a corpse and an ascetic. These helped him to understand the transience of life and renounce his comfortable palace lifestyle.

◀ Fudo Myo-o, the Japanese Buddhist deity, is shown in this depiction from 1780 with a sword in one hand to cut through evil and a rope to bind the enemies of enlightenment. He stands surrounded by flames.

⤒ This 10th-century figure from Afghanistan expresses an idea of the future. It is a bronze of Maitreya, the 'loving one', who is expected to come as the fifth and last of the Buddhas.

▲ A second-century limestone roundel showing two Buddhist deities sitting on a throne surrounded by women who dance and play music.

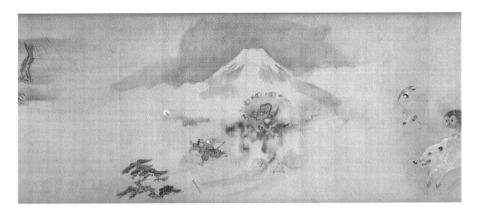

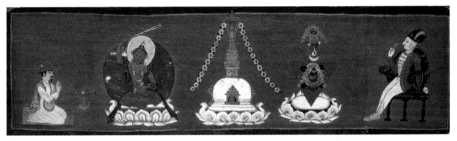

⬆ The Buddhist thunder-god, Raijin, has startled a flying demon. It flees from the sound of Raijin's ring of drums. An owl and a wild boar watch from one side. From 17th-century Japan.

▲ Captain W D Knox of the East India Company is patron of a manuscript telling the story of the early life of Buddha. On the lid of this manuscript box, he is portrayed as an avatar of Buddha. From the *Lalitavistara*, Nepal, 1803.

▶ Han Xiang was a talented and prodigal young man who once wrote poetry about flowers that bloomed spontaneously, before producing some from the earth. Later, he studied under the Taoist patriarch Lu Yan, who took him into the peach tree of the gods. Han Xiang tumbled from its branches into eternal life, becoming Han Xiangzi, one of the Eight Immortals, and he is recognized by his flute.

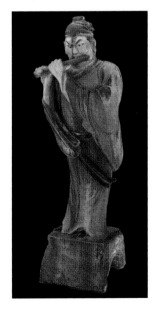

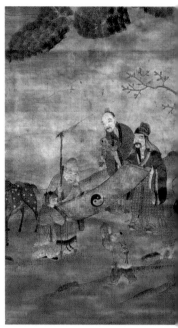

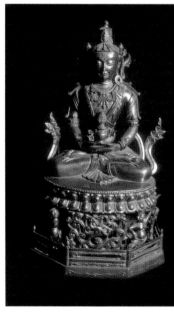

▲ Cao Dai, or 'Supreme Palace', is an eclectic synthesis of religions started in Vietnam in 1919. This image comes from the Cao Dai temple in Saigon, and shows the Eye of God.

▸ **Top to Bottom**

Tree, deer and peach symbolize longevity in t'ai chi. The Taoist yin-yang sign expresses the interaction of opposites. From 17th- or 18th-century China.

The Amitaba Buddha in his manifestation of Boundless Life. He sits holding a flask of the nectar of immortality. A bronze from 18th-century Tibet.

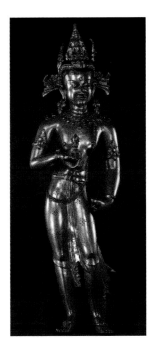

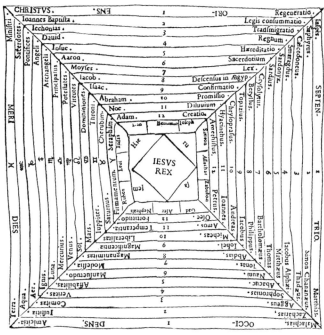

▲ Vajrasattva – beautifully formed in gilded bronze from 15th-century Buddhist Nepal.

▶ **Top to Bottom**
A Christianized version of numerology. At the centre, we have Jesus (five), Rex (three); and then we move on to the Twelve Tribes of Israel, Twelve Stages of Religion, Twelve Sacred Stones, Twelve Disciples, Twelve Human Virtues, and so on. From *Athanasius Kircher*, 1665.

From earth to the Holy Spirit. The idea of this 17th-century diagram is to express the notion of different levels of existence and evolvement. We move from the globe at the bottom of the picture, through earth and water, to the celestial realm and then into the spiritual. The whole is surmounted by a triangle of light representing the Christian Holy Trinity.

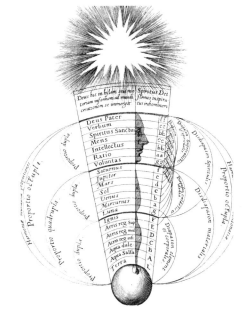

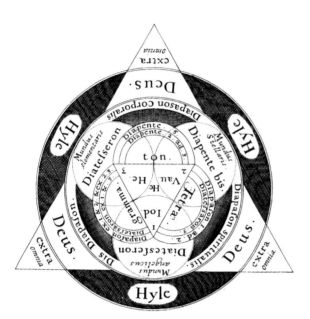

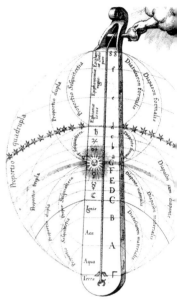

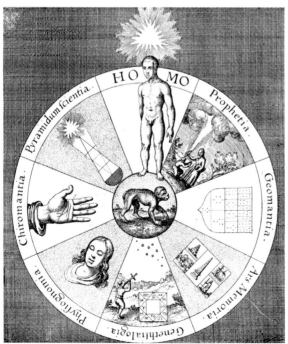

▲ Left to Right

An attempt to pin down an abstract metaphysical notion of God and life into two dimensions.

The hand of God is seen turning the universe into being.

◄ 'Seven Sources of Human Knowledge', from Robert Fludd's *Utriusque Cosmi Historia*, 1617–19. Chiromancy, Prophecy, Physiognomy, Pyramidology, Geomancy, and Astrology were once thought by some to be the way towards greater knowledge and understanding through divination.

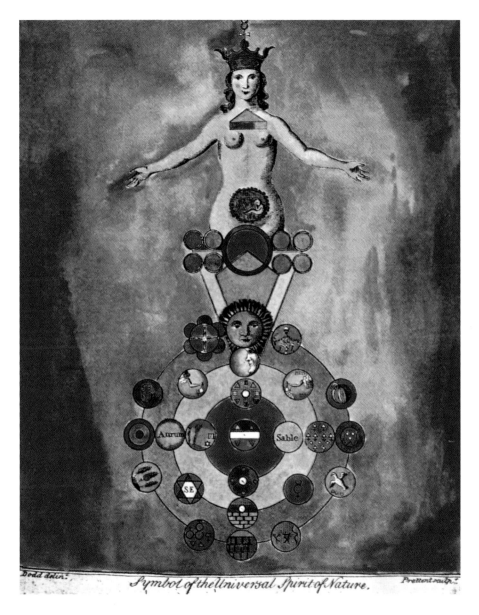

Symbol of the Universal Spirit of Nature.

▲ Early forms of alchemy influenced religions – the idea of turning poor raw materials into something higher having spiritual parallels.

Here, in Ebenezer Sibley's *A Complete Illustration of the Occult Arts* (1790), the Universal Spirit, Anima Mundi, emerges from alchemical signs.

▸ The celestial hierarchies are spelled out in this engraving from 1677. They are surmounted by the three-in-one Godhead, represented in the triangle, and surrounded by radiant beings.

▾ **Left to Right**

'Prayer of Invocation', by Etienne Dinet (1861–1929), shows a study of devotion as the faithful call upon God to hear their prayers. From *La Vie de Mohammed, Prophete d'Allah* (*The Life of Mohammed*).

God is present in Samson's strength as he destroys the Temple of Dagon, god of the Philistines. From a 19th-century lithograph.

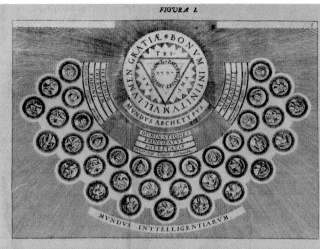

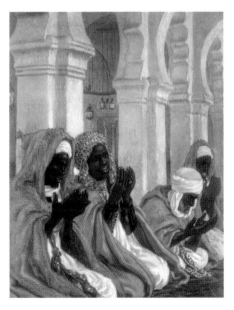

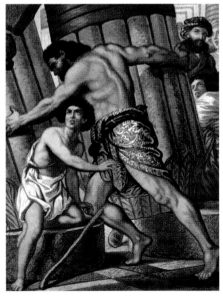

▶ This stone mould, from Nineveh in northern Iraq, c 18th century BC, would have been used for casting figures of the deities. The mass production of the figures would allow gods' presence to be felt by many.

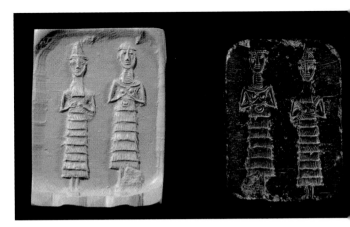

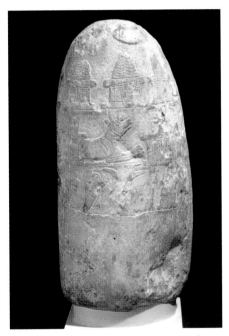

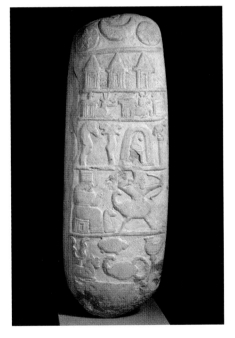

▲ A *kudurru*, or boundary stone, from Mesopotamia, c 1100–1050BC. A cuneiform inscription would have indicated ownership of the land and would have been protected by the names and symbols of gods, which we can see at the top.

▲ Also from Mesopotamia, this *kudurru* dates from c 1125–1104BC. The cuneiform script describes the military services of Ritti-Marduk to King Nebuchadnezzar I. It also bears 24 divine symbols.

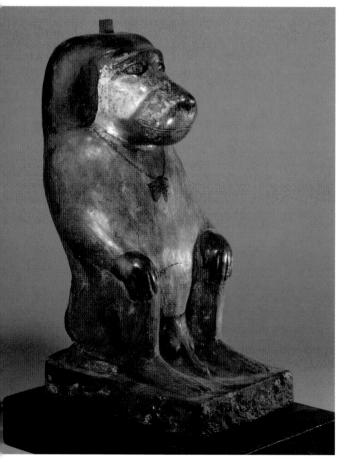

▲ A cylinder seal from Mesopotamia, c 2400–2350BC. The shell seal on the right shows two figures wrestling a stag; meanwhile, two horned gods deal with two bulls. The plaque on the left shows the repeat pattern which comes from the seal.

◀ A crouching baboon from Egypt, from the first to fourth century BC. Originally, the figure would have been surmounted by a moon disc, to highlight its association with the lunar god Thoth.

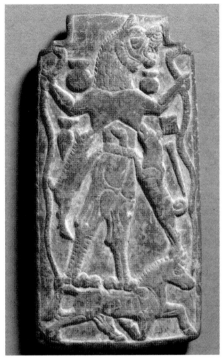

▲ From the Temple of Philae in Egypt. Isis, the Egyptian fertility goddess, holds the symbol of life. She is shown with a sun disc between cow horns.

▶ **Top to Bottom**
Lamashtu is described in texts as having a lion's head, donkey's teeth, a hairy body with naked breasts, stained hands and long fingers with talons. Here, she stands on a donkey, her sacred animal. Not surprisingly, she is often described as a demoness. Yet the writing of her name in cuneiform implies divinity. The carving comes from Mesopotamia, c 800BC.

Limestone stele from Egypt, c 1200BC. The god Seth is shown as a man with an animal's head. Seth personified storms, confusion and possibly evil, yet conversely could be worshipped as being beneficent, as we see here.

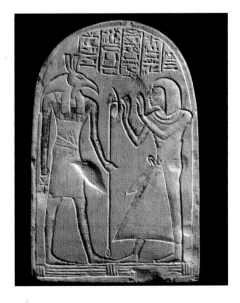

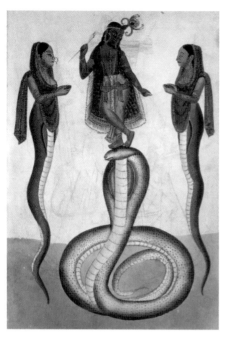

◀ Krishna and two Naginis painted in India, c 1800. Naginis are the wives of demi-gods, and here they take the form of snake spirits paying respect to Krishna.

▼ A 19th-century Kolam dancer's mask from Sri Lanka. The Serpent Demon can be recognized by the crown of coiled serpents and those crawling from its nostrils. It embodies the power of snake venom over human and animal life.

◀ John Constable (1776–1837) captures the power of the English landscape in his 1835 watercolour, 'Stonehenge'. It shows the famous stone circle, a spot where the intangible elements of the world have been honoured since prehistory.

▾ **Left to Right**

A Gaulish sentry regards the moon beside a menhir. To many, perceiving a design and purpose in the natural world implies a designer and thus a maker. By Adrien Guinet (1816–1854).

The bull-man shown on this terracotta plaque suggests a fusion of human rationale with baser, animal instincts. From Mesopotamia, c 2000–1600BC.

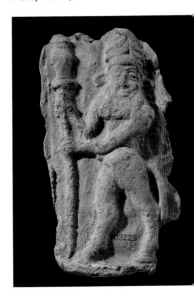

Words of God

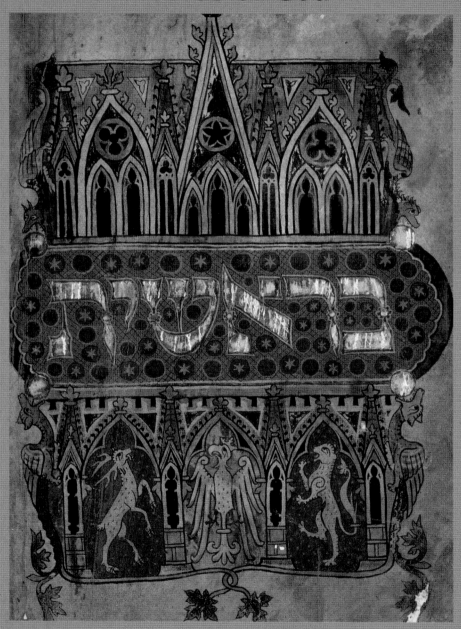

▲ 'The Rabbi', by Jan Styka (1858–1925). The Rabbi (Hebrew for 'master') wears the tefillin, which binds the words of God to the head and left arm.

▲ From the *Liturgy of the Jewish Passover, c* 1350. It reads 'Pour out Thy Wrath', and a tiny figure with a hammer is doing just that. From the *Sister Haggadah*, a service book used on Passover Eve.

▲ The Ark of the Covenant, containing God's words, is carried around the walls of Jericho as they crumble, in this Bible illustration, c 1860.

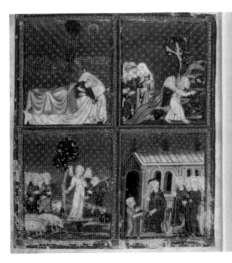

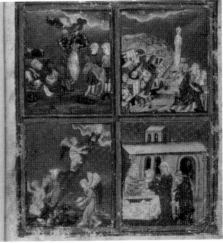

◀ 'In the beginning', the first words from the Book of Genesis. From the Duke of Sussex Pentateuch, by the scribe Hayyim, c 1300.

▲ The pages of *The Golden Haggadah*, illustrated in northern Spain, c 1320, tell the Old Testament stories of Jacob, Lot and Joseph.

▲ Islamic artists must give praise to Allah and this
is expressed in the superb calligraphy of the text in
this Qur'an, dating from 1867.

◀ The Qur'an is the scripture
of Islam, the word of Allah
as revealed to the Prophet
Mohammed between 610
and 632AD. This Turkish
manuscript dates from 1882.

▲ Mohammed received the words of Allah through Jibrail (the Angel Gabriel). They were subsequently written down and later often illuminated, as in this example from Turkey, dated 1882.

▲ An Islamic manuscript from northern India, 1838, shows elaborate, richly coloured decoration based on natural forms that take the mind away from the everyday and move it more deeply into the meaning of the words.

▲ Sultan Baybar's Qur'an, produced in Cairo between 1304 and 1306. The illustrated frontispiece shows natural shapes brought gently into line with formal geometry.

▲ On this 17th-century Qur'an, the Arabic script is framed by lush floral designs that give honour and grandeur to the words.

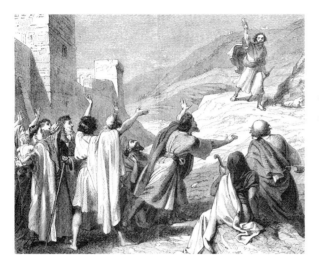

I ncipit malachiaf prophera.

dīn adiſrí in manu malachie .nīte
. ri uoſ dicit dñſ & dixiſhſ. In q̃ di
leriſti noſ.Nonne frat erat eſau ia
cob dicit dñſ.& dilcri iacob eſau
autem odio habui.Et poſui ſar
montes eiuſ in ſolitudine.& here
dirari ei in draconeſ deſerti .Qd ſi
dixerit idumea deſtruchi ſumi.ſeo
reuerremeſ edificabim̃ que deſtruc

▲ In the Book of Isaiah, a voice cries out, 'The Word of our God endures forever... go up on a high mountain and proclaim the good news!' A wood engraving from 1860 illustrates the proclamation.

▲ A page from the Book of Malachi showing the prophet preaching God's Word.

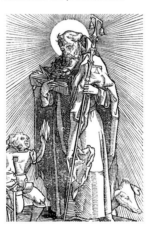

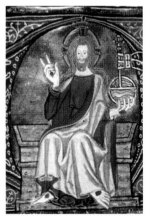

▲ God presents His Word on a 15th-century Latin psalter. Angels sing praise and beasts bow at God's feet.

▲ St Anthony the Great, father of Christian monasticism, is honoured in a woodcut dating from 1517. Monasteries played a huge role in spreading God's Word.

▲ 'The Face of God', from an English Book of Hours, c 1339. Christian manuscripts were written and illuminated in monasteries to spread and glorify God's Word.

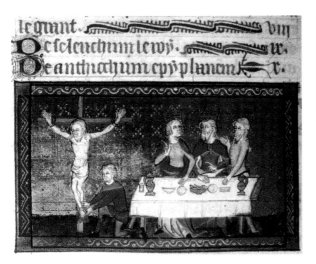

▲ An illuminated manuscript from c 1300 showing Jesus being untied from the Cross next to a group of people at supper. Note that attention to the calligraphy, appearing here at the top of the page, was as important as attending to the illustrations.

▲ Moses receiving the Ten Commandments. The words of the text are in plain view in this Bible illustration, c 1860.

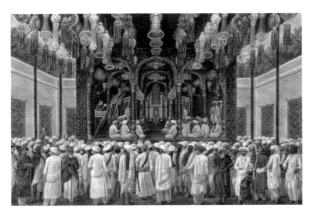

▲ In this painting, dating from India, c 1807, prayers are being said at the Muharram Festival, which occurs in the first month of the Muslim calendar.

▲ For those who did not have access to a Bible or the ability to read it, stone pictures were a way of receiving God's Word. This crucifixion plaque is from eighth- or ninth-century Ireland.

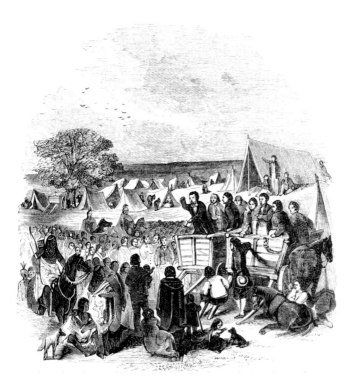

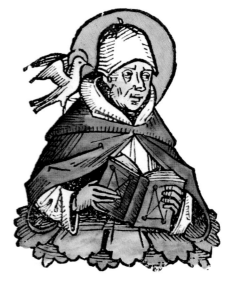

◀ Joseph Smith preaching in the wilderness, *c* 1853. In 1823, the angel Moroni revealed to Smith the location of gold tablets inscribed with God's Word; from this event, the Mormon Church began.

▼ **Left to Right**
St John the Baptist preached on the banks of the River Jordan, urging repentance and baptism to remove sin. This was painted in the late 16th century.

St Thomas Aquinas with a dove, the Holy Spirit, on his shoulder, in a woodcut from 1493. As a theologian and philosopher, he did much to broaden our understanding of God's Word and Christian concepts.

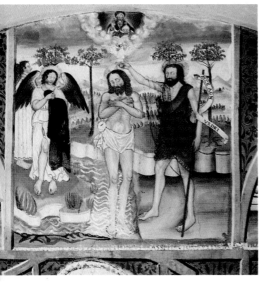

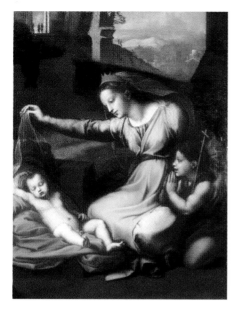

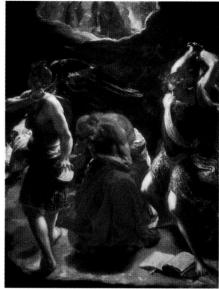

▲ St John the Baptist was related to Jesus because their mothers were cousins, so it is natural to find him as a young child with Jesus in a family scene, like this one, 'The Virgin of the Blue Diadem', by Gianfresco Penne (1488–1528).

▲ 'St Jerome's Dream', by Orazio Borgianni (1578–1616). St Jerome translated many Christian texts, including a Latin version of the Scriptures, during the fourth century. Here, he regrets the dream in which he is tempted by Roman maidens.

▶ A mosaic of Christ, laid in Cefalù Cathedral, Sicily, in the 12th century, shows Him holding the Word of God.

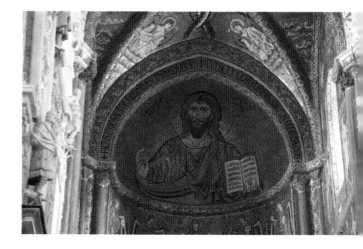

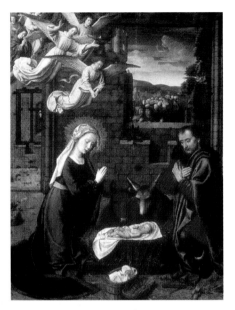

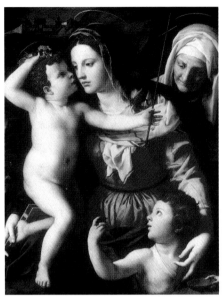

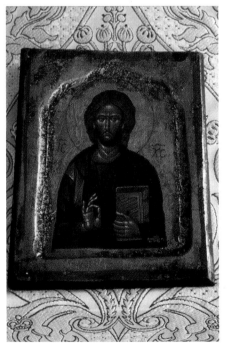

▲ Left to Right

The Gospel of St John tells us that the Word became a human being, the Christ Child. At the time of His birth, the angels brought the news to the shepherds. In this depiction by Gerard Gheeraert (1484–1523), we can see the shepherds approaching through the open window; the angels have come on ahead and point to the child.

St John the Baptist is shown here with the Christ Child, the Virgin and John's mother, Elizabeth.

◀ A Russian icon, *c* 1843, showing Christ Pantocrator, meaning 'Ruler of All'. In His hand is a book symbolizing the Word of God.

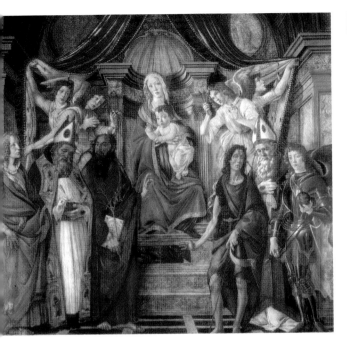

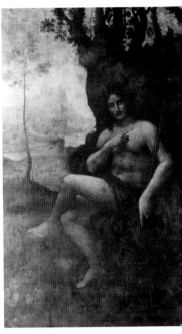

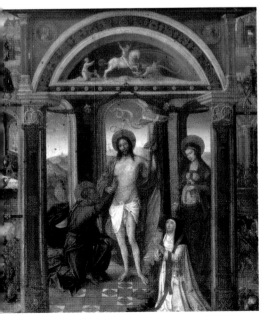

▲ Left to Right

All the figures attending this scene were responsible for the spread and execution of God's Word.

St John the Baptist dressed in animal skins and with the attributes of Dionysus – an oddcombination of abstinence and wine but possibly a reference to wine as a symbol for Christ's blood. Attributed to Leonardo da Vinci.

◀ 'Do not doubt but believe' were Christ's words to Thomas when he doubted the Resurrection, depicted here in a painting from the School of Antwerp, c 1560.

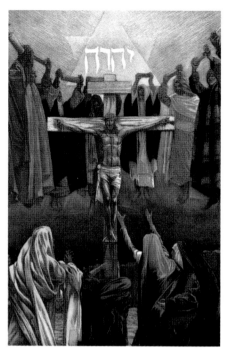

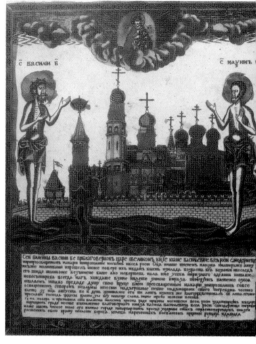

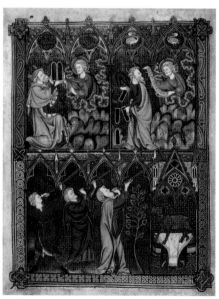

◀ Opposite
Clockwise from Left

Christ's last words from the Cross, 'It is finished', by James Tissot, from *The Life of Our Saviour Jesus Christ*, 1890.

An illustration of St Basil the Great (329–379AD) and St Maximus, the Greek theologian. St Basil wrote a treatise, *On the Holy Spirit,* and St Maximus also wrote on the Word of God.

God's Word in the Commandments is written in Hebrew, but other languages are also represented as the Word travels the world. From *Margarita Philosophica Nova*, 1512.

This illuminated page from a 14th-century manuscript has been executed within a pattern of Gothic architecture. Moses receives the Law from the hand of God, but he then disobeys the Word and has to start again.

▼ Left to Right

'The Lord Speaks to Moses and The People', from 1411. At one point, the people 'were afraid to come near him' (Moses), and this is shown by the horns on Moses' head. The Israelites are dressed in oriental clothes.

In this ninth-century interpretation, we can just see God's hand passing the Commandments to Moses in the top of the picture. Below, he shares the Word with the crowd.

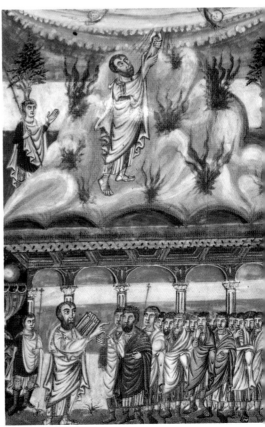

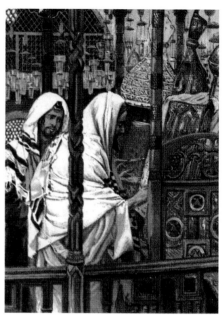

Left to Right

'The Youth of Jesus', by James Tissot, from *The Life of Our Saviour Jesus Christ*, 1890. God's words can be tacit; as the young Jesus carries a plank of wood across His shoulders, we cannot fail to see it as a symbol of the fatal burden he carries for us all.

'Jesus Teaching in the Synagogue', by Tissot, from *The Life of Our Saviour Jesus Christ*, 1879. Jesus taught from the Hebrew Scriptures, but of course His words and actions eventually gave rise to the New Testament.

▸ 'The Scouring of the Face', by Tissot, from *The Life of Our Saviour Jesus Christ*, 1879. Shortly after the event depicted here, Jesus cried, 'Forgive them, Father! They don't know what they are doing.'

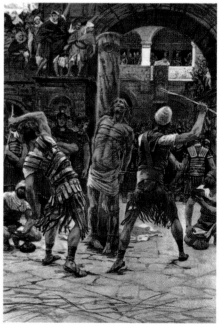

◀ Jesus telling a parable in a detail from the 13th-century 'Good Samaritan' window in Chartres Cathedral, France. Complete attention from the listener is required if the words of the parable are to be understood fully.

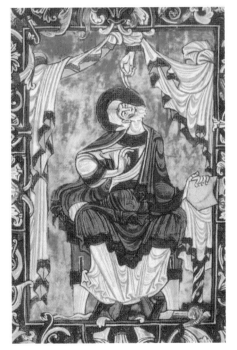

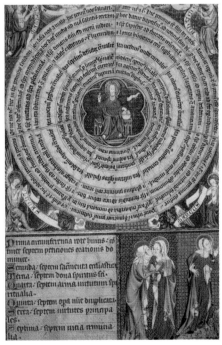

▲ One of Christ's evangelists is shown with writing tools. The touch of God's hand is helping the flow of words into the gospel. From the 11th-century 'Four Evangelists'.

▲ On this 14th-century Psalter of Robert de Lisle, angels hold scrolls of the names of the Four Evangelists; Christ appears at the centre of the circles of words.

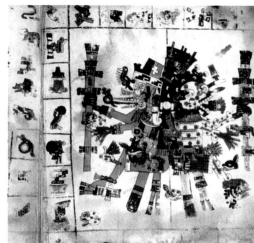

▲ Hebrew script takes the shape of a rooster on this page of the *Ashkenazi Haggadah*, 1460–1475.

▼ From 967 AD, these words of the *Bodhisattva Manjusri* are written on palm leaves in 'Kutila' script. This sutra can be found at Vikramasila, a great monastery in India. Sutras in Buddhism are the written form of the Buddha's teachings.

▲ The zoomorphic form of the *Codex Borgianus*, from 15th-century Mexico. It represents the 'Crucified Saviour of the New World'. The Spanish monks who first went to Mexico were surprised to find the crucifix there and discovered it to be a representation of the death of Quetzalcoatl.

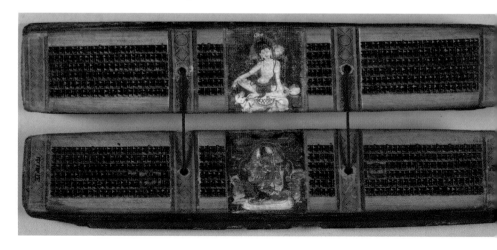

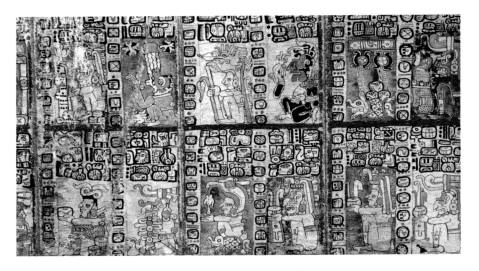

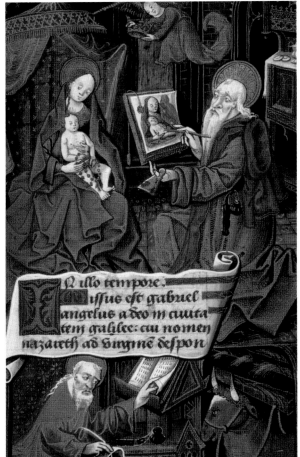

Q illo tempore.
iffus est gabriel
angelus a deo in cuuta
tem galilee: cui nomen
nazareth ad virgine despon

▲ A section from the *Mayan Troano*, a codex telling of the lost civilization of the Mu people in a form of words that is unintelligible to most people today.

◀ In this painting from 1450–1499, a saint, probably the patron saint of painters, Luke, paints the Madonna and Child. The same figure is seen copying a script at the bottom of the picture.

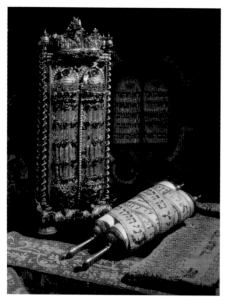

◀ The scrolls of the Torah, the teachings of the Jewish faith, shown in a painting from Vienna, dated 179. Notice the Ten Commandments appearing in the background.

▼ **Left to Right**
A scroll of Sanskrit text, illuminated with illustrations of Hindu stories and decorated with floral borders. From the 19th century.

Buddha preaching the law as he sits among his followers, in an early eighth-century illustration. The prominence of the Buddha within the picture indicates his importance.

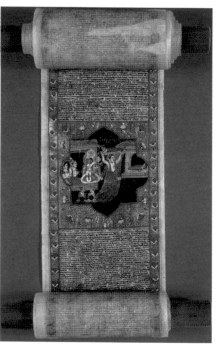

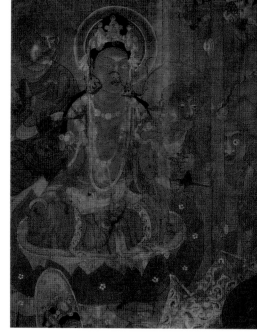

▸ A 10th-century, bronze figure of the Buddha Vairocana, one of the five transcendent Buddhas. His symbols are the wheel of teaching and the sun, indicated here by the halo of flames. His hands are in the gesture of teaching.

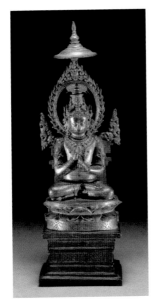

▸▸ From the 10th century, this Chinese-style figure of the Buddha shows him in the teaching position. Notice his hand gestures.

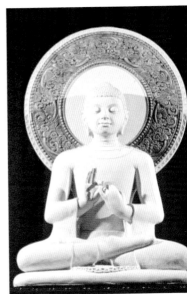

▸ This statue from fifth-century India is 'turning the wheel of law', one name given to the act of preaching in Buddhism. The *dharmachakra mudra* is the gesture that denotes it.

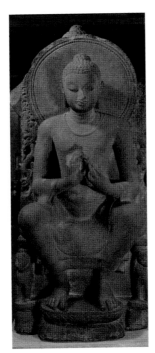

▸▸ Buddha preaching on Vulture Peak on a silk embroidery from Dunhuang, China. Dating from the eighth century, it is one of the largest known Chinese embroideries.

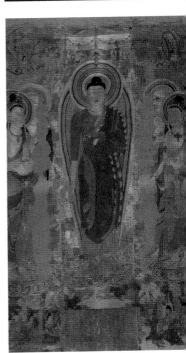

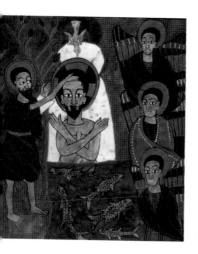

▲ A scene from 'Sinodos', or 'The Canons of the Apostles and of the Council of Pharaohs', 1744. Seen here baptizing Jesus Christ, St John the Baptist had already spent time preaching repentance and the need for God's forgiveness through baptism, thus fulfilling the words of the prophet Isaiah in the Old Testament. On this occasion, God's words to Jesus were, 'You are my own dear Son. I am pleased with you.'

▶ A page of 17th-century Ethiopic text illustrated with the nativity scene and two holy men in deep discussion.

▲ Surrounded by a rainbow and decorated with gilding, the face of God illuminates this 14th-century psalter.

▲ The face of Christ oversees the Word of God on a 13th-century manuscript. It is given greater presence by its border.

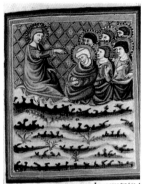

▲ Christ present in the words of the scriptures, in a 14th-century Italian manuscript.

▲ The Sermon on the Mount is shown in *The Meditations on the Life of Christ* from 14th-century Italy. The words He spoke were of true happiness.

▲ Words were spoken to Joseph in a dream; these prompted him to move the holy family to Egypt. This drawing, *c* 1557–1559, is inspired by figures in Michelangelo Buonarroti's (1475–1564) 'Last Judgement'.

◄ The 'Borradaile Triptych', crafted in the 10th century in Rheims, France, is inscribed with the words, 'Behold thy son; Behold thy Mother', which were the words spoken by Jesus on the Cross to His mother and friend.

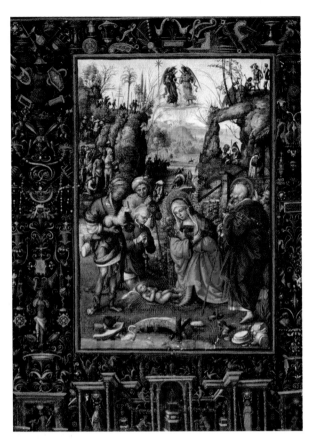

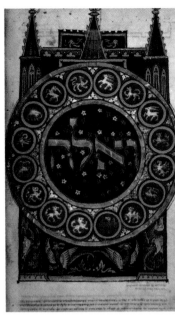

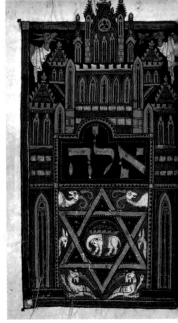

▲ Many Christian paintings present a story in an easily understandable, visual form. This Nativity scene, c 1500, manages to illustrate as well as lift the spirit of the viewer – art and evangelism elegantly entwined.

▸▸ **Opposite**

A cult member attending a Bhajan Mela celebration with the name of Rama, an avatar of Vishnu, tattooed over her face.

▸ **Top to Bottom**

The first word of the Book of Deuteronomy, in which Moses addresses the people of Israel in the land of Moab and reminds them of the importance of God's Word and their need to commit to it. From the Duke of Sussex German Pentateuch, c 1300.

The decorated first word of the Book of Exodus, with the six-pointed star, or Magen David.

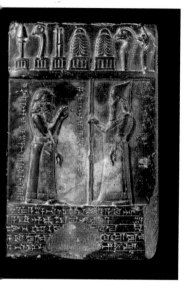

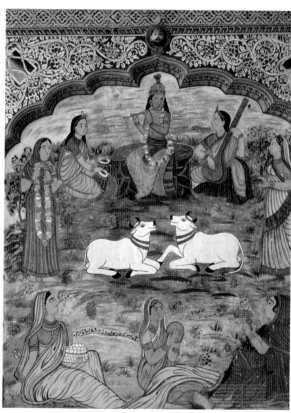

⚊ A view of the Last Supper, a 17th-century painting after Leonardo da Vinci. Jesus' words from this meal are an important part of the Christian liturgy.

▲ The words on a legal statement from Iraq, c 870BC, are protected by the symbols of the gods at the top. The King and a priest are shown below.

▲ The Hindu Lord Krishna and the Gopies, or 'keepers of cows', sing words of praise in this wall painting from Shekhawati, Rajasthan, India. Gopies symbolize the soul's devotion to God.

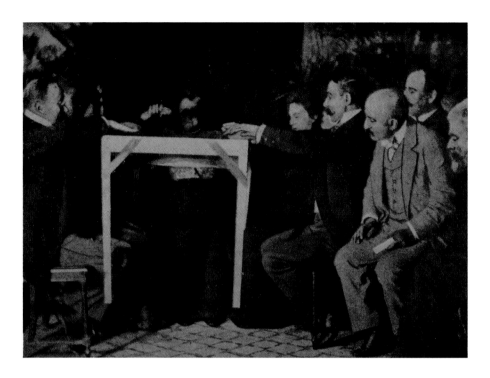

▲ A seance led by Eusapia Palladino in Milan, 1892. Those present are hoping to make contact with the spirit world through words or signs. Here, we see the table levitating.

▲ Communicating with the earthly world and the spiritual: petroglyphs, or rock drawings, from the Canyonlands National Park in Utah.

▲ The Niger Plateau neolithic rock carving, showing an elephant swinging its trunk. Pictograms and drawings spread the Word.

▲ The meeting of Lao-Tzu, the founder of Taoism, and Confucius, with an implied exchange of words.

▶ Lao-Tzu is also known as Lao Tan, the 'Old Master'. There are many tales of his activities, not least that he taught the Buddha in India. He was deified in Taoism, but this image shows him as an old man, riding an ox.

▼ A rubbing taken from a marble slab in a Confucian temple. Confucius is thought to have been born around 552BC, but little is known of his life except that he had decided on a life of study by the age of 15. His philosophy has a spiritual content but he spoke little of God, except claiming that heaven was responsible for his virtue.

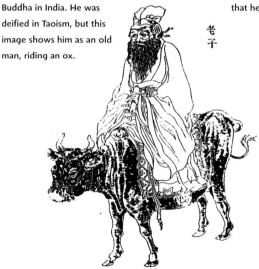

老
子

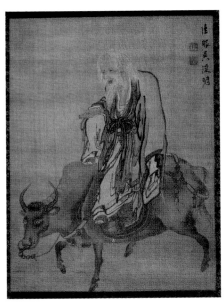

◄ Lao-Tzu is shown here on a blue ox carrying him into Asia to spread his philosophy. Legend says that he sprang from his mother's side after 81 years in the womb, hence his aged appearance.

▼ A warmth and stillness presides over this painting of Lao-Tzu from sixth century BC. Lao-Tzu is credited with authorship of the *Tao Te Ching*, the *Book of the Way and Its Power*, which is made up of 5,000 pictograms.

▲ Left to Right

The expression and richness of this 17th- or 18th-century statuette lend Confucius a regal appearance; he was obviously revered by whomever commissioned this piece.

Images of respected figures find their way into all sorts of places. Here, on a 19th-century sword guard, we see Confucius, Lao-Tzu and the Buddha taking sake together. No doubt their words of wisdom would inspire courage in the warrior.

◄ Confucius looking venerable in New York. Confucianism has found its way into mainstream Chinese philosophy over the last 2,000 years and the Confucian work ethic still holds strong.

▶ Opposite

The repeating images serve as a tangible presence of Buddhist prayer on this devotional hanging.